masterful COLOR

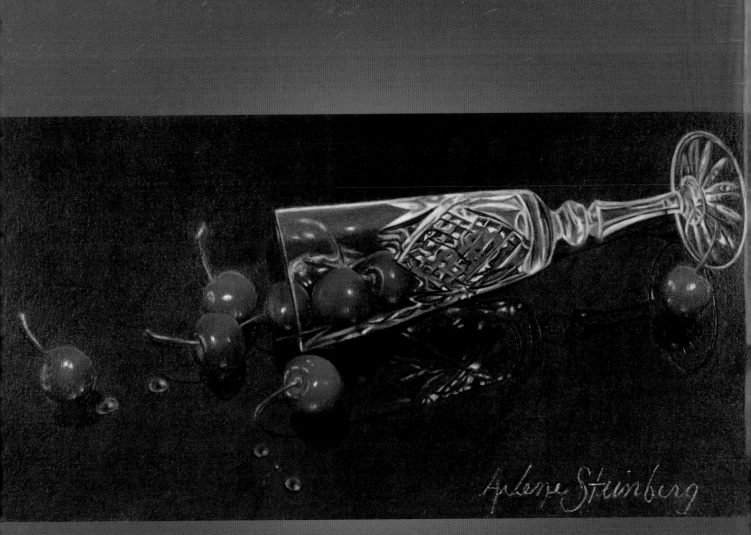

SPILLED CHERRIES
Colored pencil on Stonehenge paper · 5" × 10" (13cm × 25cm)
Collection of the artist

masterful
COLOR
vibrant colored pencil paintings
LAYER BY LAYER

arlene STEINBERG

NORTH LIGHT BOOKS
CINCINNATI, OHIO
www.artistsnetwork.com

Masterful Color: Vibrant Colored Pencil Paintings Layer by Layer.
 may quote brief passages in a review. Published by North Light Books, an imprint of F+W Publications, Inc., 4700 East Galbraith Road, Cincinnati, Ohio, 45236. (800) 289-0963. First Edition.

Other fine North Light Books are available from your local bookstore, art supply store or visit our website at www.fwpublications.com.

12 11 10 09 08 5 4 3 2 1

DISTRIBUTED IN CANADA BY FRASER DIRECT
100 Armstrong Avenue
Georgetown, ON, Canada L7G 5S4
Tel: (905) 877-4411

DISTRIBUTED IN THE U.K. AND EUROPE BY DAVID & CHARLES
Brunel House, Newton Abbot, Devon, TQ12 4PU, England
Tel: (+44) 1626 323200, Fax: (+44) 1626 323319
Email: postmaster@davidandcharles.co.uk

DISTRIBUTED IN AUSTRALIA BY CAPRICORN LINK
P.O. Box 704, S. Windsor NSW, 2756 Australia
Tel: (02) 4577-3555

Library of Congress Cataloging in Publication Data
Steinberg, Arlene.
 Masterful color : vibrant colored pencil paintings layer by layer /
Arlene Steinberg. -- 1st ed.
 p. cm.
 Includes index.
 ISBN-13: 978-1-58180-957-2 (hardcover : alk. paper)
 1. Colored pencil drawing--Technique. I. Title.
NC892.S74 2008
741.2'4--dc22
 2007038260

741.2
STE OCLC 9/17/08

Edited by Jeffrey Blocksidge
Designed by Wendy Dunning and Guy Kelly
Production coordinated by Matt Wagner

ABOUT THE AUTHOR

Arlene Steinberg has been creating and selling her art for as long as she can remember. While still in high school, she sold needlepoint designs to manufacturers and created a cover for a trade magazine. After graduating from Syracuse University with a BFA in textile design, she worked as a textile and wallpaper designer for over twenty years. After retiring from the textile industry, Arlene put her talents toward creating realistic paintings in colored pencil reminiscent of the Old Masters.

Arlene achieved signature membership status in the Colored Pencil Society of America by having her works accepted in the national exhibition the first three years she entered, and two years later she received her five-year merit award. In addition to being a member of the CPSA, Arlene is on the board of directors of the Catharine Lorillard Wolfe Art Club and is a member of the International Guild of Realism.

Her colored pencil paintings have won many awards in regional and national exhibitions, and she has had work published in *American Artist Drawing* magazine. Her painting *You Too Can Paint Like a Master* was selected to be in a traveling museum show during 2008–2010 curated by the International Guild of Realism.

Arlene teaches her techniques on Long Island, New York, where she lives, as well as nationally and in Canada. She and her friend Gemma Gylling started a Web board (www.scribbletalk.com) for artists who use drawing mediums, where she freely gives her advice. Her work can be viewed at www.arlenesteinberg.com.

COVER ARTWORK:
I THOUGHT I LOST THEM
Colored pencil on Stonehenge paper
5" × 7" (13cm × 18cm)

Metric Conversion Chart

To convert	to	multiply by
Inches	Centimeters	2.54
Centimeters	Inches	0.4
Feet	Centimeters	30.5
Centimeters	Feet	0.03
Yards	Meters	0.9
Meters	Yards	1.1

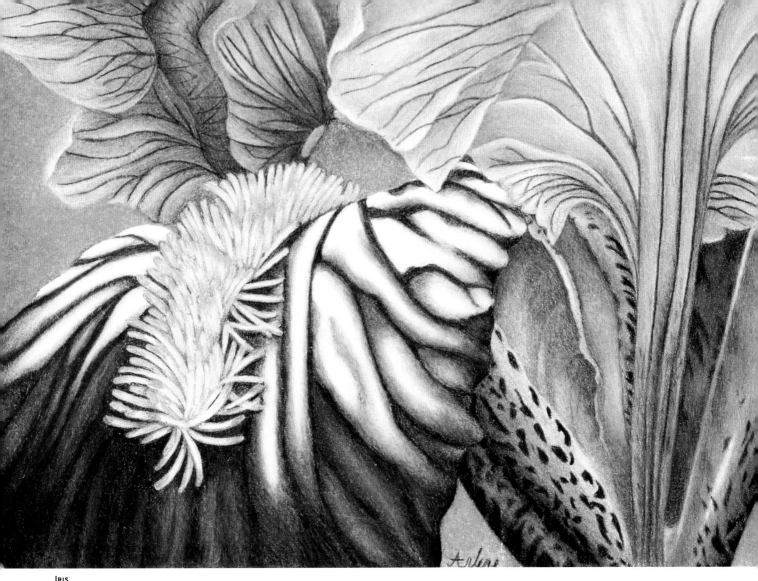

Iris
Colored pencil on Stonehenge paper · 7" × 9" (18cm × 23cm)
Collection of Susan Yuran

DEDICATION

To my mother, Toni Gardner, who always encouraged and supported my creativity, who believed in me when I said I wanted to be an artist and has always been there for me.

To my father, Len Gardner, who always made sure when I was growing up that I was able to buy the supplies I needed, and gave his blessing when I said I wanted to pursue an art education. I love you both.

To Rachel and Josh for being my two greatest creations; they are my biggest fans and almost always understood when I couldn't spend time with them while finishing this book. You can do anything you set your mind to. I love you.

ACKNOWLEDGMENTS

I'd like to extend a special thanks to: Jamie Markle for his believing in this book and Jeffrey Blocksidge for his patience in answering my endless phone calls, returning emails and editing; Ann Kullberg, Cecile Baird and Kristy Kutch for their friendship, support and encouragement both before and during this endeavor; Emily Lagore and Pam McAssey for use of their wonderful photo references; Melissa Miller Nece for the use of her artwork; my Thursday morning class and all the Scribble Talk members for their friendship and support—in both art and life; Gemma Gylling for being a good friend, managing www.scribbletalk.com while I was writing and looking at my art and manuscript whenever asked; Caryn Coville for her friendship and for finishing the tomato and peaches when I was fast approaching my deadline. Finally I'd like to thank Gil Weiner for his love and support. His help with editing and writing, keeping me on track with deadlines and allowing me to use his camera to shoot the book photos has been invaluable. He is my significant other, editor and cheerleader. I couldn't have completed this book without his continued encouragement.

 # Contents

Introduction

Since childhood, I've been enamored by the Masters' art, especially Dutch and Flemish Masters. I marveled at their use of color, value, perspective and composition. I spent hours at the Metropolitan Museum of Art wondering how I could create such beautiful artwork. I wanted to paint like a Master!

In college I majored in painting, even though my first love was drawing. In the 1970s, only oil painters were considered "real artists" and realism wasn't deemed an acceptable art style. Instead, we were instructed to express ourselves with abstract art. Frustrated, I switched to textile design, a field I worked in for over twenty years. After retiring, I created collages and paper sculptures and discovered colored pencils after buying them to embellish my collages. I've been hooked on them ever since. I love their versatility and lack of mess, but mostly I love creating dynamic drawings with vibrant color.

"Colored pencils and the Masters?" The two are almost never linked. Colored pencils are usually associated with the box of eight (or sixteen if you were lucky) we had in kindergarten. Until now, it was rarely thought of as a fine art medium. Improvements in colored pencils have led to greater varieties of colors, and many pencils are now archival. Drawings can be created that rival results achieved with more conventional fine art media such as oils or acrylics.

This book will guide you through exploring painting with pencils using a method different from most colored pencil artists. The semitransparency of colored pencils lends itself to creating a tonal underpainting using grayed complementary colors and adding layers of color on top. You'll learn to work from dark to light colors, similar to the Masters. Your colors will be richer and deeper and your lights will look more brilliant.

I wrote this book for those at any stage of their colored pencil journey. Outline drawings are provided to follow along with the demonstrations. Each lesson is a building block that culminates in a large, final still life. While I'm primarily a still-life artist, using complementary colors works equally well for any subject, including portraits and landscapes. So, pull up a comfortable chair, sharpen your pencils and start drawing like a Master!

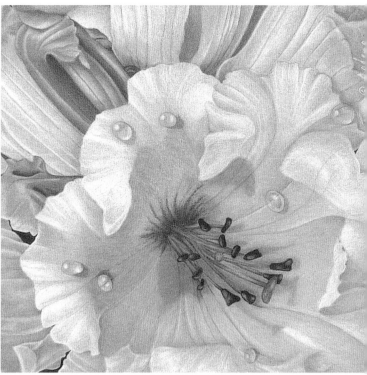

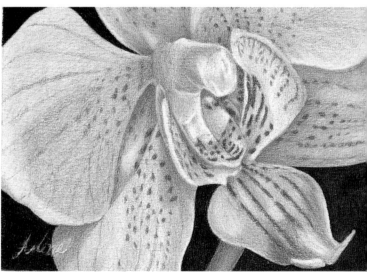

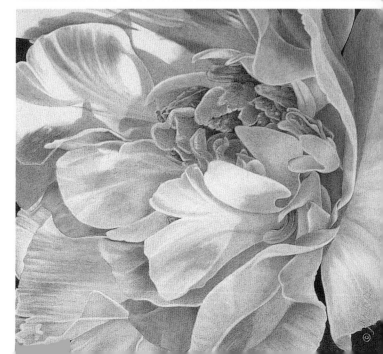

RHODODENDRON
Colored pencil on Stonehenge paper · 9" × 8" (23cm × 20cm)
Private collection

ORCHID
Colored pencil on Stonehenge paper · 4" × 6" (10cm × 15cm)
Private collection

TULIP
Colored pencil on Stonehenge paper · 12" × 11" (31cm × 28cm)
Collection of the artist

YOU TOO CAN PAINT LIKE A MASTER
Colored Pencil on Stonehange paper · 14" × 18" (36cm × 46cm)
Collection of the artist

THE BASICS

WHEN I STARTED WITH COLORED PENCILS, ONE THING I NEEDED TO LEARN WAS THAT THEY handled differently than graphite pencils. I could not use a stump for blending colors or use heavy pressure to build up color quickly. If I tried erasing the way most of us learned as children, by rubbing the eraser across the area, I wound up with a mess of smeared color. With time, I learned how much pressure was necessary to apply color, what papers worked best, how to blend colors and the best ways to correct errors and lift color.

The best advice I give my students is to spend time at the beginning learning basic techniques. You will be able to create beautiful works of art most easily when you have a basic understanding of how to use colored pencils. While the methods shown in this chapter work for me, with time and experimentation, you might find yourself refining these techniques, or even finding others that work better for you.

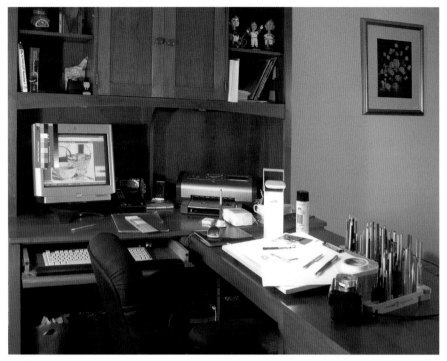

work area
A comfortable area with good lighting and a handy place for your tools will make drawing more enjoyable.

pencils and paper
Many different types of pencils and papers will work for colored pencil drawings. Experiment to find which brands work best for you.

sharpener care
Sharpener blades must be kept sharp and clean. One way to assure this is to sharpen a graphite pencil before starting work each day.

With a basic knowledge of drawing, pencils, paper and a few inexpensive tools, one can begin creating beautiful art.

WORK AREA

Use a chair with good back and thigh support, and draw on a hard, smooth surface larger than your drawing. Good artificial lighting is a necessity since you can't guarantee there will be enough daylight. Choose a lamp that uses daylight-adjusted bulbs.

PENCILS

Use artist-grade colored pencils to achieve vibrant color in your drawings. I primarily use Sanford's Prismacolor Premier pencils.

PAPER

Start with good, archival-quality paper that takes multiple layers of color, has a slight tooth and withstands erasing. I generally use Stonehenge paper by Legion Paper, Inc.

SHARPENERS

Your pencils should always be needle sharp, so use a quality electric sharpener. The sharpener's shavings should be a bit coarser than sawdust. In no way should they resemble peeled apple skins. Sharpeners that produce these shavings tend to break pencil leads, as will handheld sharpeners.

ERASERS

My favorite eraser is mounting putty intended to hang posters. Knead a small piece in your hand to warm it and press it on the paper to lift color. A kneaded eraser will not lift as much color. A white plastic eraser can lift color and be cut to reach small areas. I now have a battery-operated eraser and wonder how I ever lived without one.

TAPE

Any clear tape will act as an eraser and lift color. Hold the tape above the area where color needs to be removed and with a pencil, gently color onto the tape. Don't press, or you will lift the paper as well as the color when you remove the tape.

IMPORTANT EXTRAS

You will find yourself hunting for these eventually:

- Drafting brush or any natural, soft haired brush for dusting off pencil particles.
- Workable spray fixative to eliminate wax bloom haze (use in well-ventilated area).
- A sheet of paper to place under your hand so skin oils don't transfer to your drawing.
- Painter's or drafting tape will keep the edges around your drawing clean.
- Pencil extenders to draw with shortened pencils.
- Red or green acetate for viewing values.
- A way to store your pencils.
- Cotton makeup pads to give sheen to your work after it has been burnished.
- Clear acetate for drawing transfers.
- Tracing paper to work out your composition before transferring.

DIGITAL CAMERAS

Ideally it would be best if we could work from life, but this isn't always an option. Fruits and vegetables go bad. Flowers wilt and lighting can change. Digital cameras are so easy to use that anyone can take multiple photos, upload them to the computer, study the compositions, and print out a reference photo within minutes.

Use a camera that allows you to turn off the flash. Manual override of exposure is a nice feature to have, but isn't critical. If you also wish to take closeups, be sure to purchase one that is good for macro photography. Choose a memory card with enough memory to take lots of photos at high resolution.

OTHER EQUIPMENT

A tripod is a must for shooting still lifes. With only a single light source for your still life, you'll be shooting in low-light situations. Mount the camera on a tripod to prevent shaking and blurry photos. I also recommend using a remote shutter release.

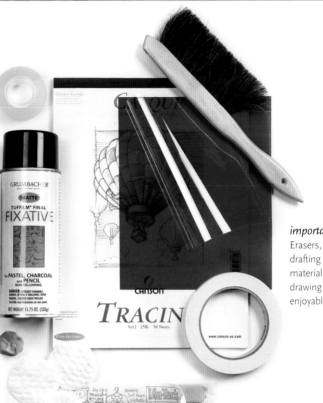

important extras
Erasers, a good sharpener, drafting brush and other materials will make drawing easier and more enjoyable.

light source
If shooting indoors, the easy way to create dramatic lighting is to use a halogen flood light and clip-on reflector hood, readily available in stores. Of course you can purchase professional quality lighting, but it's not necessary.

digital cameras
A basic point-and-shoot model (near left) and a digital SLR model for those looking to move up from a point-and-shoot.

photography 101

Correct lighting coupled with the proper camera settings will enhance your reference photos by creating depth and drama.

LIGHTING

A single light source creates interesting shadows and highlights in your still life so you have a more dramatic drawing. When shooting with artificial light, be sure your light source is mobile. Try shooting with the still life backlit, or from the side. Move the light higher, then try some shots with the light source in a lower position. Notice the different effects you get with each move, and which ones enhance your composition.

WHITE BALANCE

Theoretically, you can set this to accommodate the type of lighting you're using; incandescent or fluorescent, daylight or cloudy, etc. I usually get the best color by using the automatic white balance setting.

EXPOSURE SPEED

When shooting your reference photos, use the lowest ISO (ASA) speed to avoid a mottled, grainy appearance (image noise). I usually shoot at ISO 100 to get the crispest pictures.

APERTURE

Aperture is the width of the lens opening, which determines the amount of light the camera lets in. Aperture measurements are referred to as f-stops. The higher the f-stop number, the smaller the aperture.

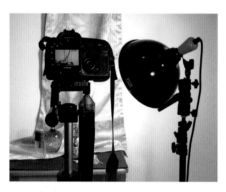

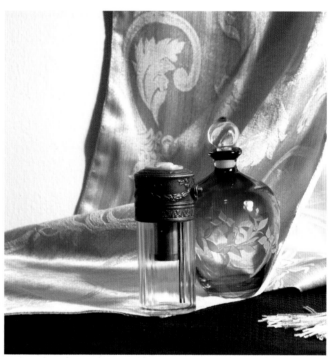

lighting your subject
Create a good balance between light and dark areas when shooting.

sharp subject, blurred background
To create a photograph with a small area of your picture in very sharp focus and the background somewhat blurred, choose a wider lens opening (f-stop between 2.8 and 4.5).

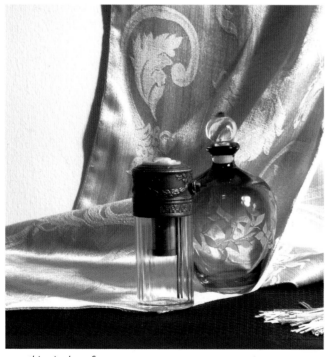

everything in sharp focus
If you prefer to have everything in sharp focus, use a smaller aperture opening (f-stop between 6.1 and 8.0).

Aperture Priority

Many newer cameras allow you to shoot with "aperture priority." This setting allows me to set my aperture opening, then the camera determines the shutter speed automatically.

WHY FLASH DOESN'T WORK

I cannot emphasize strongly enough not to use the camera's built-in flash for your reference pictures. It will undo all the effort you put into creating a pleasing still-life arrangement. A camera's flash will create "hot spot" reflections, eliminate dramatic shadows and highlights, and flatten out the objects in your image. A drawing from a reference photo shot with a flash will look like a snapshot instead of a drawing that conveys an ambiance or feeling.

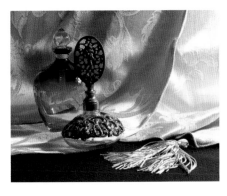

use a single light source to create drama

When you use a single light source, you'll achieve more defined and intense shadows and highlights, as well as a larger range of color. Notice how the glass is translucent in this photo taken with the light coming from the side.

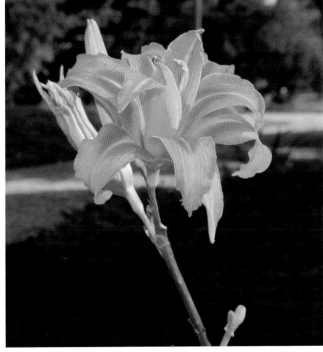

avoid using the camera's flash

Light from a flash flattens out everything. There are no dramatic shadows or highlights to create a mood. Notice how the glass appears to be opaque instead of translucent in this photo.

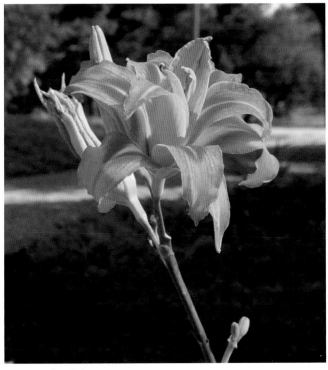

use natural sunlight

Sometimes the best light to use is natural sunlight. Try shooting outdoors in the early morning or late afternoon to get interesting light and shadows for flowers, outdoor still lifes or landscapes.

adjust the aperture instead of using a flash

Notice how the flash has washed out the flower, making it appear bland and two-dimensional. The best way to shoot in low light outdoors is to use a tripod or a monopod. A longer shutter speed requires stillness.

working with reference photos

Photos lie! We're more forgiving when issues of perspective or proportions are wrong in a photo than in artwork. When we view a photograph, we generally don't perceive the distortions, yet they become obvious when we view a drawing copied from a photograph with perspective or proportion issues. This is because we humans see with both eyes and then record the picture in the brain by combining both views into a three dimensional image. Cameras only record what they see through a single lens opening. This isn't the only problem with relying solely on a photograph from which to draw.

PHOTOS DISTORT

Many times when shooting a still life, you'll run into problems: objects that seem to be leaning, straight sides that appear to bow in or out, or objects in the foreground that look too large. These distortions can be corrected with a photo-editing program, or you can adjust problem areas on tracing paper before transferring the picture to drawing paper.

COMPOSITION

Sometimes it's necessary to move objects to create a more pleasing composition. Sometimes by moving an object in closer or creating more space around it, the arrangement will look more unified.

ELIMINATE DISTRACTIONS

Sometimes there may be distracting elements in your photo. This happens frequently when shooting outdoors and trying to capture a moment. A pole that appears to come out of

reference photo
I thought this would be a good subject for a drawing. When I viewed it on my computer, however, I realized I needed to adjust and play around with the photo before starting my drawing.

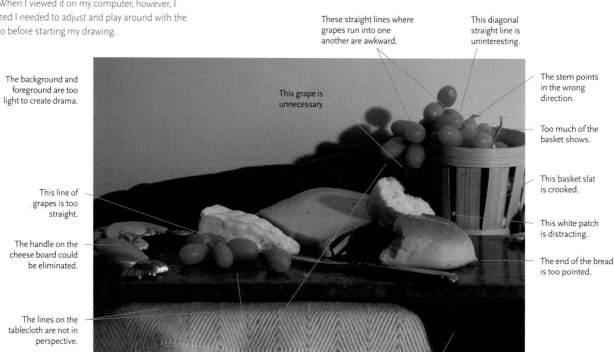

These straight lines where grapes run into one another are awkward.

This diagonal straight line is uninteresting.

The background and foreground are too light to create drama.

This grape is unnecessary.

The stem points in the wrong direction.

Too much of the basket shows.

This line of grapes is too straight.

This basket slat is crooked.

The handle on the cheese board could be eliminated.

This white patch is distracting.

The end of the bread is too pointed.

The lines on the tablecloth are not in perspective.

There is a ping-pong effect between the two groups of grapes.

There is too much foreground.

This green cloth needs to look like a napkin instead of a jacket (which is what I actually used).

use grayscale to check values
Most image-editing programs now include a way to turn your color photograph into a black-and-white photo. By using this feature, you can more easily check your values. If the values need adjusting, it's better to be aware of it before you start your drawing. If you don't have an image-editing program, you can use a sheet of red acetate and put it over your drawing. The acetate will eliminate the color so that you can concentrate on the values.

someone's head is one example. Just because something appears in the photograph doesn't mean you have to include it in your drawing. If an object in a photograph adds nothing to the drawing, then eliminate or change it.

IF YOUR OBJECTS APPEAR FLAT

If objects in your drawing appear flat, it's an easy correction to make. Make your shadows darker and the visible highlights brighter than in the photo. This should give your objects a bit more dimension.

ARTISTIC LICENSE

Realism doesn't mean copying a photograph exactly. It means interpreting with your artistic vision how you want others to view your subject. You are the one who tells the story and creates an ambiance through your artistic vision. It's your decision to reinterpret what you see or to change what you don't like.

Work From Large Photos

When working from photographs, blow up your image as large as possible to see details more clearly. I never work with a reference smaller than 8" × 10" (20cm × 25cm). For my large drawings, I'll print individual sections of the photo onto 8" × 10" (20cm × 25cm) paper.

correct problems before you draw
I deepened the shadows and darkened the background and foreground on the photo using the Adobe Photoshop editing program, but it's almost as easy to use tracing paper to correct distortions and perspective problems. Most of the problems with the previous photo have been corrected to create a more pleasing composition.

I cropped the photo to create a more pleasing composition.

The problems with these grapes I'll correct in the drawing.

I eliminated the stem.

I raised the grape to eliminate the straight line.

I modified the grape so it didn't create a straight line.

I straightened the basket slat.

I eliminated the white.

Instead of the handle on the cheese board, I created an edge. This helps add perspective to the photo.

I removed the tail on the bread.

I deepened the shadows and darkened the background and foreground on the drawing.

I corrected the perspective on the tablecloth.

To eliminate the ping-pong effect of the two groups of grapes, I added a small group of two grapes behind the bread. This helps lead the eye around the photo.

If You Can't See Details in the Shadows

Use your image-editing program to lighten the photo until you can.

from idea to paper

The most common ways to get your basic idea onto drawing paper include freehand drawing, using a grid and photocopying.

CREATING THE DRAWING

I don't recommend drawing preliminary sketches on your good paper. Erasing can damage the surface texture of your drawing paper so it's best to work out your composition on tracing paper first. Only after I'm satisfied with my drawing on tracing paper will I transfer it to the final surface.

Once I've worked out my line drawing I like to transfer it to acetate with a technical pen (I use Dura-lar by Grafix). This is an extra step, but I find it easier to see the lines on the acetate when transferring to good paper.

TRANSFERRING YOUR DRAWING

Here are three of the most straightforward methods for transferring preliminary drawings onto your final paper.

draw it freehand
I draw freehand whenever I have the time as this lets me see what's really there and allows me to choose what I want to include or leave out. The best way to draw freehand is to block in the shapes first and then refine them.

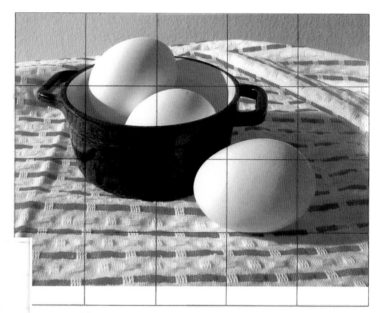

use a grid
Create a grid with ½-inch (13mm) squares using a technical pen on treated acetate. Place it over your reference photo. Create a second grid the size you want your finished drawing to be. For example, to double the size of your drawing, make 1-inch (25mm) squares. Place the second grid under your tracing paper, then copy your photo one square at a time.

use a copier or your printer
If the dimensions of your intended drawing are small enough, you can print your reference photograph on a home printer. If you are planning a larger drawing, you can print your photo in sections and tape them together. Most printing shops will size and print photos for you. Once you have a reference of the proper size, draw the outlines with a technical pen on acetate.

transfer paper

Transfer paper is a sheet of paper coated on one side with graphite or a colored ink. Use white when working on dark paper. Be careful to avoid smudges when using graphite transfer paper.

lightbox or window

This method is the most direct. Tape your line drawing on treated acetate to a large window or lightbox. Next, tape your good paper on top of your line drawing and trace using a very light pressure (see page 19).

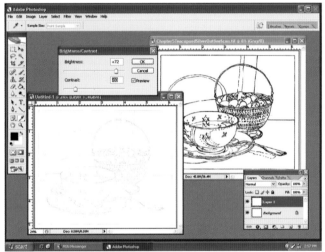

print your drawing

You won't have to worry about impressed lines with this method. First, make sure your printer will take heavyweight paper and you're not planning on using water on the drawing. Scan your line drawing at 300 dpi. With an image-editing program, turn the scan into a black-and-white drawing. Increase the brightness and reduce the contrast until the lines are a light gray. Print your line drawing onto your good paper.

Keep a Sketchbook Handy

Use it to draw whenever you have a spare moment. By sketching frequently, you'll train your hand and eye to work together and you'll have a convenient way to record any ideas that pop up.

applying colored pencil

A few basic techniques will help you get the color from the pencil and onto the paper most effectively. Your way of applying color will be different from anyone else's. That is what helps distinguish your style from someone else.

STROKES

Different strokes produce different effects. The two shown here are the most basic. For the best results, sharpen your pencil frequently—a minimum of once every minute—and use light pressure.

circular stroke
This is the easiest method to achieve even layers. With a needle-sharp point and light pressure, create tiny overlapping circles in a random pattern.

keep your circles small
Small circles create more even color. Larger circles run the risk of not completely covering the paper.

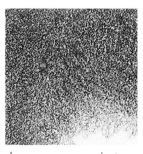

sharpen once every minute
The paper texture is more prominent in this example because the point wasn't sharp enough.

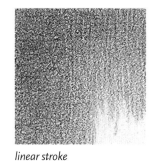

linear stroke
The linear stroke is faster, but takes more practice to get even color. Use a sharp point and keep layering in one direction. Turn your paper 90 degrees to add more layers.

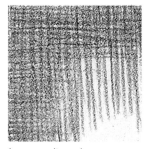

keep your lines close
If your lines are too far apart, you'll have a harder time filling in, even after you turn your paper.

stagger your line length
If you don't, you run the risk of creating a noticeably heavier line where strokes overlap.

Pencil Points

A blunt point is good for creating texture, putting color on after the paper is almost saturated and for burnishing at the end, but it doesn't work when you're trying to get even color.

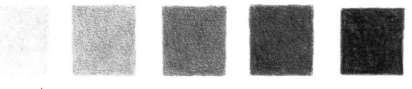

PRESSURE

Pressure refers to how hard you press the pencil to the paper. Light pressure is best for most applications. Hold the pencil about one-third of the way up the shaft and it will be easier to apply with a light touch. We all have a tendency to press harder when we hold the pencil close to the tip.

Build up color slowly by doing more layers using light, consistent pressure. This way, even after you have created a rich color, you can still add layers.

The wonderful thing about colored pencils is that when you lightly apply one color over another, the color below will enhance or change the color on top.

pressure scale
Think of pressure on a scale between 1 and 5, 1 being a light, feathery touch (feathering) and 5 being so hard it indents the paper or breaks your pencil (never used). The lighter the pressure, the more layers you'll be able to add.

LAYERING

Layering with a light touch will allow you to blend colors, mix new ones and create richer, more interesting hues. Take the time to practice layering and creating color gradations to help you get comfortable with your pencils.

build lots of light layers
Use a needle-sharp pencil and pressure 2 to get an even layer of color. Remember, sharpen a minimum of once every minute. After a while, sharpening frequently will become second nature; you'll feel the difference.

Tooth

Most paper has a tooth that, when magnified, appears as hills and valleys on the paper's surface. A very sharp pencil will reach into these valleys and make it easier to achieve even layers of color.

Impress Fine Lines And Dots Before Adding Color

After many layers, it's almost impossible to add your signature or other fine lines to a drawing. Before you begin any coloring, use a blunt knitting needle or ball-tipped burnisher to create fine, indented lines and dots in the paper. Then, color over the impression with a sharp pencil. With this technique, you can impress your signature into the paper before you start so it won't fill with color.

BLENDING

Colored pencils are dry, which means that, unlike with wet mediums, you can't mix colors on a palette. Instead you'll need to layer and blend colors directly on your paper.

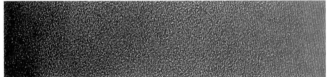

one-color gradation

To shade an area, some artists start with the light areas and work towards darker areas. I start on the darkest side. Add layers until you match the darkest value and gradually decrease how many layers you add as you move towards the lighter areas. Layer using a pressure 2. When you get closer to your lightest areas, decrease your pencil pressure to 1.

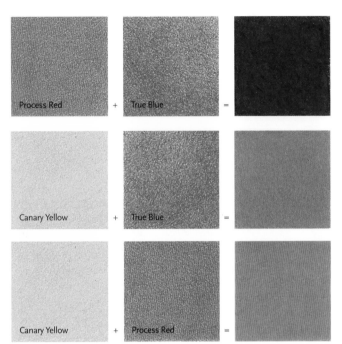

Process Red	+ True Blue	=
Canary Yellow	+ True Blue	=
Canary Yellow	+ Process Red	=

blend colors on your paper to create new colors
Light-pressure layering can create vibrant new colors. Colored pencils are transparent, so every color layered will be altered by the color underneath it.

blending two colors

Layer one color as you did with the one-color gradation. Choose a second color and work from the opposite side. Layer as you did with the first color, only reversing direction and layering the second color over the first color.

SOLVENTS AND MARKERS

Another way to blend colors is to use a solvent such as Weber's Turpenoid or a colorless art marker such as Prismacolor's Clear Blender. The solvent dissolves the wax in the pigment, forcing the color into the tooth of the paper. This is great for adding color quickly, although it can change purples and pinks. It can also give the paper a slightly rougher tooth. To apply solvent, use a small flat brush, a cotton swab or cotton pad. For small areas, I prefer a clear blender. It gives me more control. Prismacolor's Premier Double-Ended Art Marker has both a broad and fine nib.

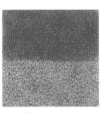

blending one color using solvent
Scarlet Lake with colorless blender marker on top half.

blending two colors together using solvent
Scarlet Lake + Peacock Blue with colorless blender marker on top half.

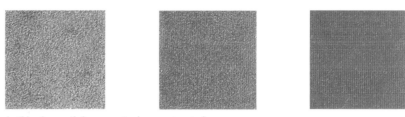

BURNISHING

Burnishing is the process of blending all the layers of color together by using heavy pressure with a blunt-tipped pencil so no paper shows from underneath. Burnished colored pencil paintings almost have the look of an oil painting. Shiny objects, glass and porcelain come alive when burnished.

WHEN TO BURNISH

It's first necessary to build up many layers of color. It's best to apply many light layers and pressure 2. As the paper becomes more saturated, you can increase your pressure to 3. Burnishing too soon will make it harder to apply more layers. Usually I don't even consider burnishing until the paper is completely saturated with color and my pencil feels like it's sliding across the paper.

Use a blunt-tipped colorless blender pencil, such as Prismacolor's Colorless Blender or Lyra's Rembrandt-Splender, or a white or lighter-colored pencil. Using a broad, circular stroke with pressure 4, go over the areas you want burnished. It's best to burnish from light colors to dark so you don't get dark streaks in the lighter colors. Don't burnish an area more than once or twice as it can create uneven areas or may even lift some color. I learned these lessons the hard way.

build color until the paper is almost saturated
In this example, I have built up the red until the color almost burnishes itself. Notice how the paper in the third example is almost completely obliterated by the pigment. Once your paper is almost completely saturated, you are ready to burnish.

use two or more colors
Here I've begun with Madder Lake and layered many layers using the circular stroke and a pressure 2. I then layered Cerulean Blue building up and blending the two colors together. Only in the third example is the color ready to burnish.

burnishing with white
A white pencil works in the same way as a colorless blender pencil, but it will lighten the value. It's sometimes possible to re-darken an area burnished with white with another layer of color.

burnishing with a colorless blender pencil
Colorless blender pencils consist solely of wax. Burnishing with these will enrich the color without changing it or adding additional hues. Once the paper is almost saturated, use pressure 4 and the circular stroke. Notice how the tooth is almost completely filled and the colors appear richer.

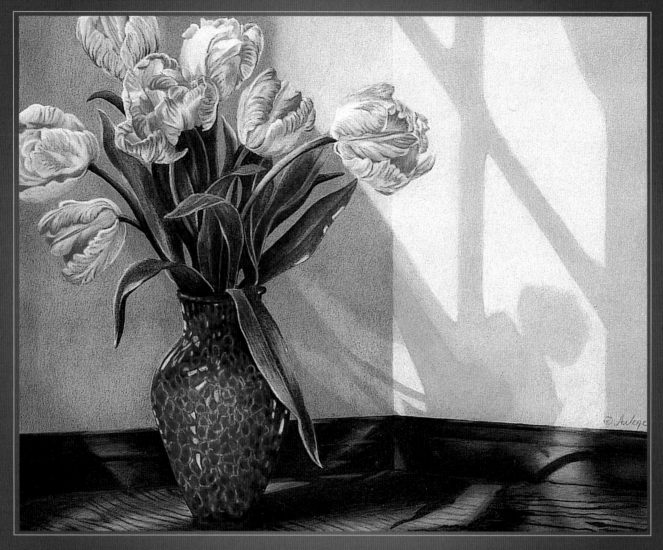

ASIAN INFLUENCES
Colored pencil on Stonehenge paper · 9" × 11" (23cm × 28cm)
Collection of Susan Mann

COMPOSITION

GOOD COMPOSITION IS THE GLUE THAT HOLDS A DRAWING TOGETHER. HOW OFTEN HAVE YOU looked at a drawing and felt something was amiss? Each object may be beautifully rendered, but if they are not tied together into a pleasing composition, the drawing will feel as if it's not quite right. You may not be able to express why it doesn't feel right, but you just know.

Probably hours were spent rendering the objects in the drawing to make them look "real," but composition became an afterthought. Most likely it's because the artist didn't really have a grasp of what makes a good composition. Let's face it: it is so much more enjoyable to jump into a drawing than to learn about the "guidelines." (I hate the word rules!) Mention golden sections, focal points, depth, movement, values or basic shapes and eyes start to glaze over—or the artist gives up in frustration.

Creating a good composition at first can seem like a daunting task. There are so many things to remember, but once you start making a conscious effort to incorporate the basic principles into your drawing, you'll be amazed at how the "guidelines" become intuitive to you. Consider how children learn to read. First they are read to by others. Later, they learn the letters of the alphabet. After mastering those, they start combining letters and learning the sounds those combinations make. Sounding out words comes next. Finally they learn to read without having to sound out each word.

Learning to create an effective composition follows a similar process. First we learn the guidelines and see how other artists have applied them. Initially the guidelines seem to involve intentional decisions that you make each time you sit down to plan a drawing, but eventually the whole process becomes instinctive. Like reading, understanding composition and applying it to your artwork will become second nature.

CHAPTER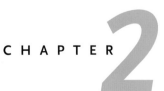

composition guidelines

Every artist has a different way of explaining how they create a good composition. These are my thoughts. There are no hard and fast rules. Many times you'll find yourself creating a dynamic composition while straying from the guidelines.

1. DECIDE ON A FOCAL POINT

The *focal point*, or center of interest, is the most prominent area(s) in a drawing. Artists use a variety of techniques to establish an area where they want the viewer to look first.

The area may have a strong shift in value, have the strongest color or use a complementary color. The texture or shape may be different from other elements in the drawing. The lines of surrounding objects can be used to help lead the eye to the focal point.

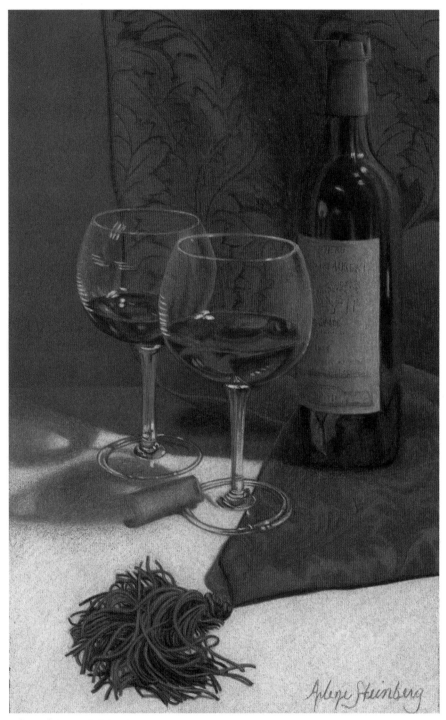

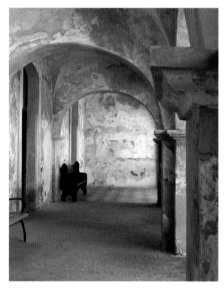

contrast creates a focal point
I took this photograph at a historic church in San Juan, Puerto Rico. The bench in the distance becomes the focal point. It is the darkest area in the photo and is surrounded by an area that is very light in value. This creates a strong contrast between the bench and the wall.

color and size create interest
Here, your eye first sees the cork because it's the smallest object and a lighter and brighter color. Only then does your eye travel to the tassel, the wine bottle and the glasses.

PRELUDE
Colored pencil on black Stonehenge paper · 12" × 7 ½" (30cm × 19cm)
Collection of the artist

2. PLACE YOUR FOCAL POINT OFF CENTER

By placing your center of interest or focal point off center in the drawing, you create movement and avoid static design. Either the *golden section* or the *rule of thirds* (see below) may be used to locate your focal point most effectively. There are no hard and fast rules about which of these guidelines to use. When I'm creating a drawing, I first play around with the placement of my focal point to see which one is more aesthetically pleasing to me.

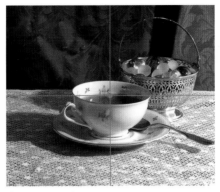

focal point in the center
Here is an example of a photograph with the center of interest (the cup) in the center of the page. The photograph is ordinary and lacks movement.

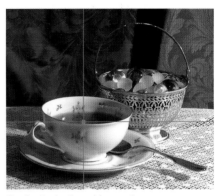

focal point in the golden section
Place the focal point in the golden section and your eye moves from one object to another making them appear less static.

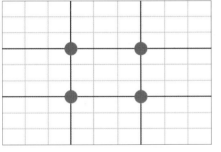

the rule of thirds
One of the easiest ways to start creating a good composition is to use the *rule of thirds*. Divide your picture into equal thirds both vertically and horizontally. Place the most important object at one of the four intersections.

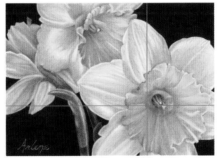

focal point located by the rule of thirds
This drawing utilizes the rule of thirds. The open center of the largest daffodil is placed where the two lines intersect.

DAFFODILS
Colored pencil on Stonehenge paper · 4" × 6" (10cm × 15cm)
Private collection

finding the golden section
I found a simplified way to figure out the golden section. Divide your drawing area into eight equal sections horizontally and vertically. If your drawing is 8" (20cm) wide, place your grid lines 1" (25mm) apart. If it is 6" (15cm) wide your lines would be placed ¾" (19mm) apart. Count in from both edges of the drawing three lines. Do this both for the vertical and horizontal lines. Place your focal point at any of the intersections.

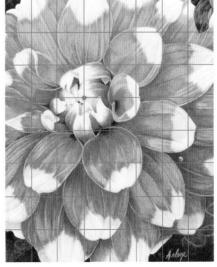

focal point in the golden section
The center of the flower is the most interesting area. It is placed in the golden section to emphasize that fact.

DAHLIA
Colored pencil on Stonehenge paper · 12" × 10" (30cm × 25cm)
Collection of the artist

3. CREATE DEPTH

Colored pencil artists are restricted to working on a two-dimensional surface while trying to portray three-dimensional objects, so they need to create a sense of depth within their compositions. Artists use a variety of tricks to fool the eye into believing objects have volume and are surrounded by space.

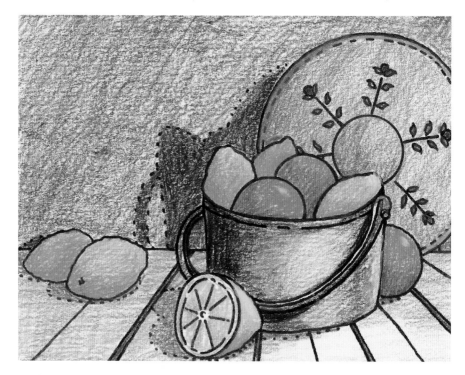

color and value

Warm colors and lighter values bring objects forward while cool colors and darker values make them appear to recede, as shown by the lemons in this example.

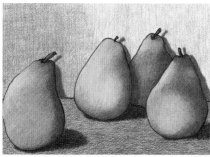

overlapping

Overlapping objects help to create the illusion of depth. From the way it's overlapped, it's clear which pear is farthest back.

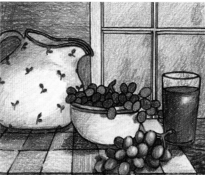

size and definition

Objects in the distance are smaller and less defined. Compare the grapes in front to those in the bowl. Objects farther back show less texture and pattern. Notice the pattern on the wood table. In front it's bold; moving back, the pattern becomes less distinct.

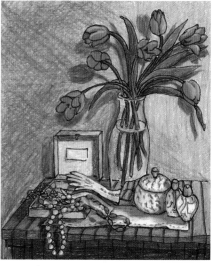

perspective

Establish a foreground, middle ground and background to suggest depth. Linear perspective is used in this drawing. The lines on the table and the jewelry box recede toward a distinct vanishing point. Perspective is necessary not only to show depth, but to show it correctly.

No Kissing

"Kissing," in this context, refers to two objects that slightly touch or an object just touching the edge of the drawing. Kissing creates one connected shape and distracts the viewer's eye, causing an unwanted visual resting point. Objects should be separated or overlapped.

4. USE REPETITION

We may think of *repetition* as one image that recurs throughout the composition, such as in a drawing of a group of pears, or a stack of books or a bunch of red flowers. Often, however, repetition refers to repeating shapes, lines, sizes, textures or colors.

The oval shapes recur in the cookies, the basket's edge and in the ellipse of the milk.

Round shapes are repeated in the apples and the shape of the rolls.

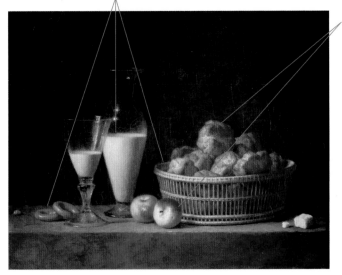

STILL LIFE WITH A CARAFE OF BARLEY WINE
Henri-Horace Delaporte (1726–1793)
Louvre, Paris, France
Photo credit: Erich Lessing/Art Resource, NY

repeat the shape

Repeating a similar shape doesn't necessarily mean you have to repeat the object. In this example by Henri-Horace Delaporte, there are lots of recurring ovals and circles. Delaporte also repeats the color throughout the painting. He replicates the color of the rolls in the cookies on the left. The color of the milk recurs in the cheese on the right. The use of these repeating shapes and colors helps to unify the painting.

repeat shapes and colors

In my drawing the teardrop shape is repeated in the flower petals, the flower stamens and the snuff bottle, while the half circle of the ginger jar recurs in the snuff bottle's cap. The fan's circular shape is replicated in the shape of some of the tulips and in the leopard's face. The upward movement of the vase with tulips is repeated in the palm trees on the ginger jar.

 Even though there are many patterns in this composition, the repetition of reds, greens and whites throughout the drawing helps to create a harmonious whole.

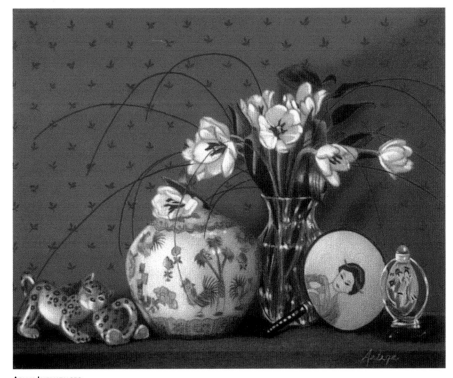

ASIAN INFLUENCES
Colored pencil on Stonehenge paper · 9" × 11" (23cm × 28cm)
Collection of Sue Schlisman

5. USE VARIETY

The old adage, "variety is the spice of life," could be changed to "variety is the spice in composition." In visual composition, there are many ways to include variety while maintaining a unified design.

creating interest through variety

This painting by Jacob van Walscapelle relies on the various shapes, sizes and colors of the flowers to create visual interest. A wide variety of values also contributes to the effect. Circles, ovals and triangles predominate to provide unity.

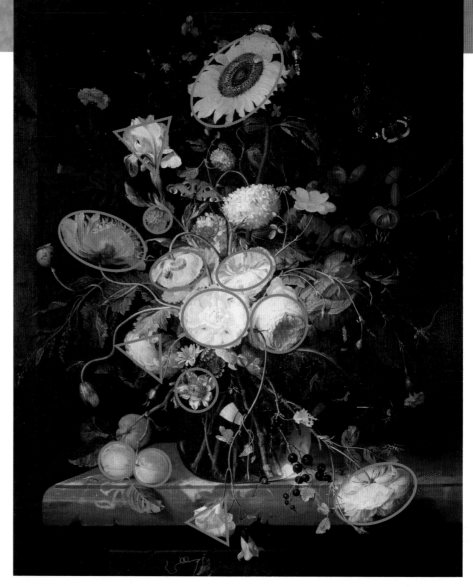

VASE OF FLOWERS ON A MARBLE LEDGE
Jacob van Walscapelle (1644–1727)
Museo Stibbert, Florence, Italy
Photo credit: Scala/Art Resource, NY

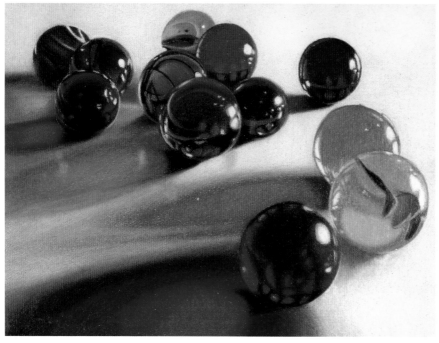

variety with unity

Changing the size and color of similarly shaped objects can create variety and give unity at the same time. What lends excitement here is the variety of sizes and colors, the different shapes within the individual marbles and the oblong shapes of the reflections on the table.

I THOUGHT I LOST THEM
Colored pencil on Stonehenge paper · 5" × 7" (13cm × 18cm)
Collection of Mr. and Mrs. Tom McHugh

6. USE AN ODD NUMBER OF ELEMENTS

Visual excitement is often created by using odd numbers. Instead of using two apples, draw three or five. An odd number of elements prevents the viewer from grouping them together in pairs. With one element always left over, the eye naturally moves around the drawing to seek balance.

7. VARY YOUR EDGES

There are three types of edges. A *lost edge* is one that is not seen but is only implied. *Soft edges* are created when the edge of an object is slightly blurred. *Hard edges* are well defined. Beginning artists commonly make the mistake of using only hard edges, especially when copying a photograph.

Try this small experiment. Place an object (a soda bottle, vase or anything similar in size) on the table in front of you. Focus on the bottle. Notice that when you focus on the bottle, everything that is behind it becomes blurry.

By using soft and lost edges in the background of your drawing, you can create the illusion of objects receding. Hard edges are best used on foreground objects or to emphasize an area of importance.

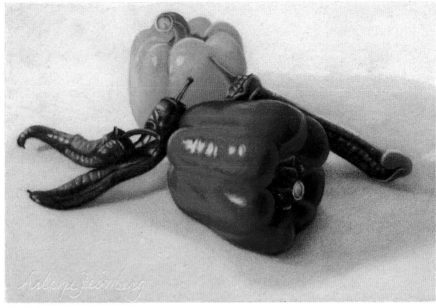

think in odds

In this drawing, the use of odd numbers is applied throughout. There are primarily three colors used: red, yellow and green. There are five peppers in total: one red, one yellow and three green.

THREE HOTTIES
Colored pencil on Stonehenge paper · 4" × 6" (10cm × 15cm)
Collection of Sharon Turner

deliberate edges

While most of the flowers in this drawing have hard edges, one tulip on the lower left has softer inner edges that visually cue the viewer that the tulip is set back. The pattern on the desk, the dark edges of the vase, and the roof of the house on the lower left fade away as they are hidden in shadow. The distinction between the wall and the back edge of the table, becomes lost along with their edges.

DICHOTOMY
Colored pencil on Stonehenge paper · 18" × 14" (46cm × 36cm)
Collection of the artist

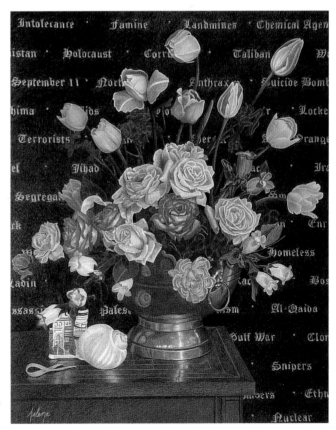

8. CREATE MOVEMENT

Use visual cues to entice the viewer's eye to move around the composition. You can lead the eye with lines (straight or curved), color, texture, size or value contrasts.

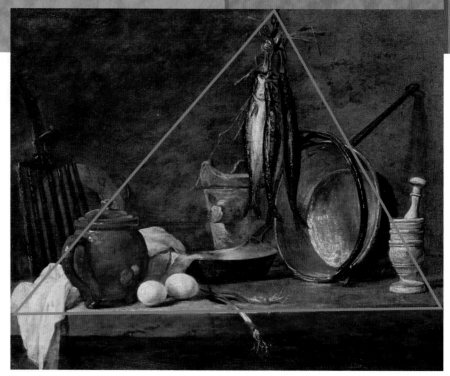

lead the eye with geometry

Chardin creates movement by placing objects within a triangular composition. The cloth on the lower left and the angle of the teapot help lead the eye towards the fish and bucket. On the right side, movement is achieved by the placement of objects and by the use of highlights in the copper pot, and the mortar and pestle.

MENU DE MAIGRE
Jean-Baptiste-Simeon Chardin (1699–1779)
Louvre, Paris, France
Photo credit: Erich Lessing / Art Resource, NY

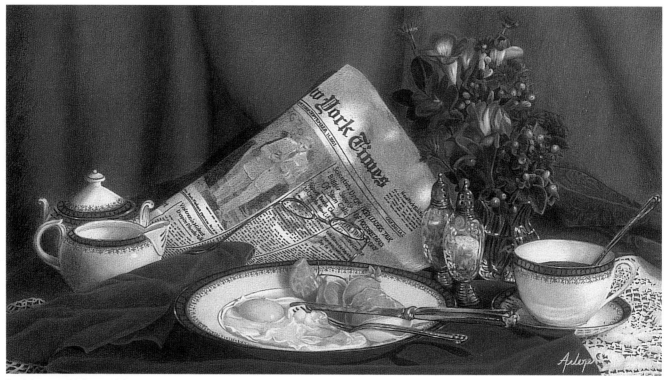

lead the eye with line and shape

Despite the fact that the newspaper and the plate take center stage (violating guideline no. 1!), the drawing isn't static because there are lots of visual elements that create movement. The fork and knife direct the eye to the eggs and then to the creamer. The creamer leads toward the lightest area of the newspaper, dated, September 11, 2001. The angle of the newspaper then leads the eye to the salt and pepper shakers, which lead to the cup, and the spoon then points back to the knife and fork.

WHEN TIME STOPPED
Colored pencil on Stonehenge paper · 11" × 20" (28cm × 51cm)
Collection of Robert and Janet Kaplan

9. MAKE EFFECTIVE USE OF NEGATIVE SPACE

Negative space is the area of your composition that surrounds the objects. It's the background, the supporting surface and the spaces between your objects. A good way to visualize negative space is to render a drawing in black, white and gray, either with a computer-imaging program or by doing a thumbnail. Use white for the main objects, gray for the supports (such as a table) and black for the background. Then observe whether the background forms interesting shapes. To create a more exciting drawing, vary the angles, sizes and shapes of the negative spaces between the different elements of your subject.

check the dynamics of your spaces
I reduced *Dichotomy* to white, black and gray to check the effectiveness of my negative space. The white forms an interesting mass and the background creates a lively negative shape.

space is shape
The shape of the negative space in *Asian Influences* is just as interesting as the rest of the painting.

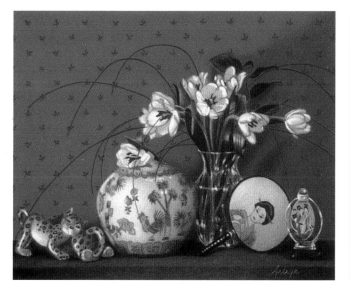
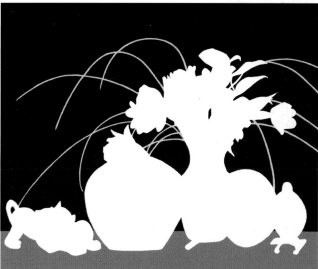

planning a good composition

1. MAKE THUMBNAILS

Planning before you commit pencil to paper is the key to making sure everything works the way you want it to. The easiest way to start is with *thumbnail drawings*. Thumbnail drawings are small (approximately 2" × 3" [5cm × 8cm]), rough sketches done to figure out placement, values and sometimes color.

dark

oranges

reflections

red apples

start with a rough thumbnail
When I first think of an idea, I draw a very rough thumbnail that often has writing on it to remind me of what I was planning to do.

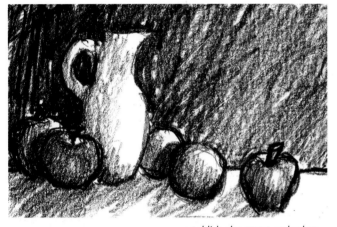
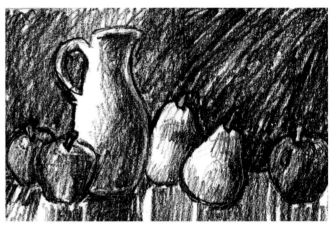

establish placement and values
Next I'll do several thumbnails to refine the composition and establish the values. I'll try out different ideas with light coming from various directions.

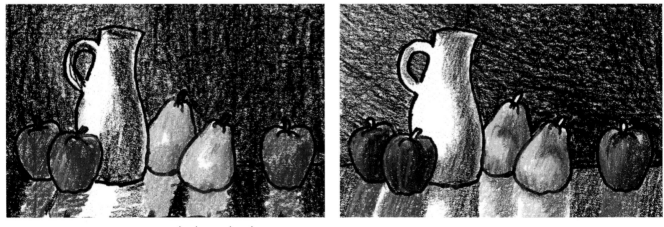

develop a color scheme
Color studies are valuable in developing a color scheme for your drawing. I find it easiest to do a rough line drawing of my chosen composition in graphite or black ink. I then make several copies of the line drawing with a copier. I am now able to try out color combinations until I find the one that best conveys what I want to express in my drawing.

2. COMBINE PHOTOS

So many times I've photographed a scene or setup, only to be disappointed when I viewed it on the computer. Oftentimes, I'll like something about one photo, and something else about a second photo. The solution is to combine the best of each into a new photo and leave out any unwanted elements.

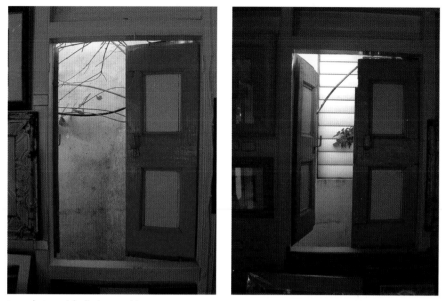

two photos with distinct problems
I shot these two photographs in Tortola while on a cruise. I liked the weathered windows. When I looked at them at home, I realized I liked the background from the first photo but I preferred the shutters in the second photo. The solution is to combine the two photos into one image.

combine the images
I started by opening the photo with the door I liked in a photo-editing program. My next step was to straighten the edges so the window frame didn't bow, and then crop the sides. Next, I deleted the inside of the window, leaving only the leaves. Finally, I selected the inside of the window from the second photo.

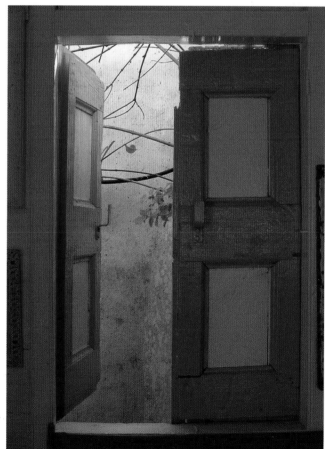

an ideal reference
By substituting the background from the other photo, I created a better reference to work from.

recognizing good composition

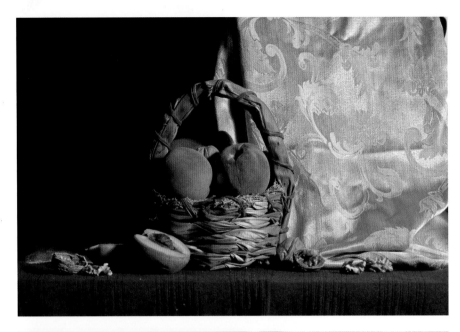

Sometimes, only small changes are needed to change a photo's composition from bad to good.

boring composition
Initially, you see the basket and fruit. Next, your eye moves to the damask curtain and, because the curtain is a very light value and takes up half the background, there it stops. Lastly, the tablecloth's perspective is incorrect for a drawing as the lines on the cloth do not recede to one vanishing point.

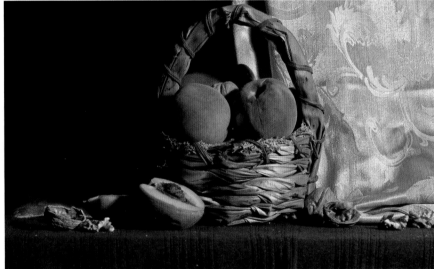

a little bit better
This is better, but still not what I'd consider a good composition. The center of interest (the peach half) is almost in the golden section. With the handle almost kissing the top edge, the basket now divides the photograph in half and the image feels cramped. The background is still divided equally between light and dark.

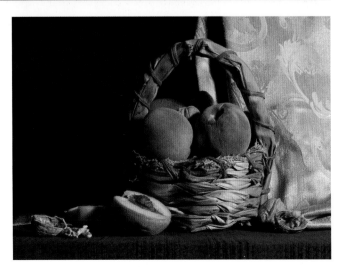

good composition
Here, the division between light and dark in the background falls at one of the golden sections. Even though the peach half isn't exactly in the golden section, it's close enough to still be pleasing. Now your eye is drawn first to the peach half, then it travels up the line of the basket handle to the whole peaches, then down the other side to the nuts, and finally across to the nuts on the left side. With most of the curtain cropped out, the pattern on the remaining fabric leads your eye toward the basket.

CROPPING TO AID COMPOSITION

Sometimes adding more space to the margins of a drawing will create a more pleasing composition. If a subject has no breathing room surrounding it, the objects within the drawing will feel cramped.

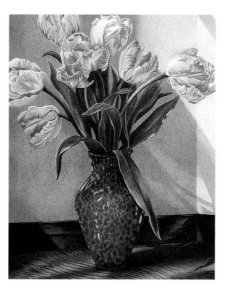

confined and static
Cropping a drawing too tightly creates a confined composition that feels cramped. Centering the vase makes it static.

unbalanced
While the vase is in the golden section, this version feels unbalanced because the vase and flowers are heavy and there is nothing to counterbalance that weight on the right side.

Conclusion

The guidelines in this chapter are not absolutes. Now that you've learned how they work, relegate them to your subconscious and use your intuition to create compositions that are more dynamic. Don't be afraid to try new ideas that don't follow the guidelines. Sometimes you'll want to place your center of interest in the middle of the painting or use an even number of elements. With experience, you'll learn to know what works. Conversely, if something doesn't "feel" right, use these guidelines to analyze the problem and correct it. Most of all don't be afraid to experiment.

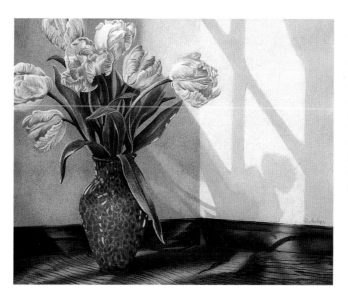

balanced and fluid
I added the dark vertical shadow on the right side to counterbalance the vase and flowers and stop the eye from leaving the frame on the right. The shadows on the wall now create a secondary interest and guide the eye back toward the vase and flowers.

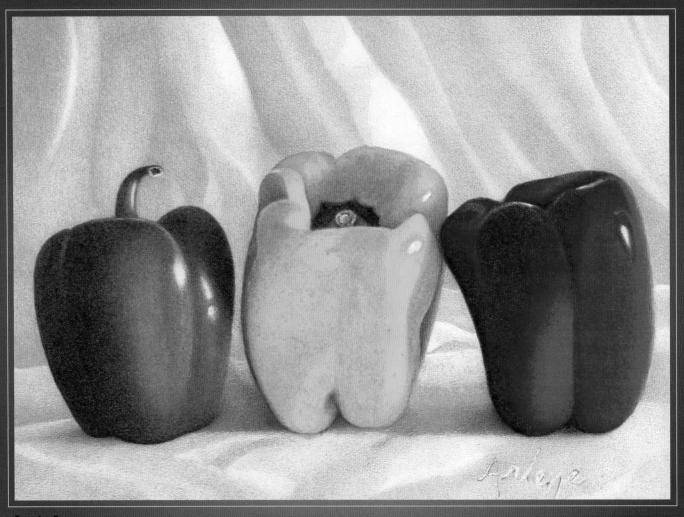

THREE'S A CROWD
Colored pencil on Stonehenge paper · 5" × 7" (13cm × 18cm)
Collection of the artist

COLOR AND VALUE

COLOR AND VALUES? MOST LIKELY YOU'RE WONDERING WHY YOU NEED TO KNOW COLOR THEORY when all you want to do is draw. Why do you need to know how to make your own color wheel or value scale? Why do you need to know about chiaroscuro or grisaille? Just as a musician must first learn to recognize notes and play scales to make beautiful music, the colored pencil artist needs to take the time to learn how to use color and values to make beautiful drawings.

In centuries past, apprentice artists would never just start painting. They'd start at the beginning: learning how to mix paints, set the paints on the palette in the Master's preferred way, clean the brushes and keep the studio clean. Only after they mastered those techniques would they move on to drawing in charcoal from plaster models. They'd learn about values, chiaroscuro and drawing, and then graduate to color theory. After many years, they'd be given the opportunity to cover the Master's whole canvas with a thinned layer of sepia paint. If they did that well, only then would they be allowed to fill in some of the less important details in the Master's piece.

Today, you aren't required to spend years apprenticing in a Master's studio. Instead, you have the opportunity to learn lessons about color, values and underpainting on your own. Take the time to slow down and study the lessons in this chapter. They will give you the foundation needed to create more successful drawings.

CHAPTER 3

DEMONSTRATION *Hues and the Color Wheel*

MATERIALS

PRISMACOLOR PENCILS

PC 903 True Blue
PC 910 True Green
PC 916 Canary Yellow
PC 918 Orange
PC 922 Poppy Red
PC 932 Violet
PC 933 Violet Blue
PC 938 White
PC 992 Light Aqua
PC 994 Process Red
PC1002 Yellowed Orange
PC 1004 Yellow Chartreuse
PC 1009 Dahlia Purple

OTHER MATERIALS

Stonehenge paper, 7" × 7" (18cm × 18cm)

Before you can become proficient using color, it's important to have a basic understanding of how colors interact with one another and how to use them to your best advantage. Color theory principles were first seen in the writings of Leon Battista Alberti and Leonardo da Vinci in the fifteenth century. In the eighteenth century, Isaac Newton's *Opticks* described color relationships with a circle of seven hues. Artists eventually adapted his circle for understanding how to mix paint colors.

The color wheel is a tool to organize color. There are many color wheels available to the artist, but the best way to become acquainted with the relationship between different pencil colors is to create your own wheel with colored pencils.

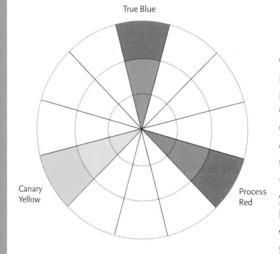

1 START WITH THE PRIMARIES Use a compass to draw three concentric circles divided into twelve pieces. Start your color wheel by putting True Blue, Process Red and Canary Yellow in the areas shown. Completely saturate the outer part of each wedge. Use less pressure to color in the rest of the wedge, as shown in the example. These are your *primary colors*: hues that cannot be mixed from any other color but, when mixed together, can create all the other colors.

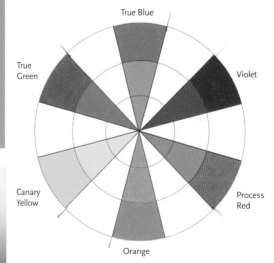

2 ADD THE SECONDARY COLORS *Secondary colors* are those hues that can be created by mixing equal amounts of the primary colors together. Add True Green, Orange and Violet halfway between the primaries.

USE CONSISTENT PRESSURE

Unless otherwise noted, use pressure 2 with the circular stroke (see pages 18–19). Keep a sharp point. Add more layers to make an area as dark as necessary; don't press harder.

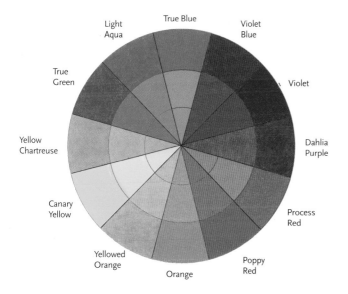

3 **TERTIARY COLORS**
When a primary color and a secondary color are mixed together, they create a *tertiary color*. Color in Violet Blue, Dahlia Purple, Poppy Red, Yellowed Orange, Yellow Chartreuse and Light Aqua. The colors on the completed outer circle of the wheel are called *hues*. *Hue* refers to a pure color, one without any white or black pigment mixed with it.

TINTS AND SHADES

Many times when asked to describe an object to someone, not only will we describe its shape, but we'll also mention its color. A lemon is yellow, a cherry is red, his hair is black and jeans are blue. These descriptions identify local color of an object. Local color only partly describes what we're seeing, since colors will change depending on the way light and shadows fall on them.

The simplest way to make an object appear darker is to add black to the hue; conversely, the easiest way to make an object appear

lighter is to add white. Colors with black added are called *shades* and those colors with white added are called *tints*.

While adding black to a hue is the easiest way to create a shade, it isn't always the best way when using colored pencils because adding black will make a color duller. There is another way, which is to mix the color with its opposite on the color wheel, its complementary color. The colors produced by mixing opposites on the color wheel are referred to as *neutral colors*; either browns or grays.

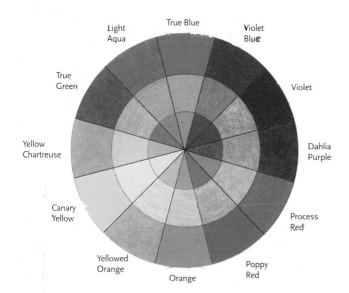

4 **ADDING TINTS TO THE COLOR WHEEL**
To create tints of each hue, add white to the middle ring on your color wheel.

5 **CREATE SHADES FROM COMPLEMENTARY COLORS**
In the center ring, add the color opposite on the color wheel to create a neutral shade; either gray or brown. Mixing complements is a good way to create shadows in your drawings. For example, the color opposite Canary Yellow on the color wheel is Violet, so you'd add Violet over the Canary Yellow in the center ring.

color relationships

Color can have a profound biological and emotional effect on us. In phrases such as "feeling blue," "green with envy" and "seeing red," we use colors to describe our feelings. Being aware of color relationships and the moods they create will help you plan more effective drawings. The color wheel will help you understand color relationships and choose appropriate color schemes for the feelings you want to express.

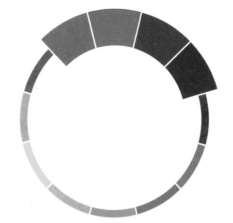

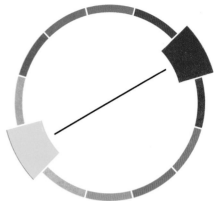

analogous colors

Analogous colors are three or four colors that are adjacent to each other on the color wheel. Cool colors—those in the blue, green or purple family—create a soothing effect. Conversely, the warm colors—reds, yellows and oranges—quicken the pulse. Usually one color is dominant and the others are used to enhance the color scheme.

complementary colors

Complementary colors are those that lie directly opposite each other on the color wheel. Complementary color schemes work best for drawings when you choose one hue as the dominant color and use its complement for accents. When mixed together, complementary colors create rich browns and grays as well as appealing shadows.

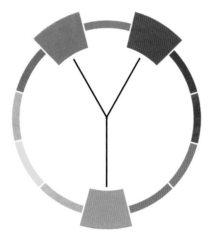

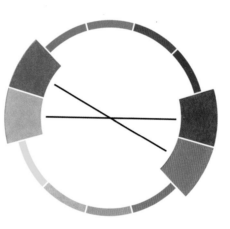

split complementary color scheme

A *split complementary color scheme* consists of a color and the two colors on either side of its complement. Like the complementary color scheme, this scheme provides your drawing with strong visual contrast, but this offers more nuances.

double complementary color scheme

A *double complementary color scheme* utilizes two colors next to one another on the color wheel plus their complements. This color scheme might be hard to balance if all colors are used in equal amounts. Instead, choose one hue as the dominant color and subdue the others to create harmony.

triadic color scheme

A *triadic color scheme* includes three colors that are equally spaced around the color wheel, such as red, yellow and blue. This color scheme provides balance while also creating strong visual contrasts in a composition.

The most important element of a drawing isn't color, but value. *Value* is the lightness or darkness of a hue. The lightest value is white and the darkest is black. With value, you can make objects appear three-dimensional, create a mood and lead the viewer's eye.

Many of my students have difficulty grasping value. They use mostly middle values and are afraid to go darker. Learning to use the correct values, however, is vital to creating successful realistic drawings.

CREATE A VALUE SCALE

You can create your own scale as a reference tool to judge values for your drawings. Doing one in colored pencil will also help you become more comfortable with the pencils.

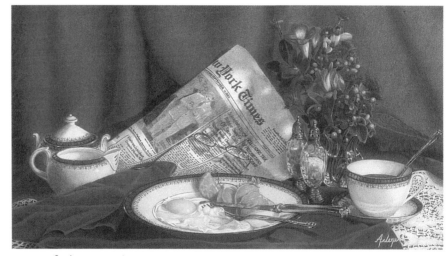

a range of values creates impact
Even without color, the art still has impact. The eye first notices the word *York* in the newspaper and then wanders downward to the date, September 11, 2001. It does this because that area has the greatest contrast between light and dark. Next, our eyes travel to the other light objects; finally, we see the gray objects.

Eliminate Color to See Value

Eliminate color so the values stand out by placing a sheet of red acetate or vinyl over your drawing. The red neutralizes the colors, leaving only the values.

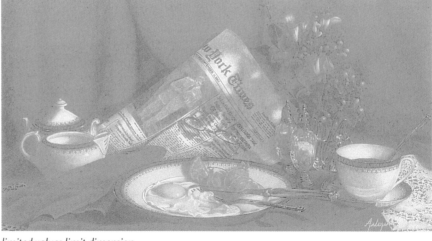

limited values limit dimension
Without the range of values, the drawing lacks dimension and impact. The eye might notice the word *York* first, but there is nothing else to direct it toward the other objects. The contrast between the word York and the white newspaper is reduced because there are no strong value changes.

MATERIALS

PRISMACOLOR PENCILS
PC 935 Black

OTHER MATERIALS
Stonehenge paper

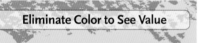

creating a value scale
Draw an outline of nine 1-inch (3cm) square boxes. The first box will be white, so leave it alone. The last box will be black, so fill that in first. Next, count five boxes in toward the center and fill in the middle value. Use a pressure of 2 so its value matches the value in the fifth box above. Work from the middle out to fill in the darker values, adding more layers to each successive box to darken the values gradually. For lighter values, work from the middle out in the other direction, using less pressure to create the correct value for each box.

training your eyes to see color and value

What color is an apple? A likely answer is red. If you look more closely at the apple, however, you'll see that it has colors other than red. An object's color changes depending on what else is near it, whether it's hidden in shadow or bathed in direct light, or even on how near the object is to us.

Take the time to learn to see the colors in each object as you walk around your house or outside. Can you see all the other subtle colors and differences in the shadows? Does the object cast a shadow onto a table or a wall? What colors are in the shadows? How do the shadows affect the values of the colors you see? Learning to see color and value is a skill, and the more you practice, the better you'll become at portraying objects realistically in your art.

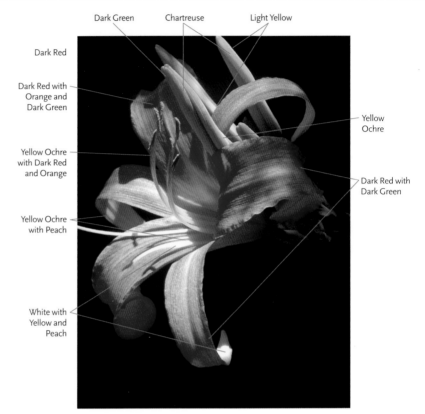

Dark Green Chartreuse Light Yellow

Dark Red

Dark Red with Orange and Dark Green

Yellow Ochre with Dark Red and Orange

Yellow Ochre with Peach

White with Yellow and Peach

Yellow Ochre

Dark Red with Dark Green

evaluate the colors you see
Don't look only for those colors that are obvious; look for more subtle variations of color in an object.

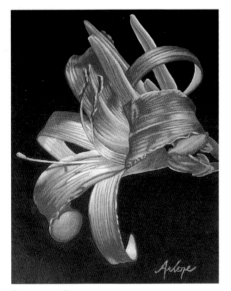

Beauty for a Day
Colored pencil on Stonehenge paper · 8" × 6" (20cm × 15cm)
Collection of the artist

a full range of values
I always try to use a full range of values when depicting an object. In this case, because I've used a full range on the daylily, the blossom has depth and dimension. The drawing also has drama because of the play between the darker areas and the lighter areas.

Bold Values Add Drama

Don't be afraid to go darker with your values than you think you need to. When you do so, you'll be creating a more dramatic painting.

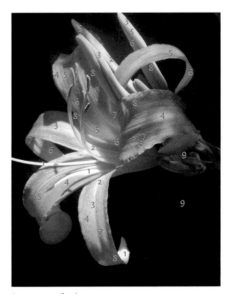

be aware of values
Being aware of color isn't enough; you must also be aware of values. Notice the full range of values in this photograph. The numbers correspond to those in the value scale.

When we see an object, we don't see its color in the absence of other colors. The relationships between colors affect our perception of them.

Do your background first. The background is not an afterthought but an integral part of any drawing. For many artists, especially beginners, only when they've figured out their main subject do they ask, "What should I do with my background?" My students tell me I'm a broken record because I continually repeat, "Do your background first!"

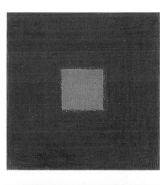
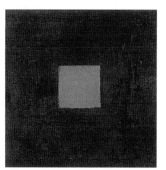

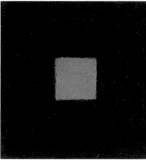

adjacent colors affect each other
In this example, all four inner squares are the same color. The color surrounding each square affects how we see its color, so each appears to be a different color.

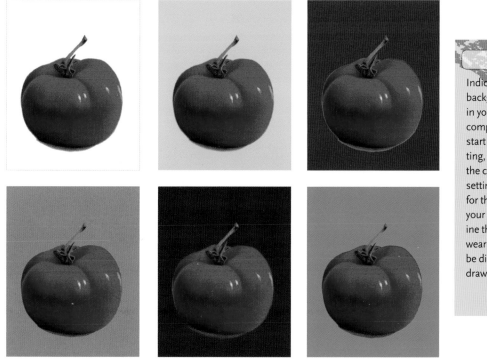

background affects color
In the examples above, the tomato is the same, but the backgrounds change. Notice how the tomato's color appears to change depending its background color.

Begin Your Background First

Indicate the colors that will be used in the background before you begin coloring in your main subject. You don't need to complete the background first, but if you start your drawing by establishing the setting, you'll have an easier time adjusting the colors on the subject. Think of a stage setting at the theater. The choice of colors for the scenery and costumes enhances your enjoyment of the performance. Imagine the actors standing on a bare stage, wearing street clothes. The effect would be diminished, and the same is true with drawing.

the masters' use of chiaroscuro

In the Renaissance artists began using a technique called chiaroscuro, or "bright-dark" in Italian, to create the illusion of a three-dimensional object. The technique gained prominence in the Baroque period. Usually a single light source is used to provide dramatic lighting on objects or figures. Gradations of values are key to chiaroscuro drawing and painting. On an object such as a cup, the illusion of volume is achieved by a gradual shift from very dark values to very light ones. The focal area of a chiaroscuro painting or drawing is illuminated with strong light. Other areas in the piece tend to have less detail, darker values, and less intense hues.

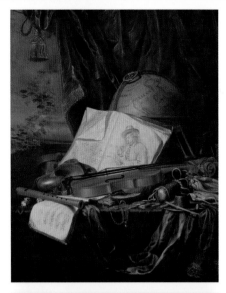

the artful use of lights and darks

Here's a wonderful example of chiaroscuro. With his judicious use of lights and darks, the artist makes it clear that he wants us to focus first on the sketchbook with the drawing. He then draws our eye to the instruments and the globe and finally everything else. Notice the gradual value changes from light to dark on the globe.

STILL LIFE WITH MUSICAL INSTRUMENTS
Pieter de Ring (1615–1660)
Staatliche Museen Preussischer Kulturbesitz, Berlin
Photo credit: Bildarchiv Preussischer Kulturbesitz / Art Resource, NY

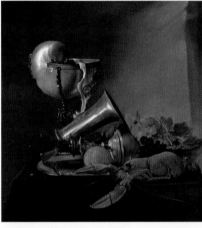

chiaroscuro guides the eye

In this painting, the single light source is located at the front, upper-left side. At first we're aware of the nautilus shell with the lemon peel, and then our eye moves downward to the wine pitcher, the chalice, the orange and finally the lobster. While color does play a role in how we see the objects, the use of chiaroscuro is more important.

NAUTILUS CUP, LOBSTER AND WINE PITCHER
Jan Davidsz de Heem (1606–1683)
Staatsgalerie, Stuttgart, Germany
Photo credit: Erich Lessing / Art Resource, NY

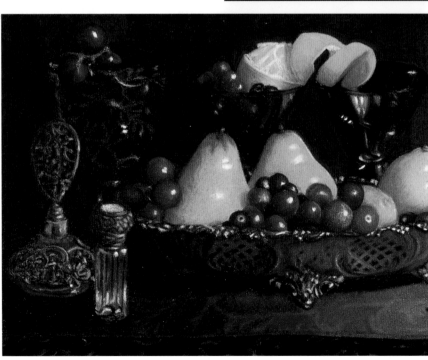

dramatic value contrasts define the center of interest

Chiaroscuro creates drama and helps define what is important for the viewer to look at first. In this painting, the eye is drawn first to the bright lemons and pears, and later to the perfume bottles and blue glass in the shadows. Colored pencil lends itself very well to chiaroscuro drawings. With the rich range of colors, it's easy to create dark shadows and light highlights.

CALLA LILIES AND FRUIT (DETAIL)
Colored pencil on Stonehenge paper · 12" × 10¾" (30cm × 27cm)
Collection of the artist

Underpainting was one of the most widely used Old Master painting techniques. This preliminary process acted as a stepping-stone to allow artists to define composition, lighting and values. The monochromatic opaque underpainting was as rich in detail as the finished color painting.

IMPRIMATURA UNDERPAINTING

Masters such as Rembrandt van Rijn, Jan Vermeer and Leonardo da Vinci started with a mid-value toned ground, usually an earth color such as Raw Sienna to establish color and value more easily than if working on a white surface. This underpainting, called *imprimatura* (Italian for "what goes before first"), allowed the painting to be established ahead of time. Other neutral colors were then painted to establish the tonal range of the painting. Trans-parent or semitransparent layers were then glazed on top. The color of the underpainting optically blended with subsequent layers of color without becoming muddy.

GRISAILLE UNDERPAINTING

Other Masters used similar underpainting methods such as *grisaille* (French for gray, pronounced "greez-eye"). A grisaille is a monochrome drawing or painting done in shades of gray, usually with a tint of color mixed in them. This technique was used for sketching to work out values before adding color, and for underpainting the final canvas. A grisaille underpainting can't be seen by the untrained eye, but what can be seen are the values that were established with the grisaille. These values help define the finished painting or drawing.

grisaille dulls colors
It's easy to create a grisaille using black and/or gray pencils, as I did in this example. Using black pencils for an underpainting can dull or change your colors, however. My yellows have lost some of their brightness and some of the yellow has a slightly greenish cast because of the black underneath it.

Because grays and blacks in an underpainting change the vibrancy of colors on top, I needed to find another method that would create rich darks yet still keep my colors crisp and clean.

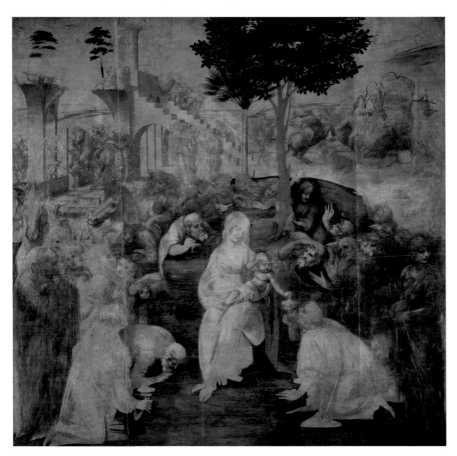

da Vinci and imprimatura
Leonardo da Vinci's unfinished *Adoration of the Magi* is a wonderful example to show how he worked. He'd first establish values with an imprimatura and would then create a detailed value underpainting. Finally he'd start to apply transparent glazes of color on top. Some of the underpainting would show through the layers, subtly helping to model the forms.

ADORATION OF THE MAGI, UNFINISHED
Leonardo da Vinci (1452–1519)
Uffizi, Florence, Italy
Photo credit: Erich Lessing / Art Resource, NY

underpainting for colored pencils

I approached my first colored pencil drawing like an oil painting. I used different grays and black to establish my values, but when I added color on top of the grays, I had difficulty achieving vibrant colors. The grays were dulling down my color too much. I then thought I might try a brown underpainting but decided to research other methods first. I came across an article by Melissa Miller Nece. In it, she showed how she achieved rich darks using complementary colors instead of blacks, grays or browns. At that point a light bulb went off in my head, and I've been using a modified version of complements for my underpainting ever since.

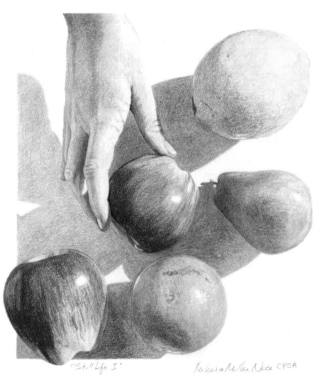

underpainting in grays lacks vibrancy

In this example by Melissa Miller Nece, the fruit was underpainted with brown pencils. It appears dull, lifeless and without dimension. The shadows on the table were drawn with grays and look flat and uninteresting. Without complements, there are no subtle color variations to give the drawing vibrancy.

STILL LIFE II
Colored pencil on bristol board · 9" × 8" (23cm × 20cm)
Artwork courtesy of Melissa Miller Nece

complements add depth and drama

Here, the background was created from mixed complements. The lightest grays were mixed from Light Peach and Cloud Blue. The lighter cast shadows on the left under the hand are a combination of Light Cerulean and Peach, with Lilac added for balance. For the darker grays, Melissa used a combination of Parma Violet and Spring Green and added Mulberry to create a red cast. To darken the shadows, she layered Ultramarine Blue and Peach. Poppy Red brought out the red apples' reflections, and Yellowed Orange picked up the colors from the orange and lemon. Subtle color variations make this drawing appear more lifelike. The use of complements under the fruit help it jump off the paper.

STILL LIFE I
Colored pencil on bristol board · 9" × 8" (23cm × 20cm)
Artwork courtesy of Melissa Miller Nece

Using bright hues in my underpainting didn't allow me to achieve the effect of an Old Master painting. So, I experimented and discovered that using complementary colors with black in them gave me the look I was after.

The general guideline for underpainting is to use grayed complementary colors to establish your shadows. As with anything, there are some exceptions. Yellows under purples will not create dark shadows, so substitutes are needed. This color chart shows which grayed complements work best under each local color.

your true colors

The left-hand side of the chart shows the hue. The right side shows its corresponding underpainting colors in varying values. For example, if you want to create an orange color, you'd find orange on the left-hand side, then move across the page and see that Indigo Blue, Slate Gray and Muted Turquoise may be used to create the underpainting, thus establishing a variety of values. Not every underpainting color must be used for each local color. Sometimes only one will be needed, other times you might use them all. For Orange, my preference would be to use all of them to create the underpainting as the Indigo Blue works better for the darkest areas and Slate Grey and Muted Turquoise work better for the lighter areas. Practice will help you choose which hues will work best for your drawings.

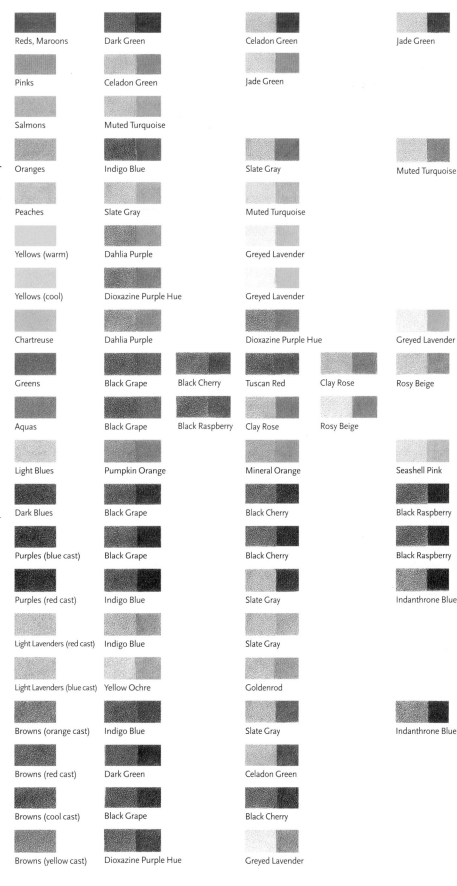

Hue			
Reds, Maroons	Dark Green	Celadon Green	Jade Green
Pinks	Celadon Green	Jade Green	
Salmons	Muted Turquoise		
Oranges	Indigo Blue	Slate Gray	Muted Turquoise
Peaches	Slate Gray	Muted Turquoise	
Yellows (warm)	Dahlia Purple	Greyed Lavender	Greyed Lavender
Yellows (cool)	Dioxazine Purple Hue	Greyed Lavender	
Chartreuse	Dahlia Purple	Dioxazine Purple Hue	Greyed Lavender
Greens	Black Grape / Black Cherry	Tuscan Red / Clay Rose	Rosy Beige
Aquas	Black Grape / Black Raspberry	Clay Rose / Rosy Beige	
Light Blues	Pumpkin Orange	Mineral Orange	Seashell Pink
Dark Blues	Black Grape	Black Cherry	Black Raspberry
Purples (blue cast)	Black Grape	Black Cherry	Black Raspberry
Purples (red cast)	Indigo Blue	Slate Gray	Indanthrone Blue
Light Lavenders (red cast)	Indigo Blue	Slate Gray	
Light Lavenders (blue cast)	Yellow Ochre	Goldenrod	
Browns (orange cast)	Indigo Blue	Slate Gray	Indanthrone Blue
Browns (red cast)	Dark Green	Celadon Green	
Browns (cool cast)	Black Grape	Black Cherry	
Browns (yellow cast)	Dioxazine Purple Hue	Greyed Lavender	

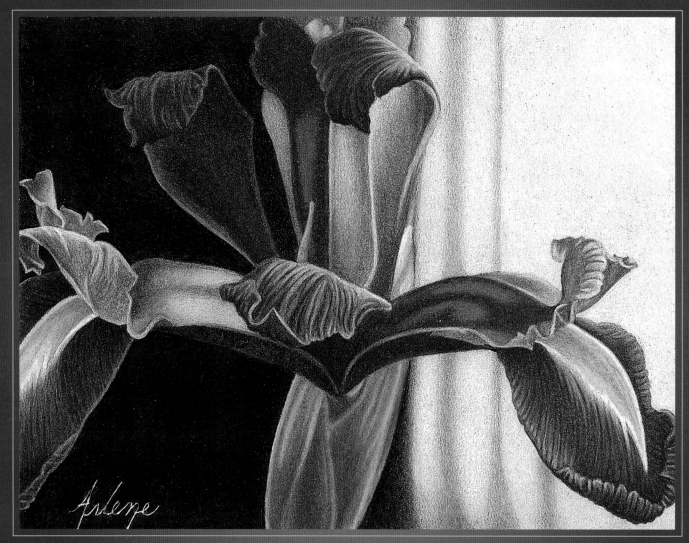

Purple Passion
Colored pencil on Stonehenge paper · 9" × 11" (23cm × 28cm)
Private collection

UNDERPAINTING

START WITH A GREEN TOMATO SO YOU CAN WIND UP WITH A RED ONE? OR, START WITH PURPLES and lavenders to create a yellow pear? It feels counter intuitive, yet these paradoxes illustrate some of the basic rules of establishing color and value with colored pencils. Starting with a complementary tonal underpainting will help you over one of the biggest hurdles in working with colored pencil: achieving correct values!

Once you have finished your underpainting, you will have a map with all your values already plotted out. This method is sometimes hard for even experienced artists to understand, which is why I'll walk you through each step of the way.

CHAPTER 4

Underpainting for Reds

I chose to start you with a red tomato. Even though at first glance it may seem daunting to start with green when you want to finish with red, these are the easiest two colors with which to learn complementary color underpainting. Thanks to Caryn Coville for drawing the tomato.

MATERIALS

PRISMACOLOR PENCILS

PC 901 Indigo Blue
PC 908 Dark Green
PC 911 Olive Green
PC 916 Canary Yellow
PC 923 Scarlet Lake
PC 924 Crimson Red
PC 925 Crimson Lake
PC 929 Pink
PC 936 Slate Grey
PC 937 Tuscan Red
PC 938 White
PC 942 Yellow Ochre
PC 996 Black Grape
PC 1005 Limepeel
PC 1012 Jasmine
PC 1020 Celadon Green
PC 1021 Jade Green
PC 1023 Cloud Blue
PC 1026 Greyed Lavender
PC 1030 Raspberry
PC 1032 Pumpkin Orange
PC 1078 Black Cherry
PC 1077 Colorless Blender Pencil
LF 132 Dioxazine Purple Hue

OTHER MATERIALS

Stonehenge paper, 6" × 5" (15cm × 13cm)
100 percent cotton makeup pads
Workable fixative

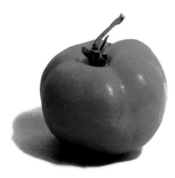

Reference Photo
Definite shadows and highlights will help to make this an interesting drawing.

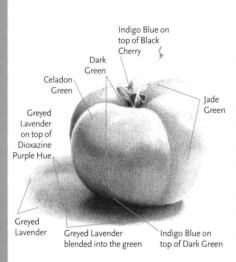

Indigo Blue on top of Black Cherry
Dark Green
Celadon Green
Jade Green
Greyed Lavender on top of Dioxazine Purple Hue
Greyed Lavender
Greyed Lavender blended into the green
Indigo Blue on top of Dark Green

1 START WITH THE COMPLEMENT

Review the instructions for applying colored pencil on pages 18–21. Use pressure 2 for darker areas and 1 for lighter areas. Layer Dark Green over the darkest red areas of the tomato and the red area on the shadow on the table. Continue to add layers, feathering out as you move toward lighter areas. Use Celadon Green for the middle values, and Jade Green for the lightest areas, always feathering one color into another. Since most of the tomato is in shadow, green will cover almost all of it.

With Black Cherry, define the shadows on the stem. Layer Indigo Blue over the darkest area on the bottom of the tomato, the darkest shadows on the table and on the stem's darkest shadows.

Shade the darker, yellowed areas of the table using Dioxazine Purple Hue and pressure 1. Over the Dioxazine Purple Hue and on the shadow's lighter areas layer Greyed Lavender with pressure 1–2.

USE CONSISTENT PRESSURE

Unless otherwise noted, use pressure 2 with the circular stroke (see pages 18–19). Keep a sharp point. Add more layers to make an area as dark as necessary; don't press harder.

Feathering

Feathering is the fading out of color by gradually lightening the pressure to 1 until barely any pigment is deposited onto the paper.

2 ADD THE FIRST COLORS

Using pressure 2 for darker areas and pressure 1 for lighter areas, layer Black Cherry over the green on the tomato. Feather out the Black Cherry near the edges of the green. Layer Black Cherry over the dark areas on the table's shadow. Layer Yellow Ochre on the other shadows on the table. Layer Dark Green over the stem's shadows.

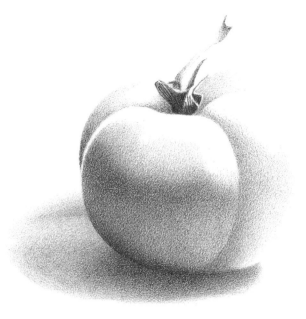

The Tomato's Lost Edge

Don't try to create a sharp edge between the tomato and the shadow on the table. This is a lost edge. When your drawing is finished, your mind will separate the tomato from the table.

3 SLOWLY BUILD UP COLOR

This is the step where you'll start to see your tomato turn red. With pressure between 1 and 2, layer Tuscan Red on top of the Black Cherry. Feather over the areas completed in step 2 onto the white areas on the tomato using pressure 1. Layer over the dark shadow on the table with Black Cherry. On the lighter areas, layer Slate Grey. Feather the Slate Grey into the red areas. Layer the stem with Olive Green using pressure 2 for dark areas, and pressure 1 for lighter areas.

4 ADD LIGHTS AND MORE COLOR

On the lightest areas on the right side of the tomato, the top edge below the stem, and the lightest areas on the stem, layer Jasmine. Layer Yellow Ochre over the yellow areas on the table's shadow. Use pressure 2, fading out to pressure 1 on the edges.

Layer Indigo Blue on the darkest shadow on the table, on the bottom of the tomato and on the darkest shadows on the stem. Over the Tuscan Red on the tomato and the table added in step 3, layer Raspberry. Cover over the Tuscan Red and feather the Raspberry just slightly into the white area.

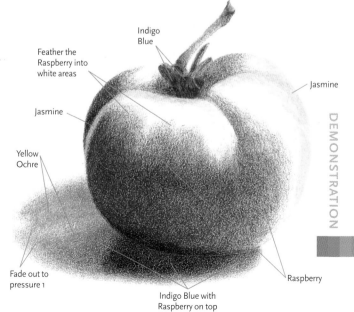

Indigo Blue

Feather the Raspberry into white areas

Jasmine

Jasmine

Yellow Ochre

Fade out to pressure 1

Indigo Blue with Raspberry on top

Raspberry

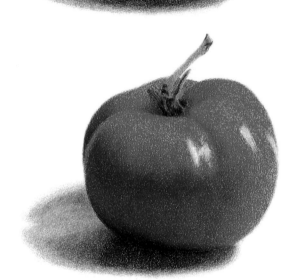

5 FILLING IN THE TOMATO

Using pressure 2, layer Pumpkin Orange over the Jasmine and over the rest of the light side of the tomato. Feather Pumpkin Orange into the Raspberry. Be sure to leave the white highlights. Layer Pumpkin Orange over the light areas on the stem. Add another layer of Raspberry to the dark shadow on the table.

Layer Black Grape on the darkest areas of the stem. Layer Crimson Lake over the tomato. Feather the Crimson Lake into the Pumpkin Orange. Then, layer Crimson Red over the red shadows on the table. Except for the darkest red on the table, layer Greyed Lavender over the table shadows, fading out at the edges.

6 TURN THE TOMATO RED

Layer Greyed Lavender on the edges of the white highlights. Using pressure 2, layer over the tomato and red table shadows with Crimson Red. Layer Cloud Blue over the other table shadows. Layer Limepeel on the light areas of the stem.

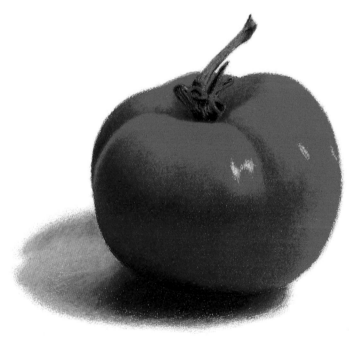

7 SATURATE THE TOMATO

Layer Black Cherry with pressure 3–4 over the darkest areas on the tomato and the red table shadow. On the light areas of the tomato, layer Jasmine and then Pink. Layer Scarlet Lake over the whole tomato and the darkest table shadow. On the lighter red areas, use pressure 3 to layer Canary Yellow over the red, followed by Pumpkin Orange. Layer Crimson Lake on the dark shadows, and Scarlet Lake over the Pumpkin Orange. Layer until the paper is saturated with color. Go over lighter areas on the tomato with Canary Yellow. Add White to the highlights, followed by Greyed Lavender.

Using pressure 3–4, layer Pumpkin Orange on the stem's light areas. Over that, layer Limepeel. Layer Black Cherry on the stem's shadows. Next layer Dark Green. Repeat until the stem is saturated with color.

On the table's lighter shadows, including the lighter red areas, layer Cloud Blue with pressure 3. Layer Pumpkin Orange on the table's light red shadows. On the darker shadows, layer Crimson Lake. On the light shadows, layer Yellow Ochre then Cloud Blue. With pressure 3–4, Continue to layer until the paper is saturated with color. Finish the table's shadow with Slate Grey using pressure 4. Finish with a layer of Greyed Lavender. Continue layering until no paper shows through.

8 BURNISH TO A FINISH

With pressure 4, use a blunt-tip Colorless Blender pencil to burnish the tomato. Start with your smallest areas first; the stem. Work light to dark in each area. Next burnish the white highlights, then the tomato and finally the table.

Use a 100 percent cotton, perfume-free makeup pad, pressure 1 and a circular motion to remove wax buildup by rubbing over the tomato and table. Work from light to dark, one section at a time. Use a different part of the pad for each new color.

Spray with two light coats of workable fixative according to directions. Wait until the fixative dries. Use a White pencil on the tomato and stem to define the highlighted areas. Over the white edges of the tomato, add Canary Yellow. Spray two to four more light coats of workable fixative and frame.

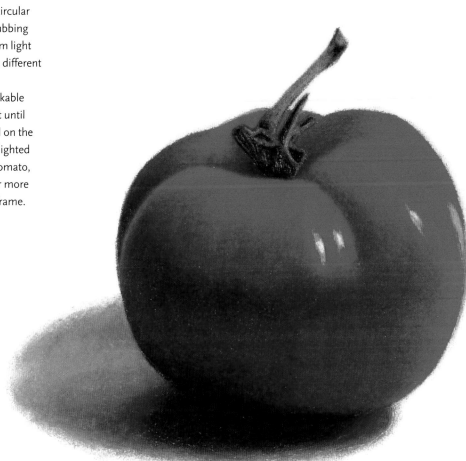

TOMATO
Artwork by Caryn Coville
Colored pencil on Stonehenge paper · 4" × 4 ¼" (10cm × 11cm)
Collection of Caryn Coville

Keep the Colorless Blender Colorless

Sharpen your Colorless Blender pencil each time you burnish a new color to keep it clean.

Using Purples for Richer Yellow Shadows

USE CONSISTENT PRESSURE

Unless otherwise noted, use pressure 2 with the circular stroke (see pages 18–19). Keep a sharp point. Add more layers to make an area as dark as necessary; don't press harder.

Shading yellow can be a difficult task because even darker yellows will not create a deep shadow. The best way to shade yellow is to use its complement, purple. This lesson is part of the final drawing demonstration beginning on page 122.

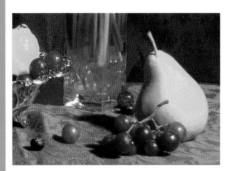

Reference Photo

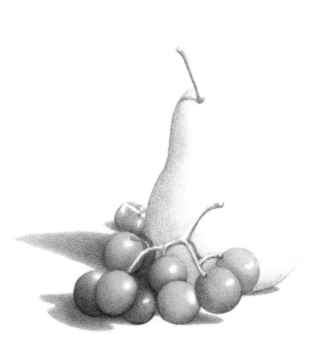

1 CREATE THE UNDERPAINTING
Using a Verithin White pencil or ball-tipped burnisher, impress the white highlights into the grapes and blueberries. (See page 19 for help with impressions.)

Define the shadows on the stems of the grapes with Dioxazine Purple Hue.

Shade the pears using Dahlia Purple on darker areas and Greyed Lavender on lighter areas. To shade the grapes, layer Dark Green, Celadon Green and Jade Green. Create the table shadows with the three greens. Add a thin shadow of Dark Green on the bottom of the pear. Then shade the blueberries using Black Grape.

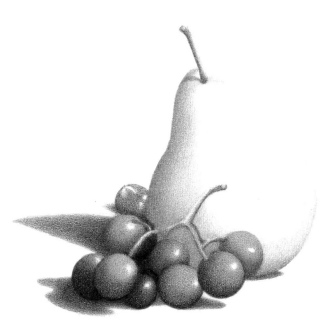

2 DEEPEN THE SHADOWS

Layer Indigo Blue over the dark shadows on the grapes and the table shadows. On top of the blue, layer Black Cherry. Layer Black Cherry over the lighter grapes, the light areas on the dark grapes, the pear stem and the left side of the pear where red is reflected. Layer Indigo Blue over the Black Grape on the blueberry. Layer Yellow Ochre on the shadows on the pear and on the grape stem.

The First Three Steps

In any drawing, steps 1 – 3 are the slowest. Here, your strokes need to be tight and your coverage thorough. These steps can take up to half the total time needed to complete a drawing. As you move on to later steps, it's not as critical to keep your strokes so close together.

3 ADD COLOR

Add another layer of Black Cherry to the grapes. Layer Tuscan Red on the table shadows, the grapes and the pear and grape stems. Layer Goldenrod on the pear's shadows.

Wash

A wash refers to an application of an even layer of color over the whole area, with no value changes.

4 ADD MORE COLOR

Layer Raspberry over the Black Cherry and, using pressure 1, on the reddish area of the pear. Add Raspberry to the shadow side of the grape stem. Cover the pear with Jasmine, leaving the white highlights.

Add a thin line of Jasmine to the right sides of the pear and grape stems. Wash Violet Blue on the blueberries.

5 DARKEN THE COLOR
Layer Crimson Lake over the grapes with a red cast but not on those with a purple cast. Add one layer of Crimson Lake to the red shadows on the pear. Layer Canary Yellow over the whole pear and the stems.

6 DEFINE FRUIT, SHADOWS AND HIGHLIGHTS
Wash (see sidebar) the fruit stems with Green Ochre. Layer Madder Lake on the light areas of the grapes with a purplish cast. Layer Orange on the light areas of the reddish grapes. Layer Orange on the pear's shadow. Cover the blueberries with Indigo Blue. Layer Canary Yellow on the pear. Layer Thio Violet over the dark grapes and on the shadows on the light grapes with a purple cast.

Using pressure 3, add Hot Pink to the pear's shadows. Switch to pressure 3–4 and layer Jasmine and Canary Yellow to the whole pear. Add White on top of the yellow on the light areas. Layer Indigo Blue to define the shadows on the grapes. Layer Crimson Red over the lighter reddish grapes. Layer Raspberry over the grapes with a purple cast. Layer Black Grape over the blueberries darks and on the shadows. Using pressure 3, build up layers of Indigo Blue, Crimson Red and Canary Yellow on the stems.

7 SATURATE THE PAPER
Use pressure 3–4. On the lighter grapes layer Orange Ochre to create highlights. Layer Hot Pink on top of that. Add Hot Pink to the lighter areas of the dark grapes. Layer Scarlet Lake over the lighter grapes. Use a combination of Hot Pink, Gamboge and Raspberry to finish the light grapes. With pressure 2, add Dark Green to the blueberries. Switch to pressure 3 and layer Violet Blue and Indigo Blue in the dark areas, Powder Blue in the light areas. Define the highlights on the grapes, pear and blueberries with White. Continue layering until no white paper shows through.

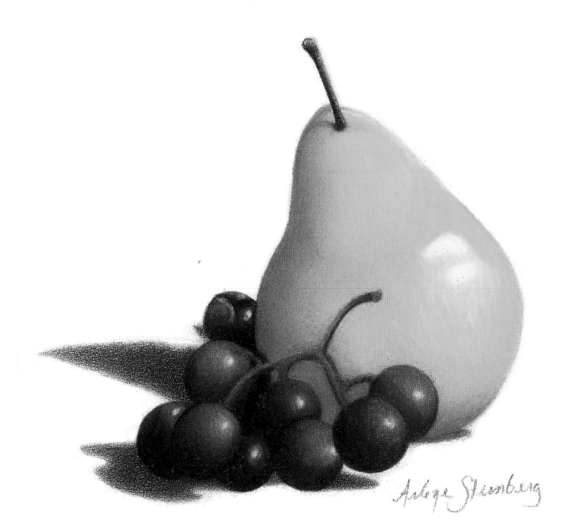

8 BURNISH THE DRAWING

With pressure 4, use a blunt-tipped Colorless Blender pencil to burnish the drawing. Start with your smallest areas (in this case, the stems). Work light to dark in each area. Next burnish the white highlights, then the pear, grapes and blueberries. Spray with two light coats of workable fixative and let it dry. Layer Yellow Ochre on the shadows on the pear, followed by Dioxazine Purple Hue on the darker shadows and Greyed Lavender on the lighter shadows. Layer Madder Lake over the purple. Layer Gamboge and Canary Yellow on the pear. With a blunt-tipped White pencil and pressure 4, brighten the white highlights and the edges of the fruit. With pressure 3, layer White over the hazy light areas on the grapes. Spray with two to four more light coats of workable fixative.

Underpainting for Dark Blues and Greens

PRISMACOLOR PENCILS

PC 901 Indigo Blue
PC 907 Peacock Green
PC 908 Dark Green
PC 916 Canary Yellow
PC 933 Violet Blue
PC 938 White
PC 942 Yellow Ochre
PC 996 Black Grape
PC 1020 Celadon Green
PC 1026 Greyed Lavender
PC 1077 Colorless Blender
PC 1078 Black Cherry
PC 1086 Sky Blue Light
PC 1087 Powder Blue
PC 1090 Kelp Green
PC 1095 Black Raspberry
PC 1101 Denim Blue
PC 1102 Blue Lake
PC 1103 Caribbean Sea
LF 118 Cadmium Orange Hue
LF 132 Dioxazine Purple Hue
LF 133 Cobalt Blue Hue
LF 224 Pale Blue

OTHER MATERIALS

Stonehenge paper, 8" × 5" (20cm × 13cm)
100 percent cotton makeup pads
Workable fixative

USE CONSISTENT PRESSURE

Unless otherwise noted, use pressure 2 with the circular stroke (see pages 18–19). Keep a sharp point. Add more layers to make an area as dark as necessary; don't press harder.

Blues and purples create a unique problem. If you were to try and use the complement of blue (orange) or the complement of purple (yellow), you'd never be able to create the dark values needed to create depth. If I'm creating a blue object, my usual choice is to use either Black Grape or Black Cherry, depending on whether the blue had a purple cast or a green cast. For a purple object, my choice is to use either Indigo Blue or Black Grape, depending on whether the purple has more red or more blue in it.

Parts of an Iris

— Standard

— Style crest

— Beard

Fall

Reference Photo

During spring, I enjoy going to public gardens to photograph flowers for reference. One day, I spent hours at a local garden but came away with nothing good; only to come home and discover my own irises were in bloom, and the light was just right for capturing the shadows and highlights.

Vary Your Strokes for Different Effects

Use the linear stroke for areas that show striations (such as the petals and the beard). Use the circular stroke for all other areas. Keep layering until you achieve the correct values. If an area needs to be darker, don't press harder: add more layers.

1 UNDERPAINT THE SHADOWS

Because the iris has red and purple undertones, start with Black Grape for your underpainting. Layer Black Grape on all the shadows, feathering out to pressure 1 in the lightest areas. Layer Greyed Lavender using the linear stroke on the shadows on the beards and on the yellow shadows. Layer Black Cherry on the stem.

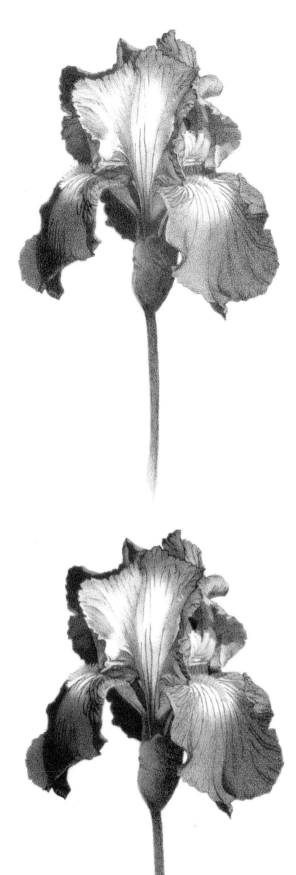

2 BEGIN ADDING COLORS

Cover over the Black Grape areas from step 1 with Dioxazine Purple Hue. Use a sharp pencil and pressure 3 to define the veins. Wash Yellow Ochre on the yellow areas. Fade the yellow into the purple where the two meet. Start to create the beard by using a linear stroke on the shadow areas of the beard. Add a thin highlight on the left side of the stem with Yellow Ochre. Layer Dark Green on the areas of the stem that are not yellow.

3 TURN THE IRIS BLUE

Cover the dark areas with Indigo Blue. Use pressure 2 and fade out to pressure 1 on lighter areas. Leave the white of the paper on the light areas on top of the falls and on the center standard. Using a linear stroke to give the appearance of hairs on the beard, layer Canary Yellow. Cover the dark shadows on the stem with Indigo Blue. Use Celadon Green on the light areas, including the yellow areas.

Values Create Depth

Be aware of how the light hits the iris. Notice all the different values and how they help give depth to the flower.

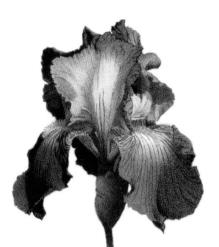

4 ADD MORE COLOR

On the darkest shadows on the falls and the left standard, layer Violet Blue. Layer Cobalt Blue Hue on the lighter areas, feathering the color out as it gets close to white areas. Use pressure 1 to achieve the feathered look.

With pressure 1–2, wash Blue Lake on the lightest blue areas. Blend Blue Lake into the Cobalt Blue Hue. On the center standard, layer over the darker blues. Wash Blue Lake onto the lighter areas on the stem. Over the darker areas, layer Peacock Green. Add Peacock Green to the shaded yellow areas on the underside of the standards near the stem.

On the beard's shadows, layer Cadmium Orange Hue. Use Cadmium Orange Hue and a very sharp point to define the darker yellow lines on the petals.

5 MAKE IT POP

Layer Denim Blue over the darkest shadows using pressure 2–3. Over the mid-value shadows, layer Denim Blue using pressure 2, followed by a layer of Caribbean Sea. For the lightest blue areas, layer Pale Blue. On the standards, layer Pale Blue over the areas covered with Caribbean Sea to soften the shadows. On the dark reddish veins on the falls and in the red areas of the underside of the falls, layer Black Raspberry. Use a very sharp point to define the fine lines. With Canary Yellow, layer over those lines you just drew. Layer Kelp Green on the stem.

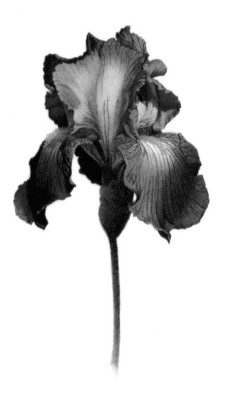

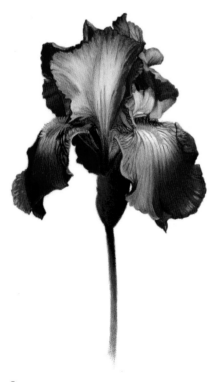

6 SATURATE WITH COLOR

Using pressure 3–4, layer Black Grape on the darkest shadows on the blue. Over the Black Grape, layer Violet Blue. Define the darkest blue veins with Violet Blue, and the lighter veins with Cobalt Blue Hue. Switch to pressure 2 and layer Black Grape on the red areas on the underside of the falls. Define the veins on the yellow with Black Grape. Using pressure 3–4, layer Cobalt Blue Hue on the lighter shadows, blending into Caribbean Sea. Add highlights in the darkest areas with Caribbean Sea. Over the lighter areas, layer Powder Blue and Sky Blue Light for the lightest areas. Add White to the lightest areas. Layer Dark Green on the stem's darkest shadows. On the lighter areas, layer Celadon Green. Layer over the stem with Peacock Green. Add highlights with Sky Blue Light. Continue to layer color until the paper is saturated and no white shows through.

7 BURNISH AND ADD HIGHLIGHTS

With pressure 4, burnish the iris with a blunt-tipped Colorless Blender pencil. Start with your white areas, then work light to dark in each area. Burnish the veins last. Spray with two light coats of workable fixative and let it dry. Redefine the veins with Black Grape over the veins with yellow underneath, and with Violet Blue over the veins on the dark blue areas. Use Caribbean Sea on the lighter blue veins. Add highlights with White. Spray with two to four more coats of workable fixative and frame.

IRIS
Colored pencil on Stonehenge paper
7" × 4 ½ " (18cm × 11cm)
Collection of Dr. and Mrs. Harvey Kaufman

Underpainting for Pinks and Peaches

Pinks can be difficult to shade. Pinks with a yellow cast seem to be easier, since many pink pencils have a slightly peachy cast. To get a bright pink with a bluer cast is more difficult. This lesson, which is part of the final drawing demonstration beginning on page 122, will teach you how to get brighter pinks.

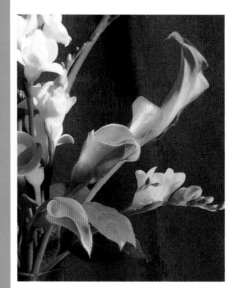

Reference Photo
I chose calla lilies for their interesting mix of colors and their unusual shapes.

USE CONSISTENT PRESSURE

Unless otherwise noted, use pressure 2 with the circular stroke (see pages 18–19). Keep a sharp point. Add more layers to make an area as dark as necessary; don't press harder.

1 UNDERPAINT THE SHADED AREAS
Shade the petals of the calla lilies with Dark Green and Celadon Green, making sure to leave any light areas white. Over the darkest areas, layer Indigo Blue.

With Dahlia Purple and Greyed Lavender, shade the yellow areas of the calla lilies. Shade the stems of the calla lilies with Black Cherry and Tuscan Red.

2 ADD COLORS
Layer over the Dahlia Purple and Greyed Lavender with Yellow Ochre. Over the Yellow Ochre, layer Goldenrod. Shade the pink areas on the calla lilies with Thio Violet. Layer Olive Green on the leaves.

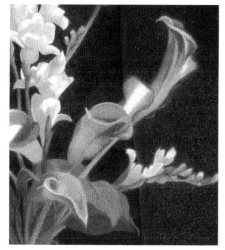

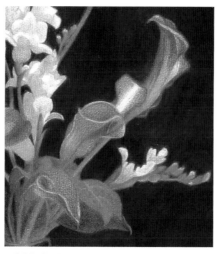

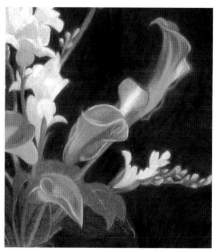

3 ADD COLOR AND DEFINITION
Layer Olive Green on the stems and on the bottom of the calla lilies. Layer Orange Ochre on the yellow areas of the flowers and the yellow areas of the stems. Layer over the dark areas on the pink flowers with Thio Violet. Add highlights of Jasmine to the yellow areas of the flowers and on the stems.

4 BRIGHTEN THE COLORS
Wash Madder Lake over the calla lilies. Using pressure 1, wash Orange over pink areas of the lilies with a yellow or peach tint. Layer Canary Yellow on the yellow areas of the stems and on the lilies. Put another layer of Madder Lake on the lilies. Use Kelly Green on the middle values of the stem to brighten them up.

5 MAKE THE COLORS POP
Use pressure 3–4 to finish defining the calla lilies. Layer Hot Pink on lighter pink areas, and Raspberry on the darkest areas. Use Madder Lake to brighten up the pinks. Add Jasmine to the pink areas with a yellow cast and to areas with a green cast. Add Limepeel to the green areas of the flower and the light areas of the stems. Define your highlights and lightest areas on the stem and flower with White. If needed, go over the White with Hot Pink again.

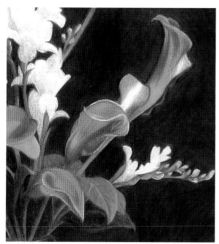

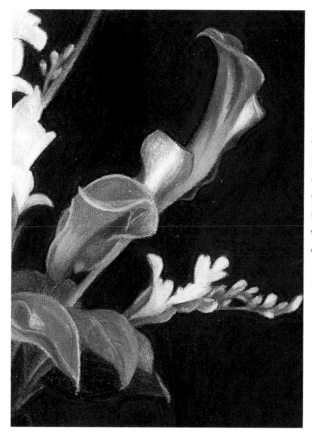

6 SATURATE WITH COLOR
Use pressure 3–4 for this step. Cover the stems with a combination of Limepeel, White, Olive Green and Kelly Green to create the rounded look. Be aware of where the light hits the stem and where the shadows are. Layer over the darkest pink areas with Thio Violet. Over that, layer Raspberry and Madder Lake. Layer Hot Pink on the lightest areas. Layer Limepeel up into the flowers. Layer over the Limepeel with Jasmine.

7 BURNISH AND BRIGHTEN
Burnish all areas with the Colorless Blender pencil, starting with the lightest areas. Spray with two light coats of workable fixative. When it's dry, add white highlights as needed. Layer Canary Yellow to brighten the yellow areas on the stems and the lilies. Spray with two to four more coats of workable fixative.

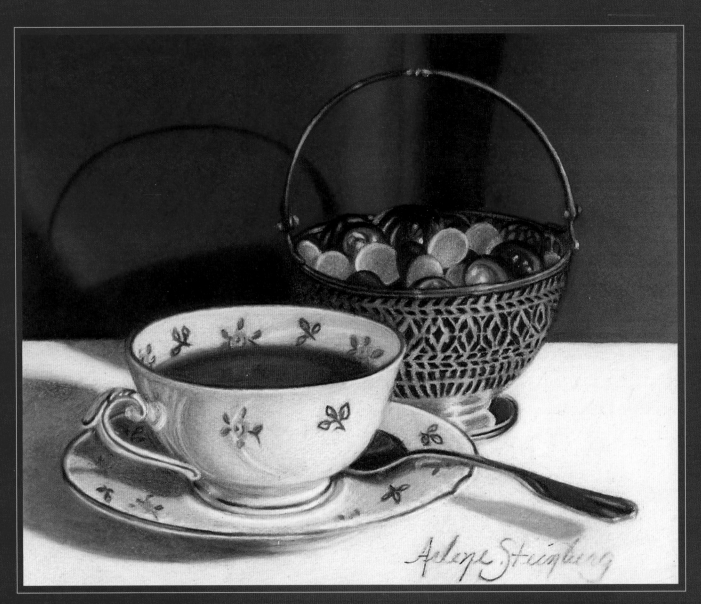

FOUR-O-CLOCK
Colored pencil on Stonehenge paper · 4 ⅞" × 6" (12cm × 15cm)
Collection of Cynthia Haase

RICHER WHITES, GRAYS AND BLACKS

HOW MANY TIMES HAVE YOU LOOKED AT A DRAWING THAT DEPICTED WHITE FABRIC, OR A WHITE vase and felt it was missing something? I used to have the same problem, but have since discovered two solutions. The first is to always make the shadows in my white areas darker than I think they should be. By going darker with a wider range of values, I'm able to suggest more depth in my white objects. The second is not to use gray pencils to make gray shadows. I found I could achieve more lively grays by mixing complementary colors on the paper. The same holds true for creating blacks. This chapter will walk you through the steps you can use to create vibrant whites, lively grays and rich blacks.

CHAPTER 5

Colorful Whites and Blacks

PRISMACOLOR PENCILS

PC 901 Indigo Blue

PC 908 Dark Green

PC 914 Cream

PC 923 Scarlet Lake

PC 925 Crimson Lake

PC 928 Blush Pink

PC 933 Violet Blue

PC 935 Black

PC 936 Slate Grey

PC 937 Tuscan Red

PC 938 White

PC 942 Yellow Ochre

PC 996 Black Grape

PC 997 Beige

PC 1005 Limepeel

PC 1026 Greyed Lavender

PC 1030 Raspberry

PC 1032 Pumpkin Orange

PC 1033 Mineral Orange

PC 1034 Goldenrod

PC 1077 Colorless Blender

PC 1085 Peach Beige

PC 1086 Sky Blue Light

LF 132 Dioxazine Purple Hue

VT 734 Verithin White

OTHER MATERIALS

Stonehenge paper, 6" × 8" (15cm × 20cm)

100 percent cotton makeup pads

Workable fixative

Ball-tipped burnisher (optional)

USE CONSISTENT PRESSURE

Unless otherwise noted, use pressure 2 with the circular stroke (see pages 18–19). Keep a sharp point. Add more layers to make an area as dark as necessary; don't press harder.

I find it challenging and rewarding to re-create all the reflected colors on white objects. Eggs are especially interesting to draw because the egg picks up not only reflected colors, but also the color from inside the egg. Blacks are a different challenge. With them, it's harder to create form and depth, but by using color instead of black and gray, you'll be able to achieve richer, deeper blacks.

Reference Photo
This is a good example of my assertion that "photos lie." Notice that the egg in front is almost twice as large as the eggs in the bowl. You can adjust the size of distorted objects in your drawing, but be sure to add missing elements such as the red threads. (See page 135 for the corrected drawing.)

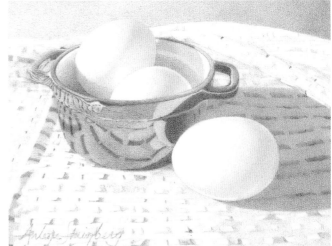

1 CREATE YOUR UNDERPAINTING

With a Verithin White or a ball-tipped burnisher, impress your signature into the paper. Begin by applying Dark Green in the shadows of the red areas on the towel. Then, layer Dark Green in the darkest areas of the bowl. To make an area darker, don't press harder, just add more layers.

Apply Slate Grey to the background wall, fading out toward the left side of the paper. Layer Slate Grey in the lightest areas of the bowl, and on the shadows on the cloth. Layer Indigo Blue over the Slate Grey to create darker reflections. For an even lighter look with the Slate Grey, feather out using pressure 1.

To show the shadow from the egg on the cloth, layer Dioxazine Purple Hue over the Slate Grey, then apply it to the darker areas of the inside of the bowl, fading out. Layer Greyed Lavender over the Dioxazine Purple Hue and the rest of the shadow areas on the bowl.

Remember, eggs are translucent and will show some yellow from the yolk inside. For this reason, use the complements of yellow, Dioxazine Purple Hue and Greyed Lavender, to shadow the eggs. Keep the areas of reflected light on the shadow sides of the eggs.

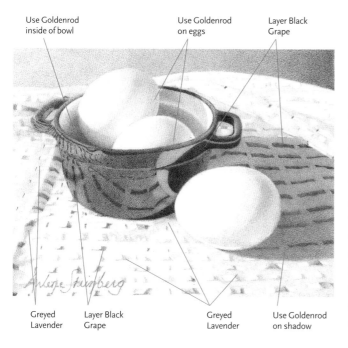

Use Goldenrod
inside of bowl

Use Goldenrod
on eggs

Layer Black
Grape

Greyed
Lavender

Layer Black
Grape

Greyed
Lavender

Use Goldenrod
on shadow

2 ENHANCE YOUR DARKS

Add another wash of Indigo Blue to the outside of the bowl.

Layer Black Grape over the Slate Grey in the background, fading it out like you did with the Slate Grey in step 1. Don't worry if it appears too dark. Layer Black Grape over the Dark Green areas on the cloth, the bowl, the rest of the outside of the bowl.

Use Goldenrod to layer over the darker areas inside the bowl fading out halfway up. Use Goldenrod on the right side nearest the egg, on the inside bottom, and on the top half of the right side of the bowl, fading it out as it gets farther from the rear egg. On the back egg in the bowl, apply a small line of Goldenrod on the bottom shadow and on the right side. Leave a thin line on the right without any Goldenrod. Add Goldenrod on the front egg in the bowl by layering a moon-shaped patch on the right side and the underside. Layer Goldenrod over the Dioxazine Purple Hue on the tablecloth, fading out to the edge of the paper.

Wash Greyed Lavender over the Slate Grey shadows on the cloth.

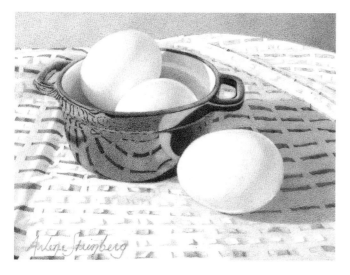

3 ADD COLOR

Use Pumpkin Orange to evenly cover the background. Lightly layer the bottom-left interior of the bowl with Pumpkin Orange and wash it on the right side nearest the rear egg. Wash Pumpkin Orange over the deep shadow areas of the cloth using pressure 1. Switch to Mineral Orange and wash over the lighter gray areas of the cloth, using pressure 1.

Layer Tuscan Red over the dark red areas on the outside of the bowl and on the darker red areas of the cloth. Also work Tuscan Red onto the lighter red areas of the cloth, defining those areas that didn't have any color on them previously and indicating any light shadows. Vary the pressure between 1 and 2.

Layer Yellow Ochre over the rest of the shadow areas on the inside of the bowl, blending over the areas already covered with Goldenrod. Using pressure 1, wash Yellow Ochre over the shadows on the eggs.

Apply Raspberry over all red areas of the cloth, making sure to cover the Tuscan Red.

4 DEEPEN THE COLORS

Add an even layer of Yellow Ochre to the background. Layer more Slate Grey over the shadows in the cloth. Using linear strokes, roughly define the weave pattern. Evenly layer Dioxazine Purple Hue over the Yellow Ochre shadow on the cloth.

If the values on your eggs and the inside of the bowl are still too light, lightly wash them with Dioxazine Purple Hue and Greyed Lavender, alternating with Yellow Ochre. Repeat until your eggs are dark enough.

With Black, cover the outside of the bowl, adding more layers in the darker areas and less in the lighter.

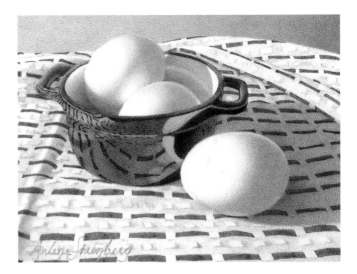

5 PUSH YOUR VALUES

With Indigo Blue, deepen the weave pattern on the cloth. Layer it over the darkest shadows on the cloth and then wash it with Pumpkin Orange to tone down the blue. Put another layer of Indigo Blue on the bowl. On the darkest areas of red in the cloth, layer Indigo Blue. Next, layer Slate Grey over the cloth, defining the weave. With Peach Beige, cover the blue and purple shadows in the cloth and background.

Wash Greyed Lavender over the lightest areas on the outside of the bowl and shadows in the cloth. Fading into the white areas without covering them, layer Greyed Lavender on the eggs and on the whites inside the bowl.

Layer Crimson Lake over the red in the cloth and the red areas on the outside of the bowl. With Crimson Lake and pressure 1, go over the inside shadows of the bowl and the darkest spots on the eggs.

Cover the eggs with Beige including the darkest areas. Preserve the white highlights. Cover the inside of the bowl with Beige. To add some sparkle, use Limepeel over the light shadows on the eggs and on the lighter areas inside and outside the bowl.

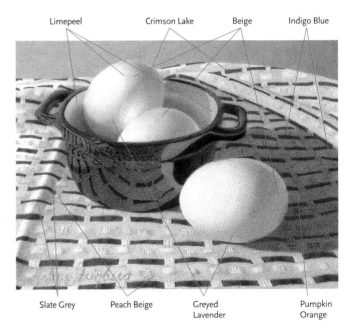

Limepeel Crimson Lake Beige Indigo Blue

Slate Grey Peach Beige Greyed Lavender Pumpkin Orange

Preserve the white of the eggs and cloth Sky Blue Light Blush Pink lightens the shadow

Blush Pink further defines the red weave Sky Blue Light

6 ADD THE HIGHLIGHTS AND DARKEN THE BOWL

Cover the eggs with Sky Blue Light, leaving the lightest areas white. Use Slate Grey over the darker areas. Over this, wash Blush Pink on the egg reflections and on the lightest areas showing hints of pink. Apply White over the eggs, leaving the darkest areas alone.

Apply Sky Blue Light over all but the whitest and red areas of the cloth, and the white areas inside the bowl.

Layer Peach Beige on the cloth. Then, apply Greyed Lavender, avoiding the raised weave and the purple shadow. Next, layer the darker areas with Blush Pink. Use pressure 3 to layer Blush Pink on the highlights in the reds and Scarlet Lake on the darker reds.

Add more Black on the outer bowl, fading out toward the lighter areas. Apply a layer of Slate Grey on the lighter areas and Indigo Blue over the darker areas. Next layer Black, then Black Grape, and finish with another layer of Black.

Using pressure 3–4 and White with a slightly blunted point, add the highlights on the bowl; then define the threads in the weave pattern using loose lines. Next, add White in the lightest areas of the cloth. Evenly layer the White over all areas of the cloth (except the red areas) using pressure 2.

Layer White over the lighter areas inside and outside the bowl.

7 SATURATE AND BURNISH

Deepen the middle of the outside of the bowl by saturating it with a layer of Violet Blue, then Tuscan Red. No paper should show through.

With the Colorless Blender, lightly burnish the background, eggs and cloth. Burnish inside and outside the bowl using pressure 4.

With a cotton makeup pad, using a circular motion, very lightly buff the background, eggs and bowl. Next go over the lighter areas of the bowl with White and very lightly burnish again with the Colorless Blender. Spray two light coats of workable fixative. Continue layering until the paper is saturated and no white paper shows through.

69

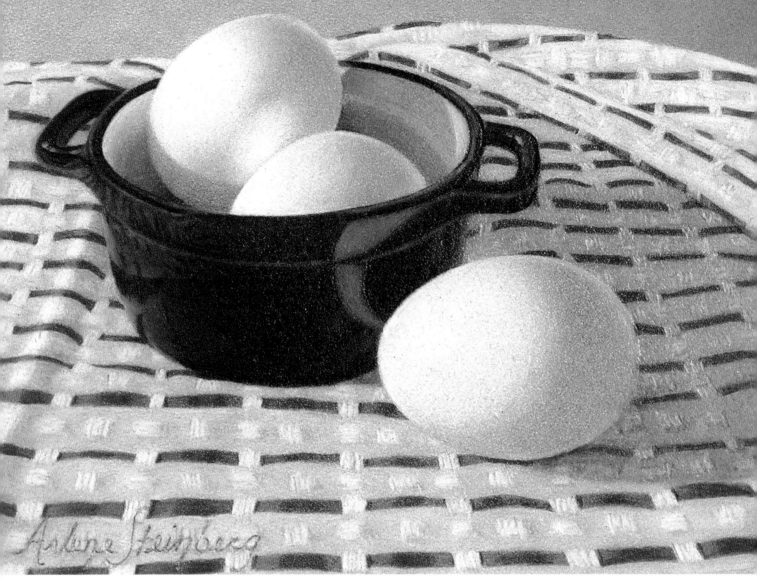

8 FINISHING TOUCHES

Apply Crimson Lake over the red lines on the bowl. Lightly wash Cream over the inside of the bowl's light areas and the lighter area of the shadows. With pressure 3, layer Yellow Ochre over the shadows in the bowl. Layer more Black on the outside of the bowl. Burnish the bowl again with the Colorless Blender. Add back the White highlights in the bowl using pressure 3–4. Use the Colorless Blender to blend the White into the Black where needed. Use Black Grape to add a few dark touches to the shadows inside the bowl. Use Indigo Blue to do the same for the black bowl.

Layer Cream over the purple shadow on the cloth to soften it. With pressure 3, layer Crimson Lake over the dark red areas on the cloth. With White and pressure 3–4, replace the highlights on the cloth and define the weave again. With Black Grape, add small touches of shadows under the egg, the bowl and the darkest corners for definition.

Bring out the lightest areas of the eggs with White. Lightly buff the bowl again with the cotton pad. Spray with two to four additional coats of workable fixative, allowing each coat to dry in between. Frame.

EGGCELLENCE
Colored pencil on Stonehenge paper · 4"× 6" (10cm × 15cm)
Collection of the artist

Not Perfect?

Don't feel bad if your drawing isn't perfect or if it's not quite how you envisioned it. Every artist I know can point out the flaws in his or her own work, yet those viewing your art will look at it on its own merit and will not see the "flaws."

Grays Without Gray Pencils

Grays without gray pencils? Yes, not only is it possible, but using complements instead of grays will give you more interesting neutrals with more depth. Another advantage to using complements instead of gray pencils will be your ability to control the neutral color you achieve. The lessons learned in this demo will also help when drawing hair or fur.

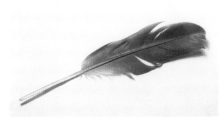

Reference Photo
This feather is from the grey goose, a bird that summers everywhere on Long Island. This reference shows the feather with a warm cast, which calls for a slightly different approach to creating grays than in the last lesson.

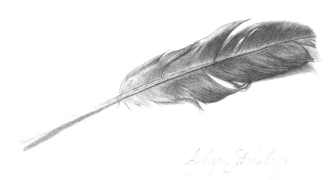

1 ESTABLISH YOUR VALUES
Use Black Grape with a needle-sharp point to establish your values. Use a linear stroke, following the direction of the feather. For each section, do the darkest area first, and then go over both the lighter and the darker areas with the pencil to establish the rest of the values. For the lightest areas, use pressure 1; for the darkest, increase the pressure to almost 3.

MATERIALS

PRISMACOLOR PENCILS

PC 901 Indigo Blue

PC 908 Dark Green

PC 936 Slate Grey

PC 938 White

PC 996 Black Grape

PC 1026 Greyed Lavender

PC 1032 Pumpkin Orange

PC 1034 Goldenrod

PC 1077 Colorless Blender

PC 1078 Black Cherry

PC 1083 Putty Beige

PC 1086 Sky Blue Light

LF 132 Dioxazine Purple Hue

OTHER MATERIALS

Stonehenge paper, 6" × 10" (15cm × 25cm)

100 percent cotton makeup pad

Workable fixative

USE CONSISTENT PRESSURE

Unless otherwise noted, use pressure 2 with the circular stroke (see pages 18–19). Keep a sharp point. Add more layers to make an area as dark as necessary; don't press harder.

Keep Your Background Clean

It's sometimes hard to keep a white background clean. I like to use a sheet of inexpensive paper to create a mat around the area being drawn. For this drawing, use your tracing to trace the outside edges of the feather onto the paper and with a craft knife, cut out an area about ⅛" (32mm) larger around the edge of the drawing. Then tape the mat to the top of your drawing using removable tape.

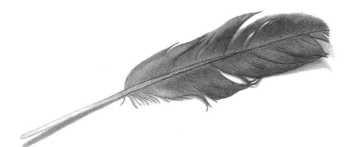

2 DEEPEN YOUR VALUES
To deepen the values further, use both Indigo Blue and Slate Grey to layer over the Black Grape with a linear stroke. Use pressure 1–2. Your feather should look blue after this step.

To warm up the feather, add the complement of purple and blue, which is a yellow-orange color. Layer over the feather and shadows with Goldenrod, keeping a sharp point and varying the pressure according to the value you want to achieve. Don't press harder than pressure 3, and then only on the finest lines. Notice that the feather already has an iridescence that would be impossible using gray pencils.

3 DEFINE THE EDGES
Use Dioxazine Purple Hue with pressure 3 and a needle-sharp point to define the edges and darkest shadows. Reduce pressure to 2 and layer the color over the rest.

Layer Greyed Lavender using a linear stroke and pressure 3 on the lightest areas of the feather and the background shadows.

Add touches of White to the very lightest areas.

4 CONTINUE TO BUILD LAYERS
With Pumpkin Orange, layer over the entire feather and the shadows. For the lines use pressure 3. Layer Sky Blue Light over the lightest areas and the shadows using pressure 3.

5 REFINE THE VALUES
On the dark areas, layer Dark Green, then Black Cherry. Next layer Indigo Blue on the darkest areas and Slate Grey on the middle values. Using pressure 3, layer Sky Blue Light on the lightest areas. Wash Sky Blue Light over the whole feather using pressure 1. Then add White over the lightest highlights and on the table shadows.

Arlene Steinberg (signature)

6 BURNISH

Lightly wash Putty Beige over the whole feather and the shadows on the ground. With a slightly dull Colorless Blender pencil, and working from light to dark, burnish the feather following the direction of its lines. Lightly wipe the feather with the cotton pad and then spray with two light coats of workable fixative. With White, bring back the highlights and then blend the edges using the Colorless Blender. Spray with two additional coats of workable fixative and frame.

GRAY FEATHER I
Colored pencil on Stonehenge paper · 6" × 10" (15cm × 25cm)
Collection of the artist

Reflective Whites and Metals

Porcelain is slightly translucent and reflects all the colors around it, creating a distinctive shimmer. Silver and gold are even more reflective. Before you determine which colors to use for these metals, carefully examine the colors nearby that they're reflecting.

MATERIALS

PRISMACOLOR PENCILS
PC 901 Indigo Blue
PC 908 Dark Green
PC 910 True Green
PC 916 Canary Yellow
PC 924 Crimson Red
PC 925 Crimson Lake
PC 927 Light Peach
PC 933 Violet Blue
PC 936 Slate Grey
PC 937 Tuscan Red
PC 938 White
PC 942 Yellow Ochre
PC 993 Hot Pink
PC 996 Black Grape
PC 1012 Jasmine
PC 1020 Celadon Green
PC 1021 Jade Green
PC 1026 Greyed Lavender
PC 1030 Raspberry
PC 1032 Pumpkin Orange
PC 1077 Colorless Blender
PC 1078 Black Cherry
PC 1085 Peach Beige
PC 1086 Sky Blue Light
PC 1087 Powder Blue
PC 1088 Muted Turquoise
PC 1091 Green Ochre
PC 1093 Seashell Pink
PC 1098 Artichoke
LF 118 Cadmium Orange Hue
LF 129 Madder Lake
LF 133 Cobalt Blue Hue
VT 734 Verithin White

OTHER MATERIALS
Stonehenge paper, 6" × 8" (15cm × 20cm)
100 percent cotton makeup pad
Workable fixative
Ball-tipped burnisher (optional)

USE CONSISTENT PRESSURE
Unless otherwise noted, use pressure 2 with the circular stroke (see pages 18–19). Keep a sharp point. Add more layers to make an area as dark as necessary; don't press harder.

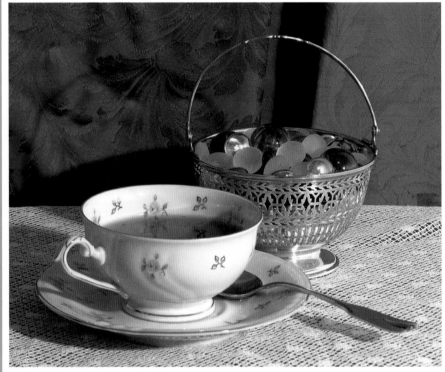

Reference Photo
I decided that the best way to focus on creating the whites, silver and gold would be to eliminate the patterns in the damask background and the crocheted tablecloth. Look closely at the way colors of the fabrics are reflected in the metal and porcelain. Draw what you see reflected.

Simulating Gold
I'm constantly asked what colors to use to make gold. My answer is: "It depends." Gold and silver reflect everything around them, and those colors can vary depending on the lighting and the distance from the reflected objects. Start with gold the same way you would with any other color: by using complements in the shadow areas.

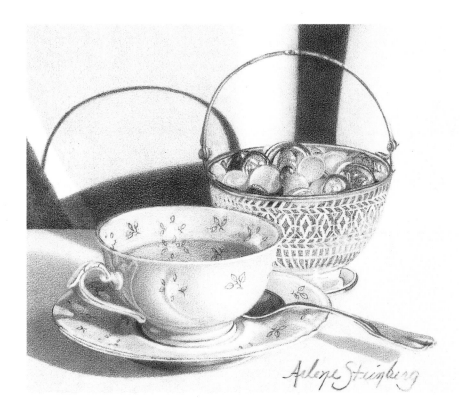

1 UNDERPAINT WITH COMPLEMENTS

Using the Verithin White or ball-tipped burnisher, impress your signature and the white spots into the glass beads, cup and saucer (no pigment will be applied here). Then layer Dark Green on the darkest shadows on the background cloth, spoon, the left side of the saucer and the lines on the silver basket. Keep a needle-sharp point when making fine lines. Use a pressure of around 1–2.

Next, wash Celadon Green over both curtain folds, the large light shadow in the middle of the curtain and the shaded areas on the cup and saucer. Then, use Jade Green on the lightest shadows in the curtain and the lightest areas on the cup and saucer.

There's a lot of red reflected in the gold, so instead of a true purple (purple being the complement of yellow), use Black Grape to define the gold.

Layer Slate Grey on the shadows cast by the cup, saucer, silver bowl, glass beads and spoon. Lightly layer Slate Grey over the shadows on the cup and saucer, but not over the pink roses.

Use Muted Turquoise over the whole cloth, including the shadows made by the objects. Then use Muted Turquoise for the first layer of the tea in the cup and the lighter areas between the lattice of the basket.

Layer Black Grape inside the lattice of the basket to define its pattern. It's easier to define the holes than to shade the actual bowl, since most of the silver itself is lost in reflections. Use Slate Grey and Greyed Lavender to shade the silver on the basket, paying attention to the reflections.

Use Indigo Blue to layer over the Dark Green on the fold in the cloth, the shadow cast from the silver bowl, the deepest shadows on the silver bowl and on the spoon. Layer Indigo Blue in the darkest cloth shadows near the saucer and the darkest shadows of the tea. Put a thin line of Indigo Blue under the cup itself.

For the glass beads in the bowl, use Dark Green for areas that will become red or burgundy, Slate Grey for the white and Black Grape for the dark blue.

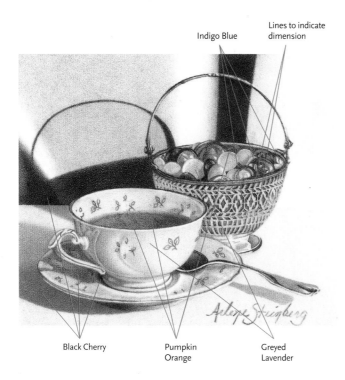

Indigo Blue

Lines to indicate dimension

Black Cherry

Pumpkin Orange

Greyed Lavender

2 ADD THE DARKEST COLORS

The green shadow in the background wasn't dark enough so I used Celadon Green to darken it.

Layer Black Cherry on the darkest areas of the curtain, the outer lines of the silver basket and the spoon. With pressure 1, wash Black Cherry over the darkest greens on the cup, the shadows on the saucer, and the dark shadows on the white cloth.

With a sharp point, layer Indigo Blue over the blue beads in the basket. For the holes of the lattice, add a thin line of Indigo Blue using pressure 3 to indicate dimension, then vary the pressure so some areas are lighter, some darker.

Next, wash Muted Turquoise over the lighter areas on the blue beads and the frosted white beads. Add touches of Greyed Lavender on all. On the two glass beads on the right side, layer Greyed Lavender on the lighter areas. Lightly wash Greyed Lavender over the teacup and saucer.

Next, wash a layer of Peach Beige over the tablecloth, including the shadows. Layer Pumpkin Orange over the tea in the teacup, around the rim of the basket, under the spoon, on the saucer and in the glass beads that have orange. Define the darkest gold areas on the teacup and saucer using Pumpkin Orange.

Wash a light layer of Yellow Ochre over the basket's lattice and under the teacup. Also use Yellow Ochre to define the lighter gold lines in the cup and saucer. Notice that in some places the same line changes values.

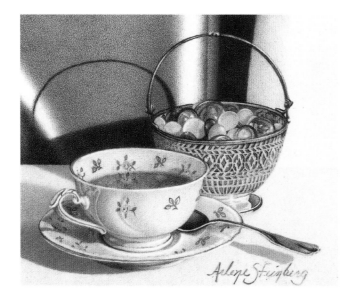

3 ESTABLISH THE LOCAL COLOR

Keeping a sharp pencil, layer Tuscan Red over the shadow areas of the curtain, including the areas with Black Cherry. In the darkest areas, use pressure 2–3. If the surface gets too waxy, wipe lightly with a cotton pad. Using a sharp point and pressure 1, very lightly feather Tuscan Red over the green edges of the curtain. Then, add touches of Tuscan Red to the red areas of the gold lines and the edges of the basket. Add Tuscan Red to the shadow side of the basket and the red areas on the glass beads and spoon. Lightly define the red lines in the roses.

Next, lightly wash Light Peach over the shadows on the cloth and follow up with Pumpkin Orange in the darkest area under the saucer to the left. With pressure 3, fill in the green leaves on the teacup and saucer with True Green and the blue leaves with Muted Turquoise.

Color in the roses with Hot Pink using pressure 3. Add a touch of the Hot Pink to the glass beads that reflect light. With pressure 1, lightly wash over the darkest green shadows on the cup with Hot Pink.

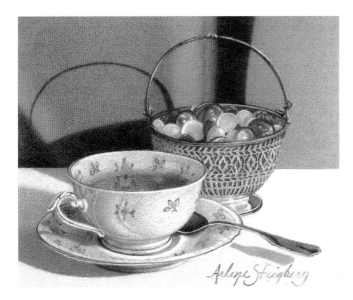

4 ADD LAYERS

Layer Raspberry over the shadows of the curtain, including the areas colored Tuscan Red. On the right side, feather Raspberry out toward the right edge. Then lightly wash Raspberry over the tea in the cup and define the centers of the roses. Wash Raspberry over the shadows on the left side of the saucer and define the reddish areas of the gold edging around the cup and saucer. Layer Raspberry on the darker areas of the spoon, the right edge of the basket, the handle and the top rim. Color in the curtain through the holes in the back of the basket.

Wash Pumpkin Orange over the dark shadows on the tablecloth and the basket.

With Cobalt Blue Hue, define the bright spots on the blue beads. Add some Cobalt Blue Hue to the bowl of the spoon, the darkest lines in the spoon, the underside of the saucer where it meets the tablecloth, and the underside of the cup where it meets the saucer. Add Cobalt Blue Hue to the inside of the lattice on the basket. Repeating touches of color from one section to another subtlely ties the drawing together.

Layer Artichoke over the cup, saucer, the lighter beads and the basket, leaving the highlights without color. Wash Artichoke over the tea in the cup.

Over the light and white areas of the curtain, layer Madder Lake. Then lightly wash this over the roses in the cup.

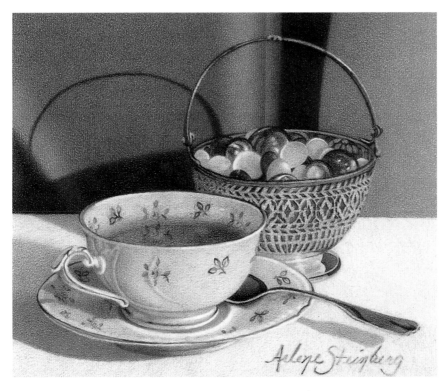

5 ADD YELLOWS AND BLUES FOR ZING

Lightly wash Seashell Pink over all areas of the table except the deep shadows.

Layer Powder Blue over the cup, saucer and lightest beads. Add a touch to the bottom of the lattice basket, the handle, the bowl and edge of the spoon and inside some of the lattice.

Next, layer Jasmine over the lightest areas of the curtain. Then add touches to the lattice basket, the glass beads, the saucer area below the spoon, and the spoon itself. Using pressure 3 and a very sharp pencil, define the lighter areas of gold on the cup.

Intensify the blue beads by layering Violet Blue over them. Add some thin lines to the edges of the lattice and the basket, the bowl of the spoon, and in the darkest areas of the cup and saucer. Don't worry about the blue becoming too dominant on the gold area; the later layers will soften it.

Layer Crimson Lake over the curtain's dark areas.

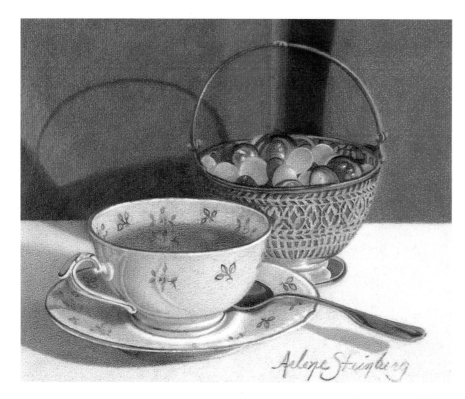

REFINE AND HIGHLIGHT

Layer Cadmium Orange Hue on the light curtain areas, the red areas of the basket and the light red areas of the spoon handle.

Layer Crimson Red over the curtain using pressure 3, then go over the dark lines in the roses. With the same color using pressure 1, wash over the dark shadows on the left side of the saucer, the shadows on the tablecloth, under the saucer, inside the cup on the right side and on the outer right side. With pressure 2, layer Crimson Red over the spoon, the spoon's edge and the bottom of the basket. Add touches to the gold lines on the cup, the edges and handle of the basket and in the glass beads.

With Indigo Blue, add touches on the edge of the gold, then do a light wash over the tea in the cup.

Layer Peach Beige over the basket, leaving the highlights. Layer Peach Beige over the edge of the spoon and in the gray and beige areas of the beads. Using pressure 1, wash the Peach Beige over the tablecloth, leaving the shadows alone.

Use White to create a fine line around the light edge of the cup and to add highlights to the cup's handle and to the basket.

Fixing Mistakes

Many times I become so focused on one area, I forget to look at the whole drawing. When I finally do, I find I've changed a shape too much. Erase mistakes with mounting putty or, for thin lines, clear tape. Then, slowly correct the problem; building up more layers wherever the color was lifted.

7 REFINE THE DRAWING

Layer Green Ochre over the tea in the cup and on the greener areas of the gold lines. Make sure your point is sharp and use pressure 3 to really set the lines in. Add touches of Green Ochre to the spoon, under the spoon, on the saucer and in the basket and beads.

Lightly wash the white beads' shadows with Indigo Blue. Then, with pressure 3, layer over the dark blue beads again. Define more inside the lattice with Indigo Blue. Then, using Indigo Blue, wash the over the dark areas of the curtain again to define the folds.

Over the lightest areas of the curtain, lightly wash Hot Pink. Put another layer on the roses and saucer and in the lighter pink areas of the beads. Lightly wash Hot Pink on the stem of the spoon and add touches to the basket, cup and saucer.

Burnish the curtain with Crimson Red, using pressure 4. When finished, wipe the curtain lightly with the cotton pad. Add more Crimson Red to the spoon's handle.

Next, lightly wash Peach Beige over the teacup, saucer and light beads, Powder Blue over the darker areas of the cup and saucer, and Sky Blue Light on the lighter areas of the cup and saucer, blending one into the other. Then, with Sky Blue Light, layer over the lattice. Layer Powder Blue over the lighter beads and the dark shadows on the table. Use Sky Blue Light on the rest of the table.

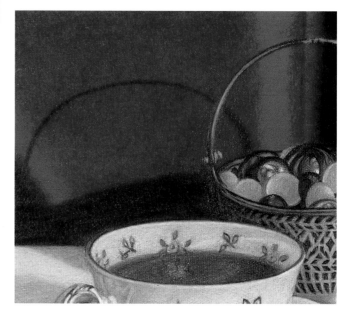

With Canary Yellow, add a few bright highlights to the gold in the cup, saucer, tea, top of the spoon handle and basket. Layer Pumpkin Orange over the tea.

Wash White over the teacup, saucer and table, including the shadow areas, using pressure 3. Using pressure 1–2, layer White over the lattice and the rest of the basket. Continue layering until no white paper shows through.

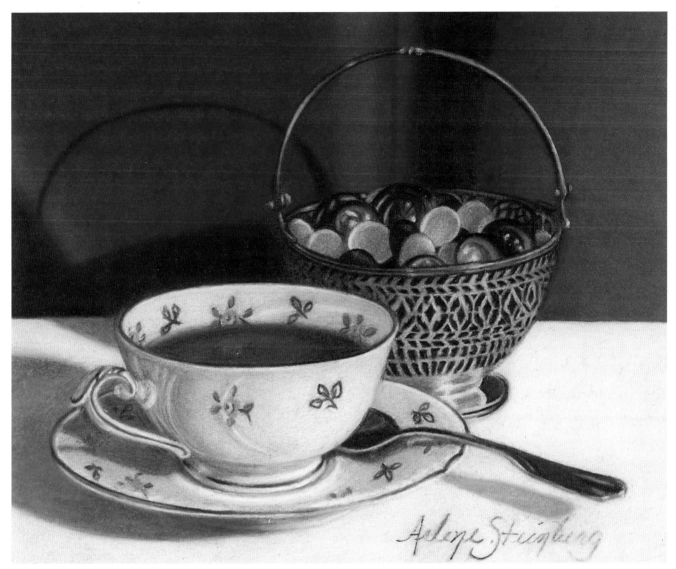

8 BURNISH AND REFINE

Burnish the whole drawing with the Colorless Blender pencil using pressure 4 and the circular stroke, starting with the lightest areas. Then, spray with two light coats of workable fixative.

Once the fixative has dried, redefine the highlights with a Verithin White pencil. Brighten the dark beads with Violet Blue and Indigo Blue. Use Black Cherry and Indigo Blue to define the darks in the lattice, handle and glass beads.

Add more Slate Grey, Powder Blue and White to the cup and saucer. On the darkest shadows on the left, wash Black Cherry. Add Pumpkin Orange, Slate Grey and Black Cherry to the shadows on the table, and burnish again with the Colorless Blender pencil. Redefine the gold leaves on the cup and saucer with Green Ochre. Follow up with a few highlights of Canary Yellow in the gold, the glass beads and the tea. Spray with two to four more coats of workable fixative.

FOUR-O-CLOCK
Colored pencil on Stonehenge paper · 4 7/8" × 6" (12cm × 15cm)
Collection of Cynthia Haase

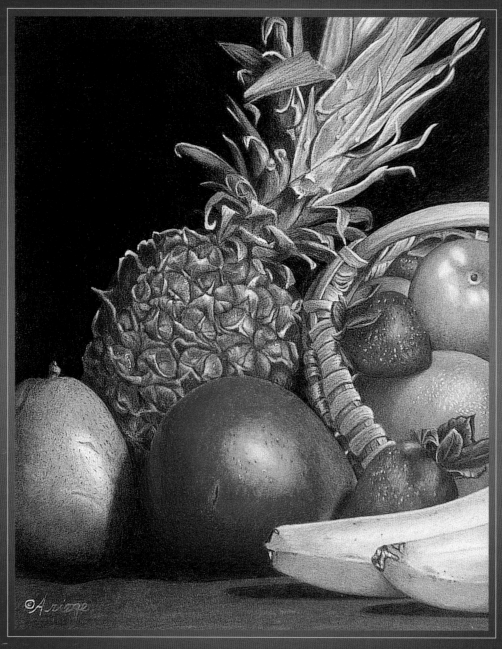

BOUNTIFUL
Colored pencil on Stonehenge paper · 10" × 8" (25cm × 20cm)
Collection of Karen Gardner

TEXTURES AND PATTERNS

DRAWING TEXTURES ISN'T HARD, BUT IT TAKES SOME FORETHOUGHT. OUR TENDENCY WHEN drawing textures is to want to create every line or bump. This isn't necessary, except sometimes in a closeup. It's easier and actually better to simply indicate the textures because that allows the viewer to focus on your main subjects.

CHAPTER

Dramatic Light and Shadow

PRISMACOLOR PENCILS

PC 901 Indigo Blue
PC 907 Peacock Green
PC 908 Dark Green
PC 914 Cream
PC 916 Canary Yellow
PC 925 Crimson Lake
PC 936 Slate Grey
PC 937 Tuscan Red
PC 938 White
PC 942 Yellow Ochre
PC 943 Burnt Ochre
PC 944 Terra Cotta
PC 945 Sienna Brown
PC 996 Black Grape
PC 1009 Dahlia Purple
PC 1020 Celadon Green
PC 1023 Cloud Blue
PC 1026 Greyed Lavender
PC 1032 Pumpkin Orange
PC 1033 Mineral Orange
PC 1034 Goldenrod
PC 1077 Colorless Blender
PC 1078 Black Cherry
PC 1084 Ginger Root
PC 1085 Peach Beige
PC 1090 Kelp Green
PC 1091 Green Ochre
PC 1092 Nectar
PC 1093 Seashell Pink
LF 109 Prussian Green
LF 118 Cadmium Orange Hue
LF 122 Permanent Red
LF 129 Madder Lake
LF 132 Dioxazine Purple Hue
LF 195 Thio Violet
LF 203 Gamboge
LF 209 Manganese Violet
VT 734 Verithin White

OTHER MATERIALS

Stonehenge paper, 7" × 12 ½" (18cm × 32cm)
100 percent cotton makeup pad
Workable fixative
Ball-tipped burnisher (optional)

My friend's mother gave him these charming dolls. When I saw them, I knew I wanted to use them in a drawing. I enjoy a challenge and felt the patterning on the dolls and the mosaic glass tiles surrounding the candle holder would provide that. Other challenges were how to reproduce the light from the lone candle that casts a warm glow over the dolls, and portraying the shadow patterns cast by the flame inside the candle holder.

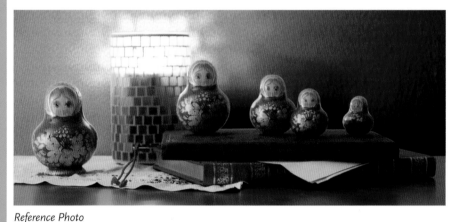

Reference Photo
The only light in the photograph came from the candle inside the mosaic holder. I made some color adjustments using my image-editing program.

USE CONSISTENT PRESSURE

Unless otherwise noted, use pressure 2 with the circular stroke (see pages 18–19). Keep a sharp point. Add more layers to make an area as dark as necessary; don't press harder.

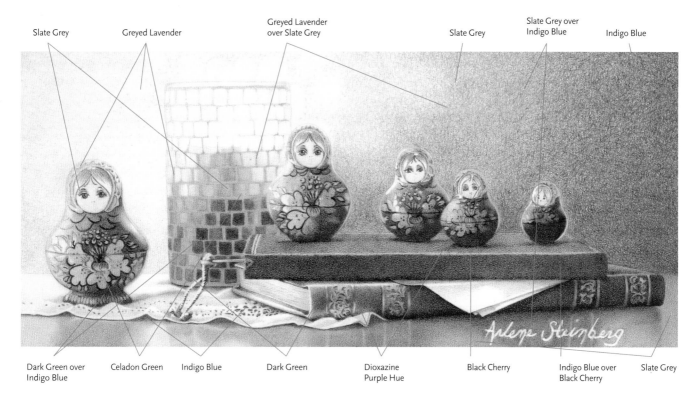

Slate Grey Greyed Lavender Greyed Lavender over Slate Grey Slate Grey Slate Grey over Indigo Blue Indigo Blue

Dark Green over Indigo Blue Celadon Green Indigo Blue Dark Green Dioxazine Purple Hue Black Cherry Indigo Blue over Black Cherry Slate Grey

1 UNDERPAINT TO ESTABLISH VALUES

With a Verithin White pencil or a ball-tipped burnisher, sign your name and impress the smallest white dots on the dolls.

Layer Indigo Blue over the darker areas of the background, using a loose circular stroke to create texture. Blend Slate Grey into the Indigo Blue, continuing to layer loosely across the left side of the background. For yellower areas, layer Dahlia Purple. On the lightest areas, layer Greyed Lavender. Layer Indigo Blue over the darker areas on the table. Blend Slate Grey into the Indigo Blue on lighter areas. For areas with a yellow cast, layer Greyed Lavender. Layer Dark Green in the shadow under the tassel. Define the lace pattern using Indigo Blue in the holes. Use a combination of Indigo Blue and Slate Grey to define the shadows on the tablecloth and on the papers under the book.

Outline the dark lines and define the darkest red shadows on the dolls with Indigo Blue. Layer Dark Green and Celadon Green over the blue and the other red shadows. Use Indigo Blue to define the outlines of the dolls' eyes and brows. Use a combination of Dioxazine Purple Hue and Greyed Lavender on the gold flowers and on the scarf. Use Dioxazine Purple Hue to define the hair. With pressure 1, layer Slate Grey over the face. Use pressure 2 on the eyelids.

Use a combination of Slate Grey and Greyed Lavender to define the lines around the mosaic tiles. For the darkest tiles, layer Indigo Blue and then Dark Green. For the lighter tiles use combinations of Slate Grey, Celadon Green, Greyed Lavender and/or Dark Green.

Layer Dark Green on the red book. Over the Indigo Blue on the table, layer Dark Green on the dark shadows closest to the book. Use Greyed Lavender and the linear stroke to define the book's pages. Don't try to define each page; just add a few lines to give the illusion of pages. With Greyed Lavender, define the gold pattern. On the darkest areas on the pattern, layer Dioxazine Purple Hue.

Layer Black Cherry over the green book. Use pressure 1 along the spine's edge and any lighter areas. Layer Indigo Blue over the darkest shadows under the dolls and on the book's spine.

Suggest the Texture

The background texture doesn't need to be copied exactly. Creating a little texture will give the illusion of a bumpy wall.

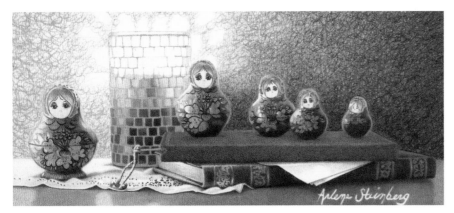

2 LAYER THE FIRST COLORS

Again using a loose circular stroke, layer Black Cherry on the darker areas of the background. Blend Tuscan Red into the darker areas and extend out. Layer Pumpkin Orange over the Tuscan Red and Yellow Ochre over the yellow areas. Layer Black Cherry over the shadows on the table, and Pumpkin Orange over the light yellow areas. On the tablecloth shadows and the paper, wash Black Cherry. Wash Yellow Ochre over the lighter shadows.

Layer Black Cherry on the darker areas of the dolls' bodies. Layer Pumpkin Orange on the shadows on the dolls' heads and on the dark shadows on the flowers. Over the lighter shadows on the heads and on the flowers, layer Yellow Ochre.

Layer Black Cherry over the dark red mosaic tiles on the candle-holder. Layer Pumpkin Orange on the orange tiles and Yellow Ochre over the yellow ones.

Layer Black Cherry on the red book. Over the light areas, layer Yellow Ochre. Layer Pumpkin Orange and Yellow Ochre over the filigree. Using a linear stroke, layer Yellow Ochre on the book's pages. Layer Dark Green on the green book.

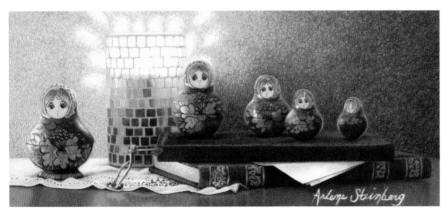

3 CREATE DEPTH WITH COLOR

Layer Pumpkin Orange over the background. Use larger circles on top of the yellow and smaller circles in the orange areas.

Layer Tuscan Red over the entire table. Layer Burnt Ochre over the light areas. Layer Goldenrod over the lighter shadows on the tablecloth.

Lightly sketch in the mouths with Tuscan Red. Layer Tuscan Red on the dolls' bodies. With pressure 1, layer Tuscan Red on the yellow on the sides of the bodies. Layer Tuscan Red on the eyes. Layer Goldenrod on the darker yellow flowers on the dolls' bodies. Layer Seashell Pink on the dolls' faces.

Layer Tuscan Red over the light red mosaic tiles using pressure 1. Switch to pressure 2, and layer Tuscan Red over the other red tiles. Layer Kelp Green and Yellow Ochre on the grout closest to the green book. Using pressure 1, layer Tuscan Red on the grout closest to the doll standing on the book.

Layer Tuscan Red over the red book, but do not cover the filigree on the spine.

Layer Kelp Green over the green book. On its shadows and spine, layer Indigo Blue.

4 ADD MORE COLOR

Use small circles to layer Crimson Lake on the background's red side, fading out toward the lighter area. Blend Cadmium Orange Hue on the background. Over light areas, layer Gamboge and Mineral Orange.

Layer Tuscan Red on the dark table shadows. Cover that with Sienna Brown, except in the lightest areas. For the lightest areas, layer with Burnt Ochre.

On the darkest shadows of the dolls, layer Indigo Blue. On red areas, layer Thio Violet. Using pressure 1, layer circles on the cheeks and define the mouths. Layer Nectar over the face and cheeks. Layer Gamboge on the scarf, hair, flowers and light yellow reflections on the bodies. Layer Pumpkin Orange over the dark areas of the scarf, hair and flowers.

Layer Thio Violet on the dark red mosaic tiles. Layer Crimson Lake on the lighter red tiles. Layer Gamboge on the yellow and orange areas. Layer Cadmium Orange Hue on the orange tiles and the grout lines. Layer Greyed Lavender on the blue tiles and grout.

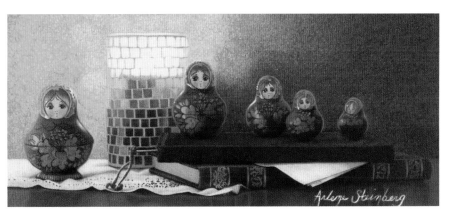

Layer Crimson Lake on the red book. Use Black Grape on its dark shadows. On the book's pages, layer Gamboge. Define the pages with Greyed Lavender.

Layer Prussian Green on the dark areas of the green book. Layer Indigo Blue on the dark shadows and Green Ochre on the light areas.

5 ADD LAYERS AND BURNISH

Unless otherwise stated, use pressure 3 for this step.

Layer Ginger Root over the lighter background areas. Layer Goldenrod on top. Layer Cadmium Orange Hue, Crimson Lake and Goldenrod as needed to brighten the background.

Layer Sienna Brown over the table shadows and the lace holes. Layer Yellow Ochre on the lightest table areas. With a pressure 2, layer Manganese Violet on the paper and tablecloth. Using pressure 2, layer Peach Beige on the white areas. Layer White on all white areas, including the white shadows. Layer Permanent Red on the tassel.

Layer Madder Lake on the light areas of the dolls' bodies and Crimson Lake on the dark areas. Using pressure 1, layer Madder Lake on the dark flowers. Layer Greyed Lavender on the dark hair. Layer Cream on the light areas of the flowers, faces and hair. Layer Black Grape over the flower lines.

With pressure 2, wash Nectar over the dolls' faces. Layer the shadows with Terra Cotta. Next layer the faces with Seashell Pink. Using pressure 1½, wash Mineral Orange. With pressure 1, layer the shadows with Tuscan Red.

Using pressure 1, wash Cream on the white areas of the candleholder. Layer Slate Grey on the blue tiles and grout. Layer Cloud Blue on the blue grout. Layer Peach Beige on top. Layer White on white areas. Layer Permanent Red on the light tiles.

Layer Crimson Lake on the dark areas and the gold areas of the red book. Layer Permanent Red on the light red tiles.

On the highlights of the green book, wash Cream and layer Peacock Green. Layer Black Cherry over the shadows. Layer Indigo Blue over the Black Cherry.

Continue layering until the paper is saturated and no white paper shows through. Burnish all areas of the drawing with the Colorless Blender pencil, working from light to dark. Spray with two light coats of workable fixative.

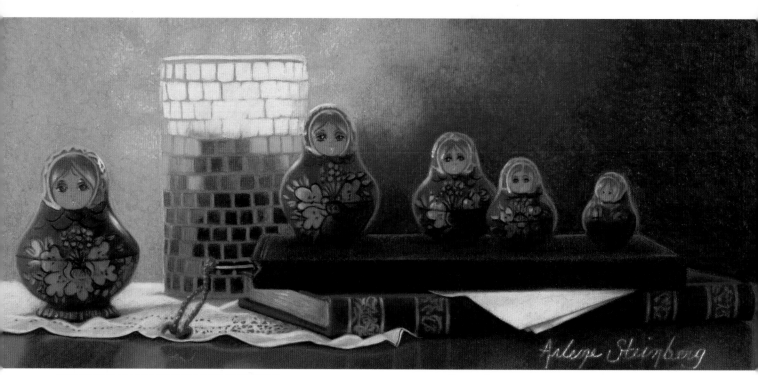

6 REFINE THE HIGHLIGHTS AND SHADOWS

Brighten the yellows on the dolls and the red book's filigree with Canary Yellow. Use Indigo Blue to define the darkest areas under the dolls, on the bottom edges of the books, and on the bottom edge of the tablecloth. Add any needed highlights with White. Spray with two to four light coats of workable fixative and frame.

COMING OUT
Colored pencil on Stonehenge paper · 4 ½" × 10 ½" (11cm × 27cm)
Collection of the artist

Correct the Values

My grout lines were too light. If yours are, darken them by layering them with Pumpkin Orange and then with Slate Grey.

Textures and Fabric

Peaches are my favorite fruit, so I eagerly await the first peaches of the season. As they sat in a basket on my counter, I couldn't resist drawing these delectable harbingers of the coming summer.

Peach fuzz, bumpy walnut shells and the natural fibers that create the basket form their own drawing challenges. However, when they're broken down into values with the underpainting, they become much easier to create. Thanks to Caryn Coville for helping me complete this piece.

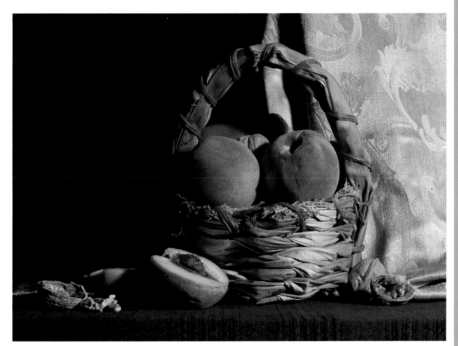

Reference Photo
I cut one of the peaches in half and set up the arrangement on a teal tablecloth. The damask fabric was added to break up the expanse of darkness.

Seeing Values and Color

Punch a hole into a white sheet of paper and put the paper over the section of the photo where you need to determine the color or value. Ann Kullberg uses this method for seeing values and color more clearly. It's an excellent tool that can help you.

USE CONSISTENT PRESSURE

Unless otherwise noted, use pressure 2 with the circular stroke (see pages 18–19). Keep a sharp point. Add more layers to make an area as dark as necessary; don't press harder.

MATERIALS

PRISMACOLOR PENCILS

PC 901 Indigo Blue
PC 908 Dark Green
PC 914 Cream
PC 916 Canary Yellow
PC 935 Black
PC 936 Slate Grey
PC 937 Tuscan Red
PC 938 White
PC 942 Yellow Ochre
PC 943 Burnt Ochre
PC 945 Sienna Brown
PC 996 Black Grape
PC 997 Beige
PC 1017 Clay Rose
PC 1020 Celadon Green
PC 1026 Greyed Lavender
PC 1027 Peacock Blue
PC 1030 Raspberry
PC 1032 Pumpkin Orange
PC 1077 Colorless Blender
PC 1078 Black Cherry
PC 1080 Beige Sienna
PC 1081 Chestnut
PC 1083 Putty Beige
PC 1084 Ginger Root
PC 1085 Peach Beige
PC 1088 Muted Turquoise
PC 1093 Seashell Pink
PC 1095 Black Raspberry
PC 1101 Denim Blue
LF 118 Cadmium Orange Hue
LF 132 Dioxazine Purple Hue
LF 195 Thio Violet
VT 737½ Verithin Aquamarine

OTHER MATERIALS

Stonehenge paper, 7" × 9" (18cm × 23cm)
100 percent cotton makeup pad
Workable fixative

1 DEFINE SHADOWS WITH YOUR UNDERPAINTING

With a blunt Verithin Aquamarine pencil, press and sign your name.

Rarely I use Black, but it's needed here to create a very dark shade. Using a loose linear stroke, layer Black on the shadows in the dark background, then layer Indigo Blue over these shadows and the rest of the background.

Layer Dioxazine Purple Hue over shadows on the curtain. Wash Greyed Lavender over the curtain, including the shadows. Layer Indigo Blue over the darkest shadows. Layer Dioxazine Purple Hue over the Indigo Blue, then over the cloth to the left. Layer Indigo Blue over the darkest areas. The damask pattern won't show because the area is in deep shadow.

Layer the shadows on the table with Black Cherry. Using pressure 3, define the lines in the tablecloth. Blend Tuscan Red into the Black Cherry and then blend Clay Rose into the Tuscan Red. Wash Indigo Blue over the shadows cast by the objects on the table.

For the basket, use a combination of Indigo Blue and Slate Grey. Start by using Slate Grey and pressure 1 to outline around the basket weave. This will help you to see where to define your values. Put in your darkest shadows across the whole basket rather than work it from left to right. For the grass, don't create each strand; block in values with tiny scribbles.

Use Indigo Blue for the darkest shadows on the walnut shells and Slate Grey for the lighter shadows. For the walnut meat, use Dioxazine Purple Hue and Greyed Lavender. Over its darkest shadows, layer Indigo Blue.

Layer Dark Green and Celadon Green on the pit of the peach. For the darkest shadows, layer Indigo Blue on top of the green. Layer Dark Green on the reddish areas of the peaches and blend in Celadon Green for the lighter areas. Over the darkest areas, layer Indigo Blue. On the right peach in the basket, layer Indigo Blue on the orange area. Layer Slate Grey over the orange areas on the left peach.

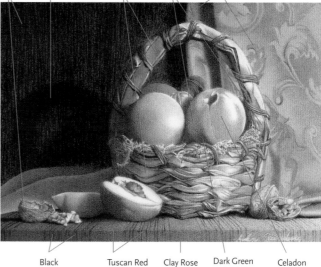

Indigo Blue — Indigo Blue over Black — Indigo Blue over Slate Grey — Slate Grey — Greyed Lavender over Dioxazine Purple Hue — Indigo Blue over Dioxazine Purple Hue

Black Cherry — Tuscan Red — Clay Rose — Dark Green and Celadon Green for the peaches — Celadon Green

2 ADD THE FIRST COLORS

Using a loose linear stroke, layer Black Cherry on the background. Using Dark Green, define the lines on the tablecloth with a very sharp pencil and pressure 3. Layer Dark Green on the dark shadows on the table. Layer more Dark Green on the table, blending into Celadon Green on the lighter side. Layer Yellow Ochre on the shadows on the curtain.

On the orange areas of the basket, layer Pumpkin Orange. Wash Black Raspberry on top of the orange. Layer Black Raspberry on the shadows on the basket. With pressure 1, layer Black Raspberry on the lightest shadows.

Layer Black Raspberry on the shadows on the walnut shells.

Layer Black Cherry on the darkest shadows on all the peaches except the half at the far left. Wash Pumpkin Orange on the shadows on the orange areas. Over the left peach half, layer Yellow Ochre. Leave the top edge without color.

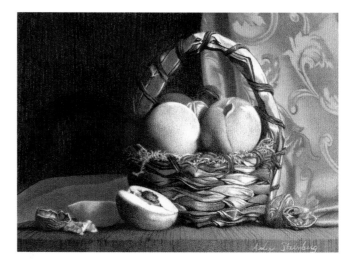

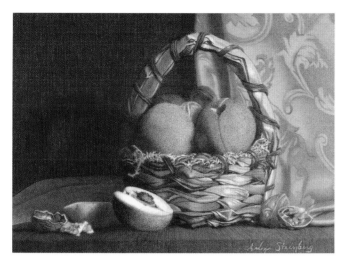

3 ADD LAYERS

Using a loose linear stroke, layer Dark Green on the background. Intersperse streaks of Peacock Blue in the background with a linear stroke. Layer Peacock Blue over the table.

On the lighter areas of the basket, layer Ginger Root. Define the straw on the basket's edge with Ginger Root. Layer Beige Sienna on the light areas on the basket ties.

Layer Beige Sienna on the walnut shells.

Wash Ginger Root over the light areas on the curtain. Blend the Ginger Root into the shadows. On the curtain on the left, layer Black Grape. Layer Black Grape on the dark shadows on the left peach half.

Layer Raspberry on the dark areas of the peaches. With pressure 1, layer Raspberry on the light red and pink areas. Over the orange areas, add another layer of Pumpkin Orange, blending it into the Raspberry.

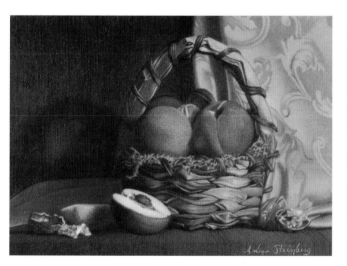

4 ENRICH THE COLOR

Layer Black on the darkest shadows on the wall with a loose linear stroke. Layer Denim Blue on the areas not in shadow on the background. Layer Burnt Ochre on the deepest shadows on the curtain, including the left side. Wash Beige over all areas of the curtain except the darkest shadows. With Denim Blue and pressure 3, define the lines on the tablecloth. Layer Denim Blue over the tablecloth with pressure 2.

Layer Pumpkin Orange over the walnut shells. Layer Canary Yellow on the walnut meat.

Layer Pumpkin Orange on the orange areas of the basket. Layer Chestnut over the orange and on the shadows on the basket. Wash Seashell Pink over all areas of the basket except the lightest areas.

Layer Canary Yellow on the orange areas of the peaches, and on the yellow areas of the left peach half. Layer White over the whiter areas of the peach, including the shadows, to show the peach fuzz. With pressure 1, wash Thio Violet over the peaches, including the orange areas. Over the shadows, layer Black Grape.

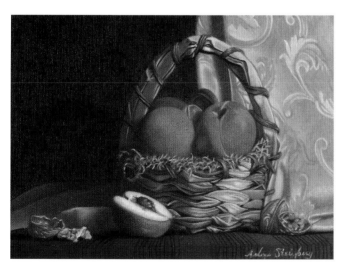

5 SATURATE AND ADD HIGHLIGHTS

Unless otherwise stated, use pressure 3 for this step.

Layer Muted Turquoise on the light side of the tablecloth and Peacock Blue on the darker side. Layer Black Grape over the shadows on the table.

Layer Cream over the light areas of the curtain and on the nut's meat.

Layer Black Cherry on the curtain on the left and on the left peach half.

Layer Cadmium Orange Hue on the orange areas of the peaches, and on the walnut meat. Layer Cadmium Orange Hue around the rim of the peach half and on the yellow areas on the left peach half.

Layer Chestnut on the walnut shell's shadows and Ginger Root on the lighter areas. Layer Putty Beige on the lighter areas of the basket, and Chestnut on the shadows.

Using pressure 2, layer Black Cherry on the shadows on the peaches. Layer Raspberry and Pumpkin Orange on the lighter areas.

Returning to pressure 3, deepen the shadows on the walnut shells and the basket with Black Cherry.

Add White highlights to the walnut shells and meat, the basket, the peach pit, the curtain and the grass. Using pressure 1, layer fuzz on the peaches.

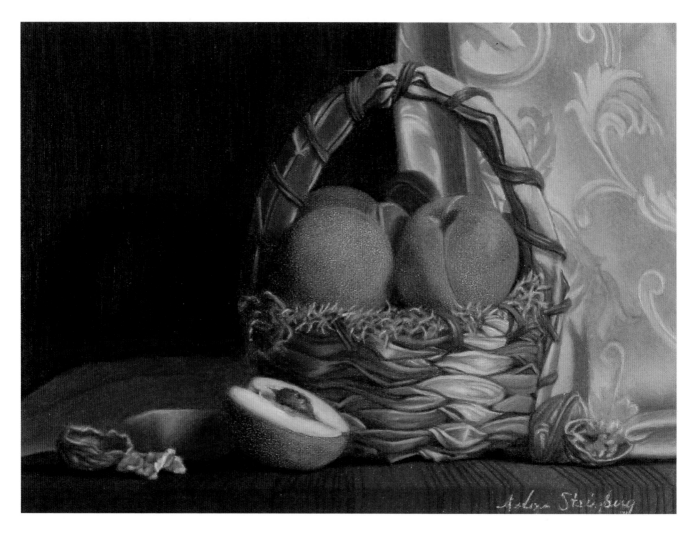

6 BURNISH

With the Colorless Blender pencil, burnish everything except the peaches and the grass. Use a linear stroke for the blue background and for the basket, following the direction of the lines. Use a circular stroke for everything else. Continue layering until the paper is saturated and no white paper shows through.

Layer Yellow Ochre over the left curtain and the left peach half. Layer Black Grape with Sienna Brown on top on the areas of darkest shadow on the basket and on the walnut shells. Layer Sienna Brown on the lighter shadows. Layer Peach Beige over any areas of the curtain that became too purple. Follow up with a wash of Burnt Ochre if needed. Layer Indigo Blue over the shadows on the table again.

Buff with a cotton pad and spray with two light coats of workable fixative. Add touches of White highlights to the walnuts, the peach half, the pit and the lightest areas of the basket. Add Indigo Blue to the right side of the peach in the basket and the area between the two peaches on the bottom. Spray with two to four more light coats of workable fixative and frame.

THE RIPENING OF SUMMER
Colored pencil on Stonehenge paper
5" × 7" (13cm × 18cm)
Partially drawn by Caryn Coville
Collection of the artist

Using Complements for More Color

This drawing consists mostly of greens with some yellow areas, so you'll be working with dark reds and purples for the complementary underpainting. Additionally, there is a mix of textures that give the drawing interest and variety.

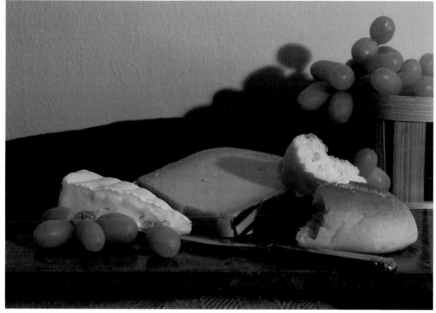

Reference Photo
One of my favorite light meals is good cheese, tasty bread and fruit. All that's missing is a salad and a good glass of vino to go with the cheese. This photo is further explained on pages 14–15.

USE CONSISTENT PRESSURE

Unless otherwise noted, use pressure 2 with the circular stroke (see pages 18–19). Keep a sharp point. Add more layers to make an area as dark as necessary; don't press harder.

DEMONSTRATION

MATERIALS

PRISMACOLOR PENCILS
PC 901 Indigo Blue
PC 907 Peacock Green
PC 908 Dark Green
PC 910 True Green
PC 914 Cream
PC 935 Black
PC 936 Slate Grey
PC 937 Tuscan Red
PC 938 White
PC 942 Yellow Ochre
PC 943 Burnt Ochre
PC 945 Sienna Brown
PC 996 Black Grape
PC 1005 Limepeel
PC 1017 Clay Rose
PC 1020 Celadon Green
PC 1021 Jade Green
PC 1023 Cloud Blue
PC 1026 Greyed Lavender
PC 1030 Raspberry
PC 1032 Pumpkin Orange
PC 1034 Goldenrod
PC 1077 Colorless Blender
PC 1078 Black Cherry
PC 1080 Beige Sienna
PC 1081 Chestnut
PC 1085 Peach Beige
PC 1087 Powder Blue
PC 1089 Pale Sage
PC 1091 Green Ochre
PC 1093 Seashell Pink
PC 1094 Sandbar Brown
PC 1095 Black Raspberry
PC 1096 Kelly Green
PC 1103 Caribbean Sea
LF 118 Cadmium Orange Hue
LF 132 Dioxazine Purple Hue
LF 195 Thio Violet
LF 203 Gamboge
LF 209 Manganese Violet
VT 734 Verithin White

OTHER MATERIALS
Stonehenge paper, 4 ½" × 6 ½" (11cm × 17cm)
100 percent cotton makeup pad
Workable fixative
Ball-tipped burnisher (optional)

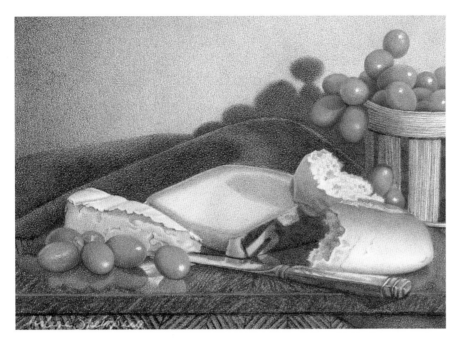

1 ESTABLISH THE UNDERPAINTING

With a Verithin White pencil or a ball-tipped burnisher, sign your name and impress the smallest white dots on the grapes.

Layer Black Raspberry on the grape shadows on the wall and on the grapes peeking through the slats in the basket. Layer Chestnut, then Black Raspberry on the dark side of the wall. Blend Clay Rose into the Black Raspberry and over the middle area of the background. Then blend Peach Beige into the Clay Rose and feather out toward the right side of the paper. Define the pattern in the tablecloth with Indigo Blue, then layer it over the whole tablecloth.

Layer Black Grape over the grapes between the slats in the basket and Black Cherry inside between the grapes. With a linear stroke, layer Indigo Blue and Slate Grey on the basket.

Layer Black Grape on the napkin behind the cheese. Layer Black Cherry on the cheese board. Roughly create a marblelike texture. Layer Tuscan Red on the grape reflections on the cheese board. Layer Dioxazine Purple Hue on the yellow reflections.

Define the top of the brie with Slate Grey. Layer Dioxazine Purple Hue on the cheese to define the shadows. On top of the cheese, layer Greyed Lavender.

For the large cheese, layer Dioxazine Purple Hue, then layer Greyed Lavender on top. Layer Indigo Blue on the rind, with Black Grape on top. Layer Dark Green on the red-tinged part of the rind. Layer Dioxazine Purple Hue and Greyed Lavender on the letter *n*.

Layer Dioxazine Purple Hue and Greyed Lavender on the knife blade to create the reflections. Layer Black Cherry and then Black Grape on the dark shadows on the knife. Layer Black Grape on the other shadows and Slate Grey on the lightest areas.

Use Slate Grey to define the deeper bread crust shadows. Layer Dioxazine Purple Hue and Greyed Lavender over the Slate Grey and on the rest of the crust. Using small circles, layer Dioxazine Purple Hue on the darker areas of the bread. Over that, layer Greyed Lavender.

To create the grapes, lay a foundation of Beige Sienna, leaving the highlights white. Layer Black Cherry on the darkest edges of the shadows, then Tuscan Red on all the grapes' shadows. Layer Clay Rose on all but the lightest areas. On top, layer Beige Sienna.

No Color Is "Wrong"

Without looking carefully, I picked up and started using my Black pencil on the napkin instead of Indigo Blue. As it turned out, it added just the right amount of punch.

2 ADD THE FIRST LOCAL COLORS

Layer Dark Green on the left side of the wall. Blend Celadon Green into the Dark Green and over the middle area of the background. Layer Jade Green into the Celadon Green and over the rest of the wall.

Layer Dark Green on the napkin and the large cheese's rind. Add Celadon Green to the highlighted areas on the napkin and rind. Layer Dark Green on the spaces between the grapes inside the basket slats.

Layer Indigo Blue over the cheese board. Define the dark gray knife areas with Indigo Blue.

Layer Pumpkin Orange on the tablecloth, on the yellow outer rind and front of the cheese, on the reflections on the knife, on the top of the bread crust and on the grape stems.

Layer Sienna Brown over the dark basket shadows. Layer Yellow Ochre over the yellow cheese, including the Pumpkin Orange. Layer Yellow Ochre on the letter *n* and the dark shadows on the brie. Blend Yellow Ochre into the orange on the bread crust and wash Yellow Ochre over the rest of the crust, using pressure 1. With a loose circular stroke, wash Yellow Ochre on the bread. Layer Yellow Ochre over all areas defined with purples.

Layer Black Cherry on the red area of the large cheese rind and Dark Green on top. Layer Dark Green on the dark shadows on the grapes.

3 ADD MORE COLOR

Layer Caribbean Sea on the dark side of the background and the grape shadows on the wall. Blend Powder Blue into the Caribbean Sea and over the rest of the background. Layer Black on the shadows on the napkin and on the darker part of the large cheese rind. Layer Black between the grapes inside the slats. Layer Peacock Green on the dark areas on the cheese board. Layer Tuscan Red on the shadows on the basket and then with a very sharp pencil, define the lines of the basket. Layer Pumpkin Orange on the lighter areas on the basket and on the basket reflection on the cheese board.

Layer Raspberry on the red area of the cheese rind. Using pressure 1, wash Raspberry on the bread crusts, the large cheese rind, the knife and the stems. Layer Raspberry on the shadows on the large cheese.

Layer Goldenrod on the large cheese, the yellow area on the letter *n* and the bread crust. Layer Goldenrod on top of the lavender areas inside the bread. Layer Goldenrod over the edges of the brie closest to the rind. Layer Raspberry on top of the large cheese.

With pressure 1, wash Peach Beige over the shadows on the brie rind. Layer Peach Beige on the bread. Layer Greyed Lavender on the shadows on the bread crust. Layer Green Ochre on the brownish red shadows on the grapes and on the grape reflections on the cheese board.

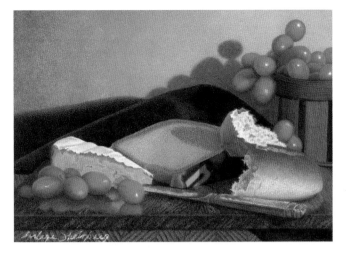

4 CREATE REALISTIC COLOR

Layer Indigo Blue on the napkin and on the grapes between the basket slats. Layer Limepeel over all areas of the grapes except the highlights. Layer Limepeel on the grape reflections on the cheese board.

Wash Thio Violet on the bread crust and on the large cheese rind. Layer Thio Violet on the shadows on the large cheese, the red area on the rind and the dark shadow on the letter *n*.

Layer Cadmium Orange Hue over the Thio Violet on the bread crust. Layer Cadmium Orange Hue on the large cheese and rind, the dark areas inside the bread and on the tablecloth. With pressure 1, layer Cadmium Orange Hue on the light areas of the knife.

Layer Gamboge on the lighter areas of the bread crust, the shadows inside the bread, the letter *n* and on the brie. Layer Burnt Ochre on the basket and on the reflections on the cheese board.

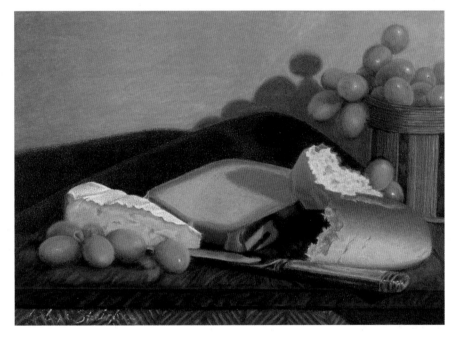

Layer Pumpkin Orange on the vertical lines on the tablecloth using pressure 3. Layer Pumpkin Orange on the tablecloth. Layer Peach Beige on the light areas. Layer Slate Grey and then layer Pumpkin Orange on top again. Layer Sandbar Brown on the diagonal lines and then layer Manganese Violet over the light areas.

Layer Manganese Violet on the light bread shadows and on the large cheese. Wash Peach Beige and then Cloud Blue on top. Layer Goldenrod on the dark areas on the bread, followed by Cadmium Orange Hue. Blend Cloud Blue into the areas on the bread crust that are too bright.

Layer Manganese Violet on the light areas of the knife. Over that, layer Caribbean Sea. Layer Goldenrod on the yellow reflections. Layer Black Grape on the dark shadows on the knife. On top of the Black Grape, layer Indigo Blue.

Layer Manganese Violet on top of the brie rind. Layer Seashell Pink on the dark areas of the brie and layer Cream on top of all areas of the cheese except the rind.

Layer Seashell Pink on the large cheese. Layer Goldenrod around the edges near the rind and on the dark shadows. Layer Cadmium Orange Hue on top. Wash Black Grape on the dark rind. Layer Goldenrod on the letter *n*.

Layer True Green on the areas of the grapes that are less yellow. Blend Pale Sage on the lightest areas, and wash more True Green on these areas if necessary. Deepen your shadows with Green Ochre. Add Limepeel on top if necessary. Layer Peacock Green along the edges and on the darkest areas of the grapes.

5 SATURATE THE COLORS

Unless otherwise noted, use pressure 3 for this step. Layer Celadon Green on the darker side of the background. On the light side, layer Pale Sage and then Jade Green on top. Blend the Jade Green into the Celadon Green. Wash Cloud Blue over the whole background. Layer Kelly Green on the grape shadows on the wall. Layer Dark Green on the napkin highlights.

Layer Slate Grey on the light areas of the cheese board, including the grape and basket reflections. Layer Peacock Green on the dark areas. Add touches of Slate Grey, Indigo Blue and Pumpkin Orange to the board. Layer Pumpkin Orange on the basket reflections and on the bread reflections. Layer Peach Beige on the light side of the basket, following the lines. Layer Goldenrod on the bread reflections. Add touches of Black Grape to the cheese board.

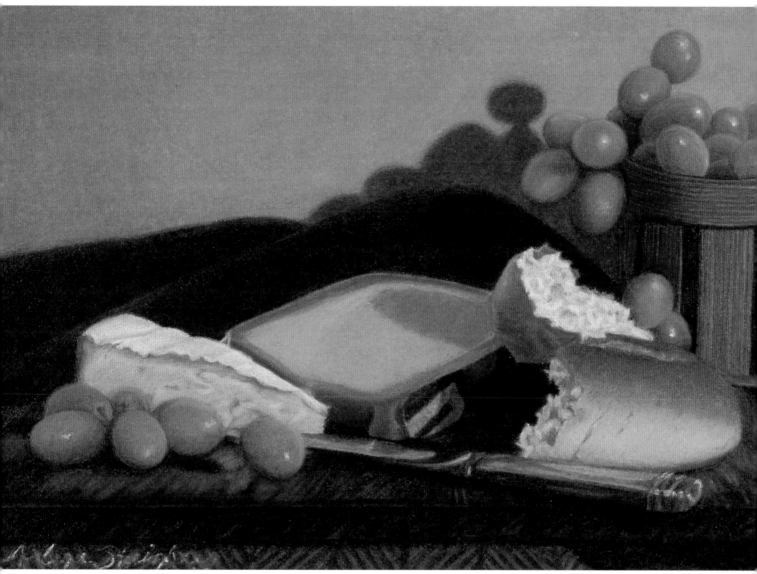

6 ADD HIGHLIGHTS AND BURNISH

Layer Cream and then White on the brie rind and inside the bread. Layer touches of White in the cheese. Add White highlights to the knife and grapes. Continue layering until the paper is saturated and no white paper shows through.

Burnish all areas except inside of the bread dough and the basket with the colorless blender pencil. Spray with two light coats of workable fixative. Redefine the highlights with touches of White. Layer touches of Pumpkin Orange on the cheese board. Spray with two to four more light coats of workable fixative and frame.

BREAKING BREAD
Colored pencil on Stonehenge paper · 4½" × 6½" (11cm × 17cm)
Collection of the artist

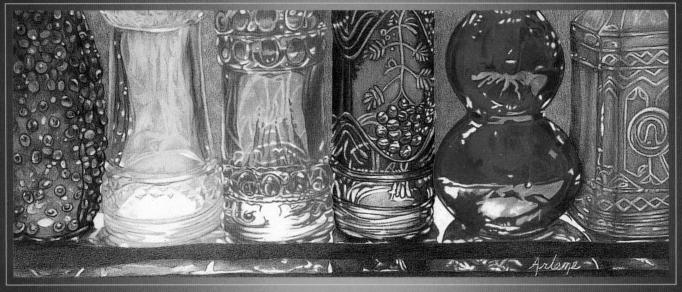

BOTTLED REFLECTIONS
Colored pencil on stonehenge paper · 6" × 15" (15cm × 38cm)
Collection of Mr. and Mrs. John Pizzarelli

REFLECTIONS

WITH REFLECTIONS AND GLASS OUR TENDENCY IS TO DRAW WHAT WE THINK IS THERE. WE KNOW that we're drawing a glass, so we show the outline, and sometimes even shade the glass trying to get it to look just like we imagine it should look. It is so much more effective to skip the outline, and instead draw what we actually do see. Through glass, we see objects distorted, shadows and maybe reflected light. When we draw what we see, instead of trying to draw what we think is there, our brain will fill in the missing details and let us know it's glass.

CHAPTER 7

Objects Through Glass

PRISMACOLOR PENCILS

PC 901 Indigo Blue
PC 908 Dark Green
PC 910 True Green
PC 911 Olive Green
PC 916 Canary Yellow
PC 923 Scarlet Lake
PC 924 Crimson Red
PC 925 Crimson Lake
PC 933 Violet Blue
PC 936 Slate Grey
PC 937 Tuscan Red
PC 938 White
PC 942 Yellow Ochre
PC 993 Hot Pink
PC 996 Black Grape
PC 1005 Limepeel
PC 1012 Jasmine
PC 1017 Clay Rose
PC 1020 Celadon Green
PC 1026 Greyed Lavender
PC 1030 Raspberry
PC 1077 Colorless Blender
PC 1078 Black Cherry
PC 1087 Powder Blue
PC 1089 Pale Sage
PC 1090 Kelp Green
PC 1091 Green Ochre
PC 1095 Black Raspberry
PC 1096 Kelly Green
PC 1101 Denim Blue
LF 132 Dioxazine Purple Hue
LF 133 Cobalt Blue Hue
LF 203 Gamboge
VT 734 Verithin White

OTHER MATERIALS

Stonehenge paper
100 percent cotton makeup pad
Workable fixative
Ball-tipped burnisher (optional)

USE CONSISTENT PRESSURE

Unless otherwise noted, use pressure 2 with the circular stroke (see pages 18–19). Keep a sharp point. Add more layers to make an area as dark as necessary; don't press harder.

The perception that glass is difficult to draw is common but it's not difficult once you stop trying to draw what you think glass should look like. Objects viewed inside glass appear distorted. Many times these objects become abstract shapes. This lesson is part of the final drawing demonstration beginning on page 122.

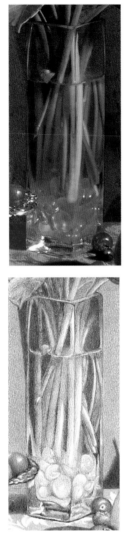

Reference Photo
The distortion in this vase isn't too great, making it a good project to learn to create the illusion of glass. Notice how I didn't copy the stems exactly.

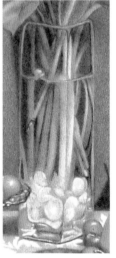

1 CREATE YOUR UNDERPAINTING
Use pressure 2 unless otherwise noted. With a Verithin White or ball-tipped burnisher, impress white highlights into the vase.

Layer Clay Rose on the background. Layer Black Raspberry inside the vase. Layer Dark Green on the table and inside the vase. Define the vase shadows with Dioxazine Purple Hue, Dark Green and Celadon Green. Shade the stems and leaves with Black Cherry, Black Grape and Tuscan Red. Shade the glass beads in the bottom of the vase with Celadon Green, Greyed Lavender and Dioxazine Purple Hue.

2 START TO ADD COLOR
Layer Indigo Blue over the background and inside the vase. Layer Tuscan Red on the table. Layer Dark Green and Celadon Green on the stems and leaves. Layer the beads with Yellow Ochre.

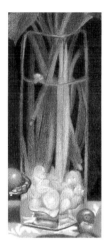 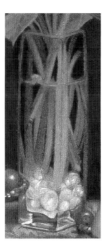 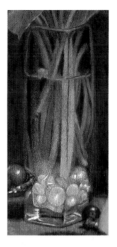

3 BUILD UP COLOR
Color the curtain with Black Grape. Layer Olive Green on the leaves. On the background and inside the vase, layer Violet Blue with pressure 3. Shade the light areas of the vase with Slate Grey. On the leaves' darkest shadows, layer Black Grape. On shadows with a blue cast, layer Violet Blue. Layer Olive Green over areas with an olive cast. Using pressure 1, wash Yellow Ochre over the front stem in the vase.

4 DEVELOP THE VASE
On the background, layer Cobalt Blue Hue. Layer Denim Blue inside the vase. Use pressure 3–4 to cover over the blues with Indigo Blue. Layer Raspberry on the table. With Jasmine, add yellow veins on the leaves and highlights. Color the front stem in the vase with Green Ochre. Layer Canary Yellow on the yellow areas of the stems and leaves. Use Kelly Green on the stems and leaves that have a more vibrant green look. Add Crimson Lake on the bottom of the vase and, with pressure 1, on the beads in the vase. Add touches of Canary Yellow to the beads.

5 MORE LAYERS
Layer Indigo Blue on the background and inside the vase. Cover the table with Crimson Red using pressure 3–4. Layer Black Grape on the shadows on the leaves. Layer True Green over leaves and stems with a blue-green cast. Layer the beads with Black Grape and Indigo Blue, using pressure 1–2. Define the bottom of the vase with Crimson Red, Raspberry and Indigo Blue.

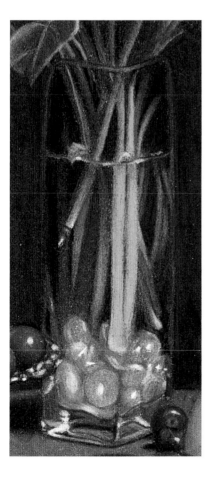

6 DEFINE AND HIGHLIGHT
Define the stems with Gamboge, Limepeel, Indigo Blue, Pale Sage, Dark Green, Kelp Green, True Green and Olive Green. Start with pressure 3 and increase to 4. On the beads and gray areas on the vase, layer Gamboge and Greyed Lavender. Layer the beads with Hot Pink and Raspberry. On top, layer a combination of Pale Sage, Limepeel and Black Grape so that the Gamboge, Hot Pink and Raspberry show through. Layer Powder Blue over the beads. Touch up all highlights with White. Layer Scarlet Lake on the table and grape using pressure 3–4. Continue to layer color until saturated and no paper shows through. Burnish everything with the Colorless Blender pencil, starting with the lightest areas. Lightly wipe the drawing with a cotton makeup pad, making sure to keep using a clean section of the pad. Spray with two light coats of workable fixative. Spray two to four more light coats of workable fixative.

Colorful Reflections

MATERIALS

PRISMACOLOR PENCILS

PC 901 Indigo Blue
PC 908 Dark Green
PC 909 Grass Green
PC 916 Canary Yellow
PC 923 Scarlet Lake
PC 925 Crimson Lake
PC 927 Light Peach
PC 933 Violet Blue
PC 936 Slate Grey
PC 937 Tuscan Red
PC 938 White
PC 942 Yellow Ochre
PC 944 Terra Cotta
PC 992 Light Aqua
PC 996 Black Grape
PC 1009 Dahlia Purple
PC 1012 Jasmine
PC 1017 Clay Rose
PC 1020 Celadon Green
PC 1026 Greyed Lavender
PC 1030 Raspberry
PC 1032 Pumpkin Orange
PC 1077 Colorless Blender
PC 1078 Black Cherry
PC 1086 Sky Blue Light
PC 1088 Muted Turquoise
PC 1096 Kelly Green
PC 1098 Artichoke
PC 1100 China Blue
PC 1101 Denim Blue
LF 103 Cerulean Blue
LF 110 Titanate Green Hue
LF 122 Permanent Red
LF 132 Dioxazine Purple Hue
LF 189 Cinnabar Yellow
LF 203 Gamboge
LF 224 Pale Blue
VT 734 Verithin White

OTHER MATERIALS

Stonehenge paper, 7" × 9" (18cm × 23cm)
100 percent cotton makeup pad
Workable fixative

Marbles, with their varied colors and the reflections they create as the light shines through them, are lots of fun to draw. The hardest part is not capturing the colors or drawing the reflections, but making sure the marbles stay round.

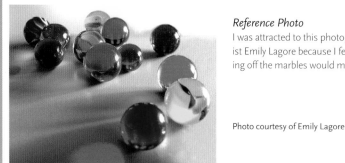

Reference Photo
I was attracted to this photograph from watercolorist Emily Lagore because I felt all the colors reflecting off the marbles would make a fun challenge.

Photo courtesy of Emily Lagore

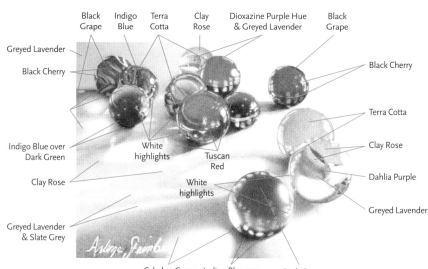

1 **ESTABLISH THE VALUES**
With a Verithin White pencil or a ball-tipped burnisher, sign your name and impress the smallest white dots in the marbles.

Use Dark Green and Celadon Green to establish values on the two red marbles. Leave any unshaded areas blank. Layer both greens on the darkest red reflections on the table.

On the darkest shadows on the two red marbles, layer Indigo Blue on top of the Dark Green. Layer Indigo Blue on the orange

USE CONSISTENT PRESSURE

Unless otherwise noted, use pressure 2 with the circular stroke (see pages 18–19). Keep a sharp point. Add more layers to make an area as dark as necessary; don't press harder.

shadows in the yellow marbles, and on the orange and blue marble.

On the yellow shaded areas of the back yellow marble, layer Dioxazine Purple Hue and Greyed Lavender. On the front yellow marble's shadows, layer Dahlia Purple and Greyed Lavender.

Layer Clay Rose on the light green shadows on the yellow marbles.

Layer Black Grape over the darkest areas of the blue and green marbles. Layer Black Cherry over the lighter areas of dark blue. Layer Terra Cotta over the shadows on the turquoise marbles. Use a combination of Black Cherry and Tuscan Red on the green marbles. On the reflections from the green marbles, use a combination of Black Cherry, Tuscan Red and Clay Rose.

On the darker gray reflections the table, layer Slate Grey. For the lighter areas, layer Greyed Lavender.

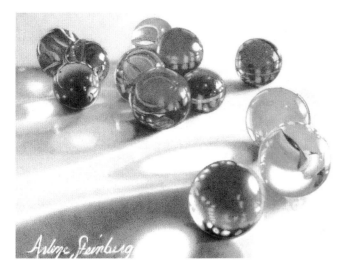

2 ADD COLOR

Wash Indigo Blue over the blue marbles. Layer Indigo Blue on the blue and darker turquoise reflections on the table. Layer Dark Green over the two green marbles and lightly layer Dark Green over the turquoise and green areas of the marble to the left of the green marbles. Layer Dark Green on the reflections on the table. Lightly wash Indigo Blue over the light turquoise marble and then over that layer Celadon Green.

Layer Celadon Green over the green areas on the yellow marbles. Layer Yellow Ochre over the shadows on the yellow marbles and yellow highlights on the other marbles.

Layer Black Cherry over the shadows on the red marbles, the darkest orange areas on the marbles and on the red reflections on the table. On the shaded orange areas, including those you covered with Black Cherry, layer Pumpkin Orange.

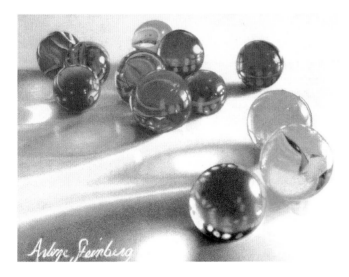

3 ADD MORE COLORS

Wash over the two red marbles and the dark reflections on the table with Tuscan Red. Leave blank any areas that are bright red. Wash over the dark orange areas of the front yellow marble with Tuscan Red.

Layer over the two light turquoise marbles and the turquoise areas on the orange and turquoise marble with Muted Turquoise. Also use it to wash over the turquoise reflections the table.

Wash Kelly Green over the two green marbles, the table, and the green areas of the turquoise and blue marble behind the large green marble. Using pressure 1, wash Kelly Green over the light green areas on the yellow marbles.

Over the dark yellow areas, layer Artichoke. Layer Jasmine over all the yellow areas on the marbles and table, including areas covered with Artichoke.

Layer Denim Blue on any blue areas in the marbles and on the blue table reflections.

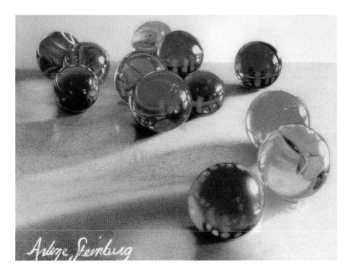

4 STRENGTHEN THE COLORS

Redefine your highlights and lightest areas with White. Using pressure 1, wash over the background shadows with Slate Grey.

Layer Tuscan Red and then Indigo Blue over the darkest shadows on the two green marbles. Layer Tuscan Red and Dark Green over the darkest shadows on the two blue marbles behind the green ones.

Wash Raspberry over the red area in the left rear blue marble, the red reflections on the table, on the two red marbles, and on the table reflections above the rear red marble.

Layer China Blue over all the blue marbles and the blue shadows on the table. Define any blue reflected onto other marbles with China Blue. Wash China Blue over the turquoise marbles and then layer Light Aqua over the them.

Layer Titanate Green Hue over the green marbles, the green reflections on the other marbles and on the table. Wash Titanate Green Hue over the green areas of the yellow marbles.

Layer Gamboge over the yellow areas of the marbles and lightly over the yellow-green areas of the yellow marbles.

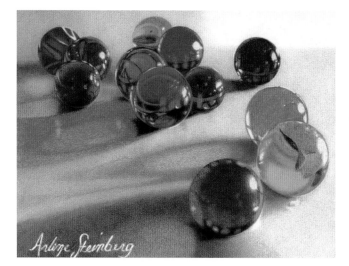

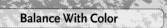

Balance With Color

Add subtle touches of a color that is prevalent in one area to another area to tie the drawing together.

5 BRIGHTEN THE COLORS

With Crimson Lake, using pressure 2, layer over all red areas of the marbles, including the shadows. With pressure 2, layer over all the red shadows on the marbles. Over the lightest areas of the red marbles, add a bit of zing by washing them with Canary Yellow. Layer touches of Canary Yellow on the other marbles, and on the table to brighten the drawing.

Layer Dioxazine Purple Hue over the darkest areas of the red, green and blue marbles to deepen the value even more. Wash Dioxazine Purple Hue on the shadow under the front yellow marble.

Layer Cerulean Blue over the left and top center blue marbles. On top of the dark shadow areas, layer Violet Blue over the Cerulean Blue. Layer the Cerulean Blue over the deeper turquoise reflections on the table. Add touches of the Cerulean Blue to the other marbles. Layer Violet Blue over the dark areas of the blue marble on the right. Layer Cerulean Blue on the lighter areas.

Layer Dark Green over the darkest green shadows again, and then layer Titanate Green Hue over all but the darkest areas of the green marbles. Do the same for the multicolored marble to the left of the two green ones and for the green reflections on the table.

Wash Greyed Lavender over the table and on the shadows on the wall. On the left side of the table between the red and yellow reflections, layer Greyed Lavender.

6 ACHIEVE FULL SATURATION

Increase to pressure 3 and layer Pale Blue over all light blue and green areas. Layer Pale Blue over the lighter turquoise areas, and on the edge of the reflection from the front red marble. Decrease to pressure 2 and layer the Pale Blue over the green areas on the yellow marbles and the shadowed yellow areas.

Layer Violet Blue on the dark areas of the blue marbles and on the dark blue reflections on the table. Layer Cerulean Blue on the lighter blue areas on the three blue marbles.

Layer Titanate Green Hue, then Cerulean Blue and finally Pale Blue on the light turquoise marble. Layer Muted Turquoise over the turquoise areas on the table. Over that, layer Cinnabar Yellow on the center part of the turquoise reflection. Layer Cinnabar Yellow over the outer green reflection circle. Layer Cerulean Blue over all the turquoise reflections on the table.

Layer Yellow Ochre over the yellow-green areas of the green reflections. Layer Grass Green over the green reflections on the table. Increase to pressure 3 and layer Grass Green over all the darker green areas.

Using pressure 3, layer Scarlet Lake on the two red marbles. Decrease to a pressure 2 and layer over the red reflections on the table. Layer Violet Blue over the darkest areas of the red marbles and then layer more Scarlet Lake over that. Layer Permanent Red on the lightest areas of the red marbles and the table.

Layer Pale Blue around the edges of the red reflections to further blend them into the background. Cover the lighter areas of the turquoise reflections with Pale Blue. Layer Cinnabar Yellow over the inside of the reflection and its outer edge. Layer Cerulean Blue on top of that.

I layered over the blue-gray reflections of the turquoise marble with blues instead of gray as it appeared in the photo because I felt the front

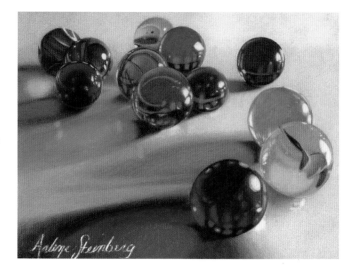

marbles were too disconnected from the rear ones. Moreover, the drawing needed more of a color punch there.

Layer Light Peach over the whole background, except the reflections. Over the Light Peach, layer Sky Blue Light. Use pressure 2 for the darker areas of the background, and fade out by decreasing to pressure 1 in the lighter areas.

Layer Crimson Lake and Permanent Red on the reflection of the front red marble. On the edges, add Cerulean Blue and then Pale Blue. On the outer edges, layer Sky Blue Light. Add a layer of Canary Yellow to the center and apply more Permanent Red on top. Layer Cinnabar Yellow on the outer edges of the reflection, and then repeat with Pale Blue and Sky Blue Light.

Continue to layer color until the paper is saturated and no paper shows through.

7 BURNISH AND REFINE

Using pressure 3, layer White over all the background areas. Repeat. With the Colorless Blender pencil, using pressure 3–4, burnish the background, the reflections and the marbles. Using a cotton makeup pad and a circular motion, very lightly buff the background, the reflections and the marbles.

Spray with two light coats of workable fixative. Let it dry thoroughly.

Deepen any shadows that need strengthening. Add White to brighten the marble edges and the highlights. Use Canary Yellow to add touches of brightness on the marbles. Spray with two to four additional coats of workable fixative, waiting for the previous coat to dry before applying another and frame.

I THOUGHT I LOST THEM
Colored pencil on Stonehenge paper · 5" × 7" (13cm × 18cm)
Collection of Mr. and Mrs. Tom McHugh

USE CONSISTENT PRESSURE

Unless otherwise noted, use pressure 2 with the circular stroke (see pages 18–19). Keep a sharp point. Add more layers to make an area as dark as necessary; don't press harder.

Depicting cut crystal isn't difficult; it just takes patience and concentration. Notice how the color of the champagne is reflected in the stem of the glass, and that it has a redder cast nearer the strawberry. It's important to be aware of the range of values in the glass. Strong darks and highlights will give your cut crystal depth and dimension.

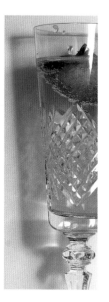

Reference Photo
I just loved the way the bubbles were clinging to the fruit and how many colors were actually in the photo.

1 DEFINE THE GLASS

Use a combination of Dioxazine Purple Hue, Dahlia Purple, Greyed Lavender and Slate Grey to define the glass and the champagne. As you move toward the stem, use more Slate Grey and less purple and lavender. On the stem use a combination of Indigo Blue, Dioxazine Purple Hue and Slate Grey. Over the Slate Grey, lightly wash Greyed Lavender. Do the same for the top of the glass. Omit all but one water drop. Add a highlight within the dark area of the drop with White.

Create the reflection on the wall by combining Slate Grey for the darker gray areas, Muted Turquoise for the lighter gray areas and Greyed Lavender for the yellow areas. Layer over the Slate Grey and Muted Turquoise with Greyed Lavender.

Shade the green stem of the strawberry with Black Cherry. On the bottom of each bubble on the strawberry, make a half moon using Yellow Ochre. Shade the strawberry with Dark Green. On the darkest areas, layer Indigo Blue.

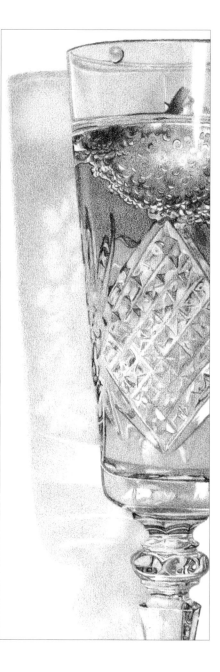

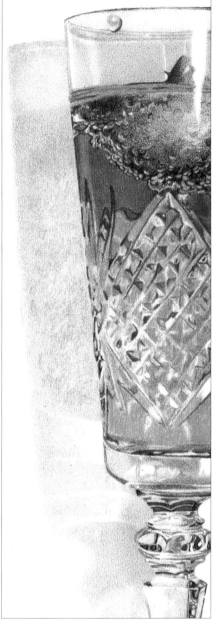

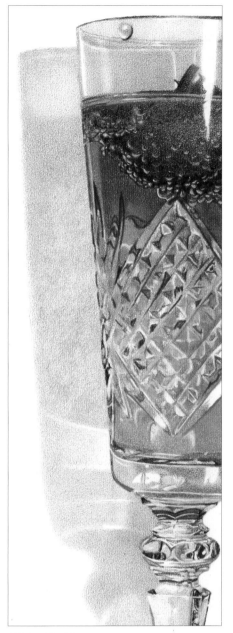

2 ADD COLOR

Layer more Slate Grey over the reflection and the glass. On the strawberry, layer Black Cherry. Add Black Cherry to the darker lines on the glass near the strawberry. Layer Yellow Ochre on the glass and on the champagne within. Layer Pumpkin Orange over the redder areas of the champagne, the darker areas on the glass and on the lightest areas of the strawberry. Layer Dark Green on the strawberry's leaf.

3 ADD MORE COLOR

Wash Seashell Pink over the gray areas on the glass and the reflection on the wall. Layer Tuscan Red on the strawberry and the champagne near the strawberry. Outline the reddish lines in the glass with Tuscan Red. Wash Canary Yellow over the champagne and the bubbles clinging to the fruit. Redefine the crystal areas with Yellow Ochre. Redefine the highlights with White. Be sure your pencil is very sharp when you do this. Wash Indigo Blue over the shadows on the wall.

Focusing on Details

Take a small white sheet of paper or cardboard and in it, cut a 1" × 1" (3cm × 3cm) square hole. Place the hole over the area of your photograph where you're working and draw only what you see within the square. This is a great way to see details like cut crystal or bubbles as you're not distracted by the whole picture.

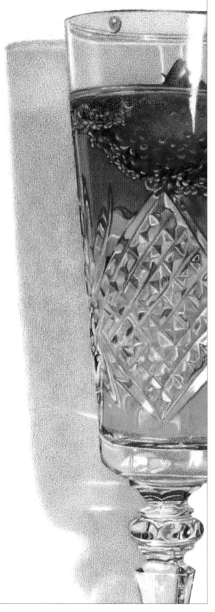

4 CREATE LUSH COLOR

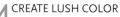
First, layer Goldenrod over the mid-range values of the champagne. Wash Goldenrod on the walls' gold reflections. Redefine any whites you might have lost with White. Lighten the lightest yellows with White. Layer Crimson Red on the strawberry. With pressure 1, add Crimson Red to the red areas on the champagne. Layer Seashell Pink on the champagne near the bottom of the glass, and the areas with a peach cast to them. Using pressure 1, layer Black Grape on the shadow on the wall.

5 SATURATE THE COLOR

Unless otherwise stated, use pressure 3 for this step. Layer Canary Yellow over the champagne again, including the redder areas. Add Canary Yellow to the lightest area of the strawberry. With pressure 3, layer Hot Pink on the light area on the strawberry. Over the whole strawberry, layer Permanent Red. Add White to the bubbles and the inside of the strawberry to indicate the highlights. On the leaves, layer Peacock Green; over the darkest shadows, layer Indigo Blue. Using pressure 3–4, add dark lines of Indigo Blue to define the bubbles, the edges of the strawberry and the champagne glass. Over the gray on the glass, with pressure 2, layer Pumpkin Orange to dull the tone slightly. On top, layer Indigo Blue on the dark areas and Slate Grey on the lighter areas. Do the same for the wall reflections. Switch back to pressure 3 and continue layering color until no paper is visible on the glass. Leave the grain of the paper showing on the wall reflection.

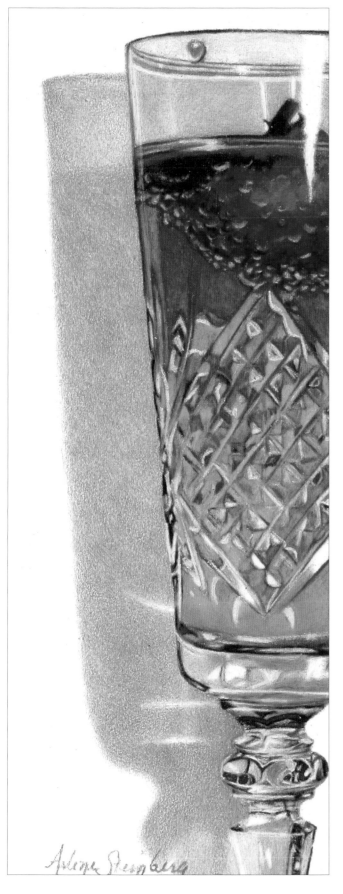

6 BRIGHTEN AND BURNISH

Lightly layer White over all the gray areas on the glass. Brighten any white areas that need it by using pressure 4 to cover the area. With pressure 3, wash White over the background reflection.

Burnish the glass and everything except the white areas inside the glass with the Colorless Blender pencil. Start with the lightest areas. Lightly wipe over the drawing with a cotton pad, making sure to keep using a clean section of the pad. Spray with two light coats of workable fixative. With pressure 3–4, go over the darkest shadows using Indigo Blue and Black Grape. Redo any highlights that need brightening with White. Spray with two to four more light coats of workable fixative and frame.

CHAMPAGNE WISHES
Colored pencil on Stonehenge paper · 7" × 2½" (18cm × 6cm)
Collection of the artist

USE CONSISTENT PRESSURE

Unless otherwise noted, use pressure 2 with the circular stroke (see pages 18–19). Keep a sharp point. Add more layers to make an area as dark as necessary; don't press harder.

Over the past twenty-five years, I've collected antique perfume bottles and atomizers. I have a collection of over sixty bottles and wanted to use them in a drawing. I chose to use bottles that focused on the different shapes, colors and textures of glass and metals.

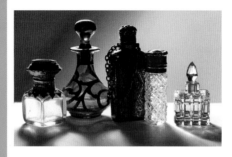

Reference Photo
My concern was lighting the setup to achieve the most dramatic reflections. After experimenting, I decided I liked the reflections cast by backlighting. Notice that the green bottle is reflected in the nearest bottles, and that the black bottle is distorted in the cut crystal bottle.

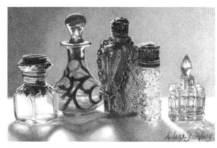

1 CREATE THE UNDERPAINTING
With an Indigo Blue pencil, impress your signature. On the background, do a gradated wash starting with Black Grape on the darker side and fading into Clay Rose.

Define the left bottle cap with Dioxazine Purple Hue. On the darkest areas, layer Indigo Blue over the purple. For the reflections in front of the left bottle, layer Dioxazine Purple Hue and Greyed Lavender on the yellowish areas, Black Grape on the green areas and Slate Grey over the grey areas. Follow with Pumpkin Orange over the blue areas.

On the green bottle's silver, layer Black Grape. Over the darkest areas, layer Indigo Blue. For the silver on the underside of the bottle, first layer Black Grape and then Black Cherry. Wash Black Cherry on the bottle's green areas. Layer Black Grape on the darker green shadows. On the green and black table reflec-

tions, layer Black Cherry in the darker areas and Tuscan Red over the lighter ones. Wash Slate Grey on the gray reflections and Pumpkin Orange over the blue reflections.

Define the black bottle's yellow pattern with Yellow Ochre. This will help you maintain the pattern. Layer Dioxazine Purple Hue over the bottle cap and chain and Indigo Blue on top of the purple in the darkest areas. Layer Tuscan Red on the green areas of the bottle and Indigo Blue on the black areas and over the Tuscan Red.

Layer Dioxazine Purple Hue on the cut crystal bottle cap. Layer Indigo Blue over the purple on the dark areas. Use Slate Grey to outline and then fill in the shapes on the bottle. On light areas, layer Clay Rose. Use Indigo Blue for dark areas. Define the green table reflections with Black Grape and the blue reflections with Black Cherry, followed by Pumpkin Orange.

Lightly define the blue bottle's lines with Pumpkin Orange. Define the shadows with Pumpkin Orange and Black Raspberry. Layer Black Grape on the darkest shadows. I find it easier to work a small section at a time using the three colors. Layer Slate Grey on the table, and wash Pumpkin Orange on top.

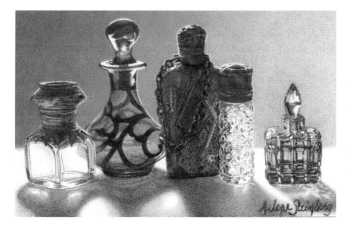

2 ADD COLOR

Layer Ginger Root over the background.

Layer Dark Green on the green bottle, the bottle's reflection and the green reflections in the bottle on the left. Layer Dark Green over the black bottle and on the green reflections in all the bottle stoppers. Add touches of the Dark Green on the cut crystal bottle.

Layer Indigo Blue on the blue bottle on the right. Add another layer of Indigo Blue to the darkest areas of the bottle stoppers and the chain on the black bottle. Layer Indigo Blue on all blue areas on the table.

Cover the chain and the three metal bottle caps with Yellow Ochre. Layer Yellow Ochre on the yellow areas of the bottle on the left and on the table's reflection.

Add touches of Pumpkin Orange to the bottle stoppers, the orange areas on the green bottle, the bottle on the left, and the red areas of the black bottle.

3 BRIGHTEN THE DRAWING

Layer Indigo Blue over the background and over the silver on the green bottle again.

Layer Denim Blue on the turquoise reflections on the two left bottles, over the dark and medium shades on the blue bottle and on the table reflections. Layer over the dark and medium shades on the blue bottle.

Layer Phthalo Green on the green reflections on the left bottle and cap and on the green glass bottle. Use pressure 1 on the yellow-green areas. Cover the silver on the rear of the green bottle, but not the silver on front. Layer over the green table reflections and in front of the black bottle. Layer the Phthalo Green over the design on the black bottle, leaving small areas of yellow showing. Layer Phthalo Green on the green areas of the cut crystal bottle cap.

Layer Black Grape on the dark areas of the metal bottle caps and on the chain of the black bottle. Layer Black Grape over the black perfume bottle.

Layer True Blue on the blue bottle. Don't be concerned about preserving the lighter areas; you'll be adding lights over those areas later.

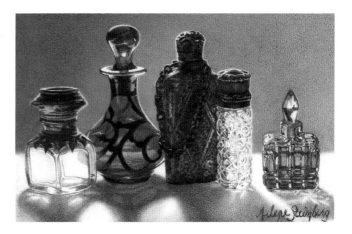

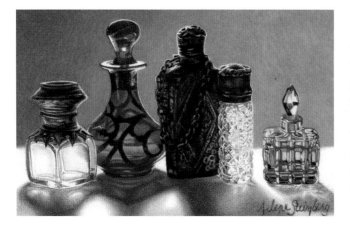

4 LAYER WITH COLOR

Layer Denim Blue over the darker side of the background. Layer Greyed Lavender over the whole background, using pressure 3. Add layers until no paper shows through. Wash Greyed Lavender on the gray shadows on the table. Use True Blue to brighten the blue reflections on the table and the blue reflections on the green bottle.

Using White, redefine the white highlights and light areas on the blue bottle. Add White highlights on the chain on the black bottle. Layer more Indigo Blue on the darkest shadows on the metal bottle caps, on the chain, and over the black bottle. Define the darkest values on the blue perfume bottle with Indigo Blue.

Layer Phthalo Yellow Green Hue on the lighter areas of the green bottle and the lighter reflections on the table. Using pressure 1, wash Phthalo Yellow Green Hue on the inside shadows of the cut crystal perfume bottle. On the yellow-green areas, layer Cinnabar Yellow. Add a thin line of Cinnabar Yellow to the top edge of the blue perfume bottle. Layer Peacock Green on the darkest shadows on the glass on the green bottle and on the silver on the underside. Add Peacock Green accents to the glass on the left bottle.

Layer Blue Lake over the middle values on the blue perfume bottle. If necessary, redefine the dark values with True Blue.

Layer Canary Yellow on the yellow areas on the bottle caps and on the black bottle's yellow areas. Layer Crimson Red on the bottle caps, the orange areas on the green bottle and on the red areas on the black bottle. These will be toned down in the next step.

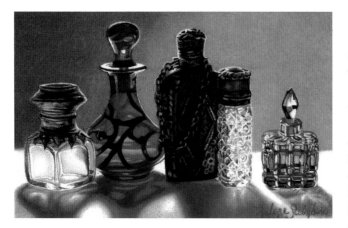

5 DEFINE THE SHADOWS AND SATURATE THE PAPER

Use Ginger Root to define the shadows on the cut crystal bottle and the left-hand bottle. Layer Ginger Root on the lightest table reflections, being sure to blend it near the darker reflections' edges. Layer Blue Lake over the green bottle's blue shadows, along the edges of the left bottle and cap, the blue bottle and the blue table reflections. Layer Blue Lake over the cut crystal, especially the reflected shadow of the black bottle. Over the dark shadow areas on the cut crystal bottle, layer Peacock Green. Layer Peacock Green on the darker areas of the green bottle and on the green-blue reflections in front of the black bottle. Layer Slate Grey and then Greyed Lavender over the lighter shadows on the cut crystal bottle. Layer Greyed Lavender on the light shadows on the glass of the left bottle. Layer Aquamarine and then Blue Lake again over the blue shadows on the table. Wash Phthalo Yellow Green Hue on the lighter areas of the green bottle and the lighter areas of the table reflection. Layer True Green on all areas of the glass on the green bottle except the yellow-green areas, and on the table's green reflections. Layer True Green in the green areas on the black bottle. Lightly go over the orange reflections with Canary Yellow. Layer Dark Green on any dark green areas.

Continue to layer color until the paper is saturated and no paper shows through.

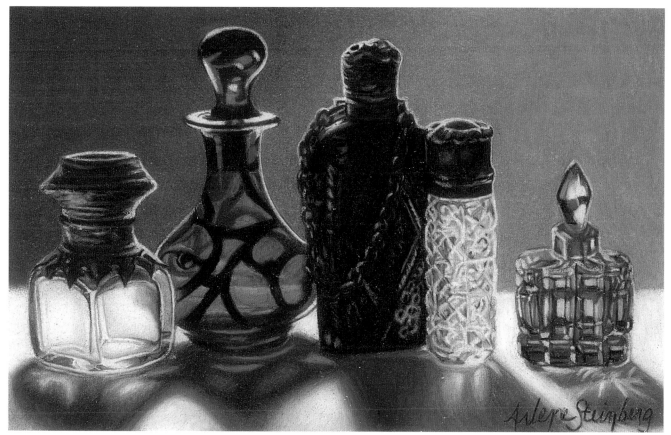

6 BRIGHTEN AND BURNISH

Using pressure 1, lightly layer White over the cut crystal perfume bottle. Use White and pressure 3–4 to define the fine lines in the cut crystal. Brighten any white areas that need it using pressure 4 to cover the area. Cover the white areas on the table with White. Using pressure 3, cover over the inside clear areas on the glass on the left bottle.

Carefully burnish the drawing with the Colorless Blender pencil. Lightly wipe the drawing with a cotton pad, starting with the lightest areas and making sure to keep using a clean section. Spray with two light coats of workable fixative. Go over the darkest shadows using Indigo Blue. Redo any highlights that need brightening with White. Spray two to four more light coats of workable fixative and frame.

REFLECTIONS OF THE PAST
Colored pencil on Stonehenge paper · 4" × 6 ¼" (10cm × 16cm)
Collection of the artist

HANGING ONTO YOUR ILLUSIONS
Colored pencil on Stonehenge paper · 14" × 18" (36cm × 46cm)
Collection of Andrew Terhune and Janice McMillen

"Don't part with your illusions. When they are gone you may still exist, but you have ceased to live."

—Mark Twain

PUTTING IT ALL TOGETHER

AN EXCELLENT PIECE OF ART SHOULD APPEAR EFFORTLESS. THINK OF A TOP ICE SKATER performing complex jumps and spins. The skater practiced each step diligently and repetitively for years to reach a level of skill that makes those complex moves look easy. All the skater's work culminates in one moment, when she performs before her audience. We are captivated by the grace and beauty of the skating, not by the years of effort that went into it.

It's the same way with art. Viewers respond to pleasing arrangements of shapes, colors, highlights and shadows without thinking about the hours of work the piece represents.

This chapter will guide you through all the steps I use to create one of my drawings, from initial concept to setup to the actual rendering.

CHAPTER 8

the masters' inspiration

I love the Old Master still life paintings. The Masters created a mood and told a story with the objects chosen, their use of light, composition and technique.

What really excites me about those old still lifes are the feelings they create. The deep, rich colors, triangular composition and use of chiaroscuro, with its highlighted objects and dark shadows, tells the viewer what the artist considered important.

What wonderful motivation to use the Masters as the inspiration for a modern still life drawing that utilizes some of the concepts they employed.

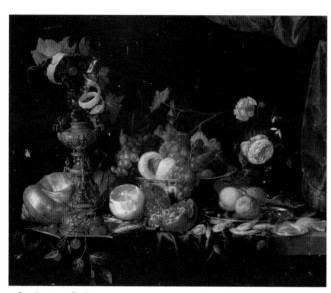

a focal point of color
When I started thinking about my idea for this chapter's drawing, I had a different concept in mind. I wanted a drawing with an abundance of objects and lots of color; similar to this painting by Jan Davidsz de Heem. The brilliantly colored yellow fruits become the focal point because they are so bright. Nothing else is as vibrant, so there's no competition. Observe how he used the color and placement of other objects to lead your eye back to the focal point.

STILL LIFE
Jan Davidsz de Heem (1606–1683)
Galleria Palatina, Palazzo Pitti, Florence, Italy
Photo Credit: Nimatallah / Art Resource, NY

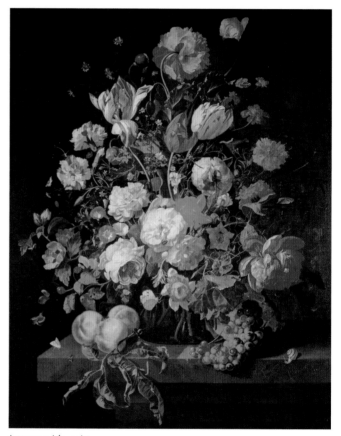

interest with variety
Rachel Ruysch, a favorite artist of mine, created paintings that are always colorful and unified. This painting employs a triangular composition. Most of the flowers and fruit are similar shapes, but she keeps our interest with their variety in color and size.

A BOUQUET OF FLOWERS
Rachel Ruysch (1664–1750)
Kunsthistorisches Museum, Vienna, Austria
Photo Credit: Erich Lessing / Art Resource, NY

simple and effortless

I find myself drawn to those still lifes that create a mood through their simplicity of placement and color. Some artists use bold colors to create mood. Others, like Willem Heda Claesz, use subtle color. The triangular composition, shapes and colors provide the drama.

BREAKFAST STILL LIFE WITH CHALICE
Willem Heda Claesz (1594–1680)
Kunsthistorisches Museum, Vienna, Austria
Photo Credit: Erich Lessing / Art Resource, NY

all the essentials

Here in Willem van Aelst's painting we see a mood created with his dark background and effective use of chiaroscuro. There is a repetition of shapes, a variety of object sizes and a triangular composition.

STILL LIFE WITH FRUIT, PARROT AND NAUTILUS PITCHER
Willem Van Aelst (1626–1683)
Galleria Palatina, Palazzo Pitti, Florence, Italy
Photo Credit: Scala / Art Resource, NY

setting up your still life

There's so much to remember when setting up a still life. You have to be aware of the lighting conditions as well as the arrangement of the objects. You also need to make sure that any organic objects are in good condition.

LOCATION

What's wonderful about creating still lifes is that the setup is completely in your control. You don't need a large area to shoot a good still-life photo. Any table, counter, chair, bench or floor will work. Try different areas in your house: a corner of your bedroom, the living room or even the bathroom floor. Try different backdrops: a view of the outdoors, a tile backsplash, printed fabrics, woven textures or wallpaper.

After setting up your still life, look through your camera's viewfinder to see if it's as you've envisioned. Move, eliminate or add objects to create a more pleasing composition.

TAKE LOTS OF PHOTOS

Digital memory is cheap. Take many photos of each scene or setup. Change your camera's exposure. Move your lights and camera around. Change the background. Most of all, experiment, be inspired and have fun!

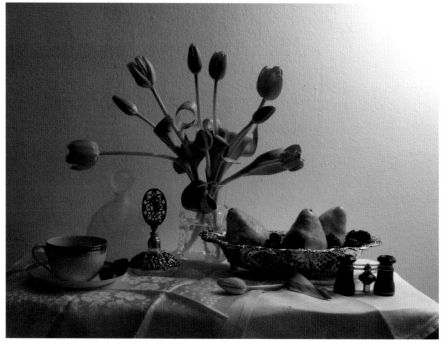

don't settle if you're unsatisfied
This was my first attempt with creating the still life. I wasn't happy with the perfume bottle that got lost in the background or the tulips that fanned out in an unbalanced arc. Overall, the arrangement was just bland.

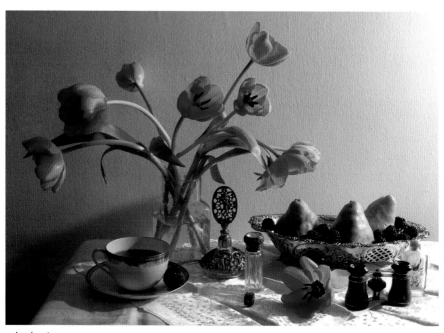

take the time to rearrange
After evaluating the results of my first photo shoot, I tried to make the composition more exciting. I waited until the tulips opened up, and rearranged the objects.

ADAPT AND TRY AGAIN

Even after reshooting my original still-life idea, I still wasn't happy. I analyzed it for several weeks and finally realized I hadn't achieved the look I was after, that is, the drama of darks and lights. I couldn't salvage anything from the shots I'd already taken, so I began again.

plan your colors and objects

I started with a triadic color scheme of red (the cloth, grapes, pink flowers and red glasses), yellow (the pears, lemons and perfume bottles) and blue (the curtain, blueberries and blue glass). I worked within the framework of a triangular composition, repeating shapes and colors and employing a variety of sizes. Because tulips were no longer in bloom, I switched to calla lilies and added white freesia.

keep trying

A drawing can only be as good as its setup. I shot close to seventy-five pictures of this setup, yet I still felt I needed to change a few things around. I moved the red cloth down to the edge of the table, eliminated some of the grapes, added some blueberries, rearranged all of them and shot over seventy-five additional photos.

choosing the best reference photo

The photo you choose is your roadmap for the drawing, so it's important to cull your photos and choose the one that best reflects your intention, keeping in mind mood and composition.

no focal point
I felt the setup was better in this photo but didn't like the fact that because everything was evenly lit, there was no focal point.

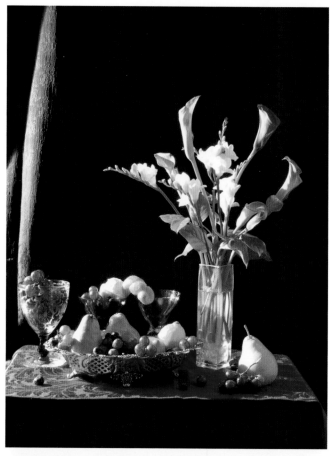

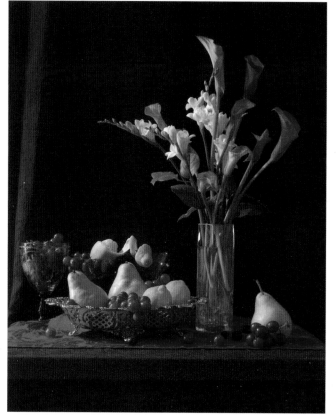

wrong emphasis
I loved the soft lighting in this photo, but not how the lighting was concentrated on the pear, or how the photo had no one object as a focal point. This stage is about getting a feel for what's "working" and what isn't.

static and rigid
Here, I liked the lighting on the fruit on the left and the vase, but felt the lighing on the pear on the right was too harsh. I also felt the vase's position was static and the flowers lined up too rigidly.

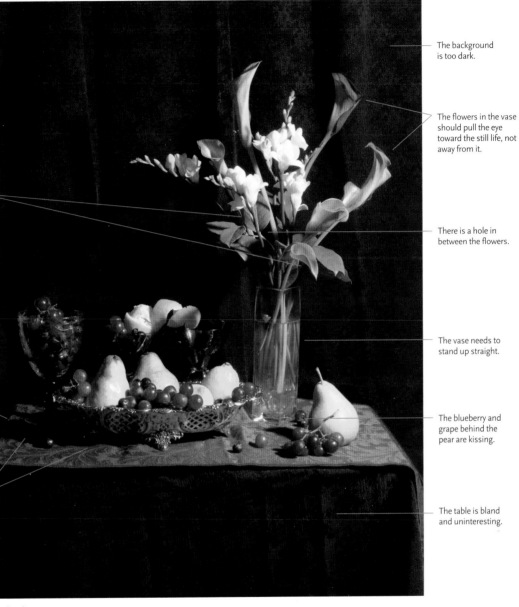

The photo needs to be cropped to create a more intimate feel.

The straight lines of the stem and flower lead the eye away from the focal point.

The edge of the fabric should extend to the edge of paper.

Something needs to fill the space in front of the compote.

The background is too dark.

The flowers in the vase should pull the eye toward the still life, not away from it.

There is a hole in between the flowers.

The vase needs to stand up straight.

The blueberry and grape behind the pear are kissing.

The table is bland and uninteresting.

best yet

I liked the way the lighting in this photo made the flowers stand out as the focal point. There is enough contrast for a painting using chiaroscuro and the angle of the vase became another interesting shape. I felt most of the adjustments would be fairly simple ones: adding flowers, removing some stems, adjusting angles and moving a few objects.

Why Not Reshoot?

When the elements that need to be changed are "uncooperative," such as the flowers in this floral arrangement, you'll save time and frustration by making the adjustments with a pencil and tracing paper or in your photo-editing program. It's almost impossible to get flowers to behave.

fine-tuning your reference

Once you've settled on a photo to work with, it's sometimes necessary to make small changes to create the best reference possible. This is the time to straighten anything that is at an angle or lopsided, to move an object closer or farther away, to add additional elements, or to adjust colors and values to create more drama. By working out the kinks now, you'll have an easier time when drawing.

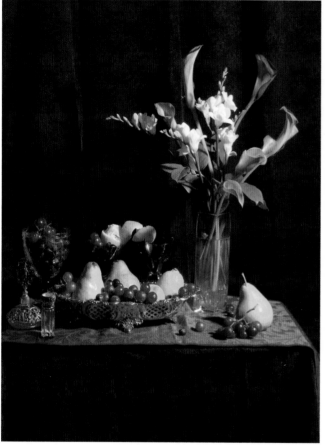

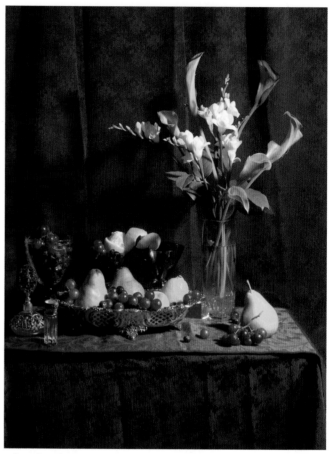

add elements for a better composition
To offset the hole on the left side of the photo, I added two perfume bottles with gold tops.

adjust the colors
I adjusted the colors to lighten the background and bring out the shadows. I replaced the two green pears in the silver bowl with the pears from the bottom right photo on page 118. I felt the pears from the other photo had more depth and dimension to them and weren't as harshly lit.

use your resources
I used the perfume bottles from the photos I originally shot. I found a photo taken from the same angle and selected the bottles using my image-editing program. I then used the copy function and pasted them where I wanted them in my new photo. I changed the colors inside the bottles to dark reds to reflect the color of the tablecloth, also using the image editor.

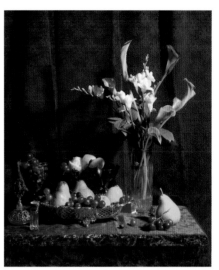

re-create what you need

Many times the seventeenth century Masters used marble or wood tables in their still lifes. I decided to re-create the look of marble using this reference photo.

keep the light in mind

With the help of my image-editing program, I was able to add the marble to create the look of a marble table. I adjusted the perspective, deepened the values under the ledge and on the left side where the table would have been in shadow.

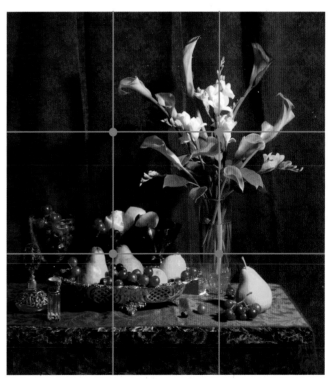

improve the arrangement

I felt I could improve the flower arrangement by adding and subtracting flowers. I selected a flower from one of my other photos, then pasted it into the reference photo.

crop for a more intimate view

I cropped the photo so the flowers were at one of the rule-of-thirds focal points, with the fruits in the basket in the secondary focal point. I wanted viewers to feel that they were part of the scene—that they could walk up to the table to grab a piece of fruit or look closely at the flowers. I did this by eliminating much of the background.

Creating Your Own Masterpiece

This final lesson is a culmination of all you've learned throughout the book. You've learned about composition, color and complementary tonal underpainting. You've created small drawings that focused on whites, on different textures and patterns, and on glass and how the light reflects within it. Hopefully you've been taking more time to really see color and the patterns around us.

Now you're ready to complete a larger, more complex painting that combines many of the different techniques you've learned from the book. This is a traditional still-life setup and incorporates different patterns and textures, glass and reflections, shadows and chiaroscuro. When your drawing is finished, it can be called a painting.

MATERIALS

PRISMACOLOR PENCILS
PC 901 Indigo Blue
PC 908 Dark Green
PC 910 True Green
PC 911 Olive Green
PC 916 Canary Yellow
PC 918 Orange
PC 923 Scarlet Lake
PC 924 Crimson Red
PC 925 Crimson Lake
PC 933 Violet Blue
PC 935 Black
PC 936 Slate Grey
PC 937 Tuscan Red
PC 938 White
PC 942 Yellow Ochre
PC 993 Hot Pink
PC 996 Black Grape
PC 1005 Limepeel
PC 1009 Dahlia Purple
PC 1012 Jasmine
PC 1017 Clay Rose
PC 1020 Celadon Green
PC 1021 Jade Green
PC 1026 Greyed Lavender
PC 1030 Raspberry
PC 1034 Goldenrod
PC 1077 Colorless Blender Marker
PC 1078 Black Cherry
PC 1087 Powder Blue
PC 1089 Pale Sage
PC 1090 Kelp Green
PC 1091 Green Ochre
PC 1095 Black Raspberry
PC 1096 Kelly Green
PC 1101 Denim Blue
LF 129 Madder Lake
LF 132 Dioxazine Purple Hue
LF 133 Cobalt Blue Hue
LF 142 Orange Ochre
LF 145 English Red Light
LF 195 Thio Violet
LF 203 Gamboge
VT 734 Verithin White

OTHER MATERIALS
Stonehenge paper, 14" × 13" (36cm × 33cm)
Cotton swabs
Denatured alcohol
PM 121 Prismacolor Premier Double-Ended Art Marker, Clear Blender
Workable fixative
Ball-tipped burnisher (optional)

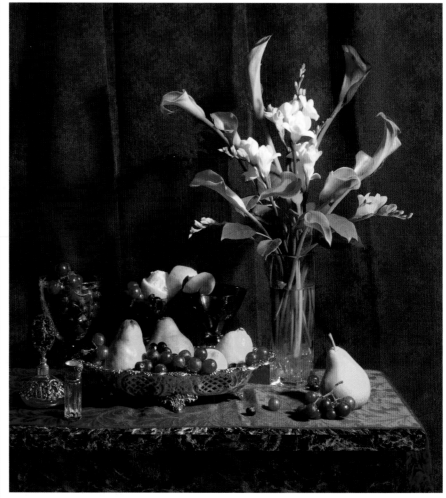

final reference photo
In the line drawing which can be found on page 141, I moved the red glass on the right down a bit so it is on the same level as the other glass. My final adjustments:

- I eliminated some stems, leaves and flowers to make a more balanced arrangement.
- I straightened the vase.

- I added flowers and leaves to the vase and used the warp tool to bend some stems; for others I used parts from other photos. If the light was on the wrong side, I flipped the section taken from the other photos.

- I added tablecloth fabric on the edges at the left and right so that the damask fabric appears to be draped over the table.

USE CONSISTENT PRESSURE

Unless otherwise noted, use pressure 2 with the circular stroke (see pages 18–19). Keep a sharp point. Add more layers to make an area as dark as necessary; don't press harder.

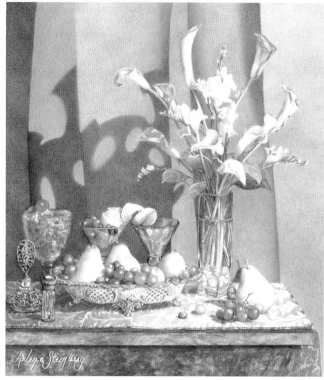

1 DEFINE THE SHADOWS
Use a Verithin White pencil or a ball-tipped burnisher to impress your signature and the white highlights into the grapes, blueberries, glass vase, silver bowl, glasses and perfume bottles.

Define the shadows on the curtain and inside the vase with Black Raspberry. Layer Clay Rose over the Black Raspberry and over the lighter areas of the curtain.

Scribble Indigo Blue on the underside of the marble table, and then use the clear blender marker or alcohol and a cotton swab to dissolve some of the wax and blend the pigment (see page 20). After completing the underside, do the tabletop the same way. Be careful not to get pigment into other areas.

Define the dark shadows and the pattern on the cloth with Indigo Blue. Use Dark Green and Celadon Green on the lighter areas. Shade the silver bowl with Indigo Blue.

Layer over the grapes and the three glasses in the back using a combination of Dark Green and Indigo Blue. Don't layer over areas that are not in shadow.

Using Dioxazine Purple Hue, with Greyed Lavender for the lighter shadows, define the lemons and the white freesia. Create the gold filigree pattern on the far left perfume bottle and the cap of the other bottle with Dioxazine Purple Hue. Shade the yellow areas on the bottom of the small bottle and create the shadows on the stems of the grapes and the vase with Dioxazine Purple Hue. Shade the calla lilies, the pears and the glass vase per the earlier lessons.

DEMONSTRATION

123

2 SCRIBBLE AND BLEND (THE UGLY STAGE)
Use Dark Green to scribble over the marble table, leaving areas of blue showing through. Dissolve the pigment as you did in step 1.

Wash over the shadows on the curtain with Dark Green. Cover all the blue areas on the grapes, glasses, silver bowl and tablecloth with Dark Green.

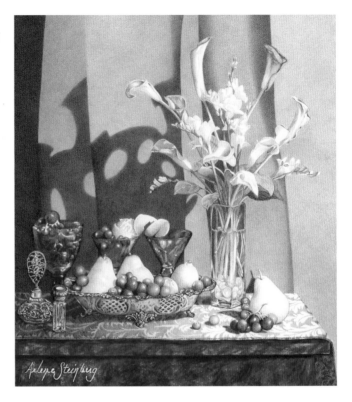

3 ADD COLORS
Layer Indigo Blue over the curtain. On the marble, scribble White in uneven patterns. Then scribble Black Cherry roughly over parts of the marble. Use your clear blender marker or alcohol to blend the White and Black Cherry. Once the surface dries, wash Black Cherry over the marble again.

Layer Black Cherry over the dark areas of the tablecloth, the three glasses, the grapes, the pear stems, the red areas of the perfume bottles, and the silver bowl. Layer Black Cherry over the darker areas with a reddish tint on the lemons and on the brown areas on the two pears in the silver bowl.

Layer Dark Green and Celadon Green over the leaves, remembering to keep white areas white. Layer Yellow Ochre over the yellow shadows on the fruits, the bottom of the perfume bottle, the marbles in the vase, the calla lilies and the freesia.

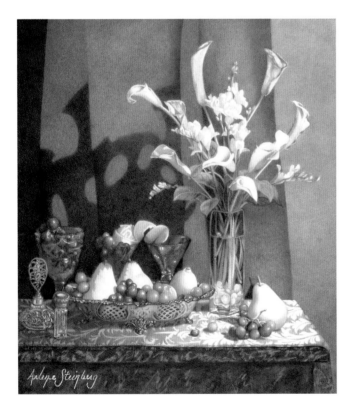

Why "Background First" Is Necessary
Notice how washed out the other colors look against the dark background. This is why it's best to put your background in first. When your background is almost saturated, you will have a better sense of how dark you have to make your main subject.

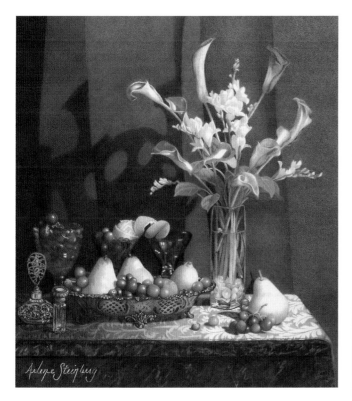

4 DEFINE THE SHAPES

Color over the curtain with Black Grape. Layer Black Grape in the dark areas on the blue glass on the left.

Scribble on the marble table with Tuscan Red. With a clear blender marker or alcohol, rub over the area. Layer Tuscan Red over the shadows on the tablecloth and on the red areas of the two perfume bottles. With a very sharp point, add lines to the darkest areas on the shadow sides of the perfume bottle's filigree. With pressure 1, wash Tuscan Red over the brown areas of the pears and on the shadows on the lemons. Layer Tuscan Red over the shadows on the grapes, stems and pears.

Layer Goldenrod over the shadows on the pears, and lemons. Layer Greyed Lavender over the shadows on the white freesia to darken them. Layer Olive Green on the leaves.

Treat Yourself to Your Accomplishment

Putting in the background can be boring. Divide it into small sections, and work to finish each color one section at a time. Stand the drawing so you can view it from a distance, then stretch, step back and admire what you've accomplished so far.

5 ADD MORE LAYERS

Scribble Black over parts of the marble table, then dissolve and blend the color as in step 1.

Using pressure 3, wash Dark Green over areas of the curtain that are not in shadow. Next, layer Violet Blue over all areas of the curtain using pressure 3. Follow this by washing Black on the dark shadows on the curtain, then layer Violet Blue over the shadows.

Layer Violet Blue over the darkest shadows on the left side of the tablecloth, but do not cover the darkest shadows cast by the vase and fruit. Layer Violet Blue over the shadows on the three glasses and silver bowl. Over the two red glasses and the grapes, wash Tuscan Red again. Wash Tuscan Red over the blue shadows on the tablecloth.

On the darkest shadows of the leaves, layer Black Grape. Over shadows on leaves with a blue cast, layer Violet Blue. Layer Olive Green over areas with a yellower cast. Wash Olive Green over the green pears, the filigree on the perfume bottle and on the stems.

Layer Orange Ochre over the dark areas on the lemons, and on the yellow areas of the freesia, calla lilies and stems.

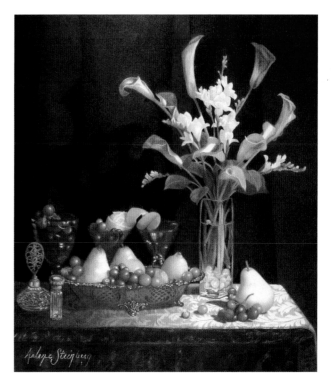

125

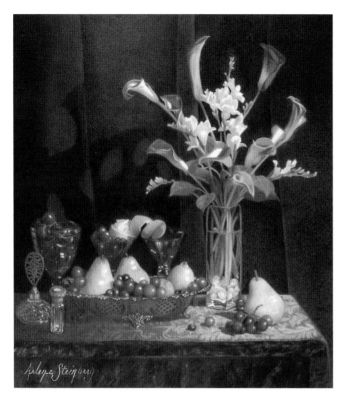

6 ADDING DEFINITION

With White, add a highlight to the curtain where the light is hitting it. This will create subtle highlights noticeable in certain lights.

With Raspberry, color in the grapes, the tablecloth, the silver bowl, the glass on the perfume bottles, and the red glasses. With pressure 1 add Raspberry to the shadows of the lemons. Define the etching on the blue glass and redefine the highlights on the red glasses with White.

Cover the shadows on the perfume bottle's filigree with Dioxazine Purple Hue. Layer Jasmine on the lemons and the pears, and add veins and highlights to the leaves.

Wash Violet Blue over the blueberries.

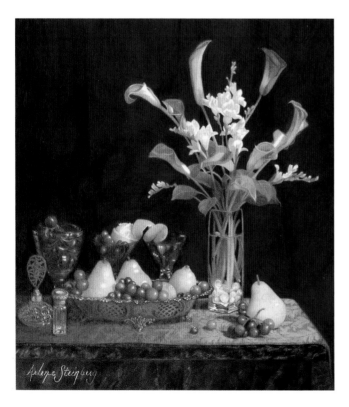

7 ESTABLISH A MOOD

Over the dark shadows on the curtain, layer Denim Blue. Use Cobalt Blue Hue on the rest of the curtain, including over the white highlights. Use pressure 3–4 and cover the Denim Blue and the Cobalt Blue Hue with Indigo Blue.

Layer Crimson Lake over the tablecloth, the perfume bottles and the reddish grapes. Don't cover over the grapes with a purplish hue. Using pressure 1, wash Crimson Lake over the shadows on the lemons.

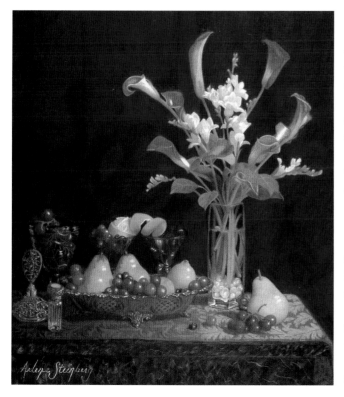

8 DEEPEN THE SHADOWS

Color over the filigree on the perfume bottle and the cap of the other bottle with Yellow Ochre. Define the shadows with Indigo Blue, then layer Green Ochre on top. Layer over the top edge and the legs of the silver bowl with Green Ochre. Using a needle-sharp pencil and pressure 3, wash over the fruit stems with Green Ochre. Deepen the dark shadows on the freesia and cover the brown areas on the pears with Green Ochre.

Layer Orange over the brown areas on the pears, then wash it on the shadows on the lemons and the lighter areas of the red grapes and the red glasses.

Over the marble table, scribble Black, then Green Ochre and then Indigo Blue.

Layer Black over the darkest areas on the blue glass. With pressure 3, layer over that with Indigo Blue. Layer Indigo Blue on the far left perfume bottle's stopper, over over the dark areas on the two red glasses, and the darkest areas on the silver bowl. Layer Indigo Blue on the darkest shadows on the left side of the tablecloth, under the silver bowl and on the draped side of the tablecloth on the right. Layer Indigo Blue over the shadows on the blueberries.

Layer Canary Yellow over the lemons, the highlights on the perfume bottles, and on the yellowish stems and leaves.

Layer Thio Violet over the darker grapes and on the shadows on the light grapes.

Use Kelly Green on the bright green areas of the stems and leaves.

> ### Don't Worry Until You Burnish
>
> Don't worry if your colors seem to lose some of their contrast or get lighter. Burnishing will help bring out the layers underneath and define the shadows.

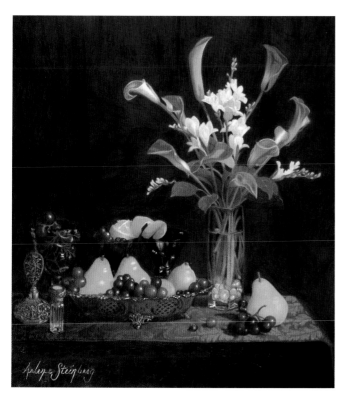

9 INCREASE THE PRESSURE

Use pressure 3–4 unless otherwise stated. Refer to pages 62–63 to color the calla lilies.

For the white freesia, use pressure 3 to layer Greyed Lavender over the shadows. Follow this with touches of Hot Pink and Lime-peel. Layer White over all of the flower petals.

Using pressure 3, add Hot Pink to brighten the shadows on the lemons. Use pressure 3 to layer Jasmine and Canary Yellow over the lemons. Add White highlights on the right side and the edge of the lemons.

With pressure 3, layer Canary Yellow, then Jasmine and White over the two pears in the silver bowl.

Layer Crimson Red over the lighter grapes. With Crimson Red and pressure 3–4, cover the dark side of the tablecloth and the shadows. Switch to pressure 3 and layer over the dark areas of the pattern on the light side.

Layer Raspberry over the purple grapes and the two red glasses. Using pressure 3, layer Black Grape over the filigree and stoppers on the two perfume bottles. Layer Black Grape over the dark areas on the blueberries and the shadows on the leaves. Layer True Green over any leaves and stems with a blue-green cast.

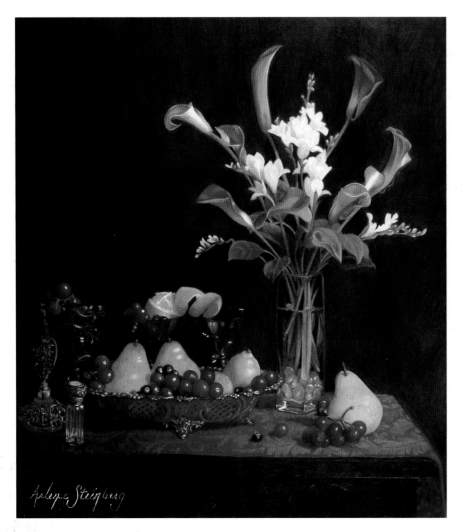

10 ENRICH THE COLORS

Layer Orange Ochre over the areas on the leaves with an orange-yellow cast. Cover the leaves with a combination of Gamboge, Orange Ochre, Limepeel, Raspberry, Indigo Blue, Pale Sage, Dark Green, Kelp Green, True Green, White, Olive Green and Kelly Green to define and shape the leaves and stems. Each leaf will use a different combination of colors, depending on the color-cast of the individual leaf. Start with pressure 3 and increase to pressure 4 to completely cover each leaf. Don't be concerned about matching each individual leaf exactly. It is more important to have the values correct.

On the lighter grapes, layer Orange Ochre to create highlights. Layer Orange Ochre over light areas on the tablecloth and on yellow areas on the perfume bottles. To brighten the grapes and tablecloth, layer Hot Pink over the Orange Ochre and on the lighter areas of the dark grapes.

Over the Hot Pink on the tablecloth, layer Scarlet Lake and then add another layer of Hot Pink using a pressure 3–4. Cover the silver bowl with Scarlet Lake and then use a combination of Gamboge and Hot Pink in the lightest areas. With White, add highlights to the silver bowl, including the rim. Layer Scarlet Lake over the lighter grapes. Layer a combination of Hot Pink, Gamboge and Raspberry to finish the light grapes.

11 BURNISH AND ADD DETAIL

Starting with the lightest area, burnish all areas with the Colorless Blender using the circular stroke. Spray with two light coats of workable fixative. When it is dry, layer English Red Light over parts of the marble table. Add soft veins in the marble with Gamboge. Finish by layering Indigo Blue over the table. Burnish and add more touches of the English Red Light. Create veins using White. Burnish parts of the white veins to soften the edges.

Cover the shadows on the lemons with Orange and then Canary Yellow. Add Canary Yellow to the light areas on the two perfume bottles. Layer Limepeel and then Canary Yellow over the two pears in the silver bowl. Use White to brighten the white highlights and the edges of the fruit. Layer White over the hazy areas on the grapes. Spray with two to four more light coats of workable fixative and frame.

CALLA LILIES AND FRUIT
Colored pencil on Stonehenge paper · 12" × 10¾" (30cm × 27cm)
Collection of the artist

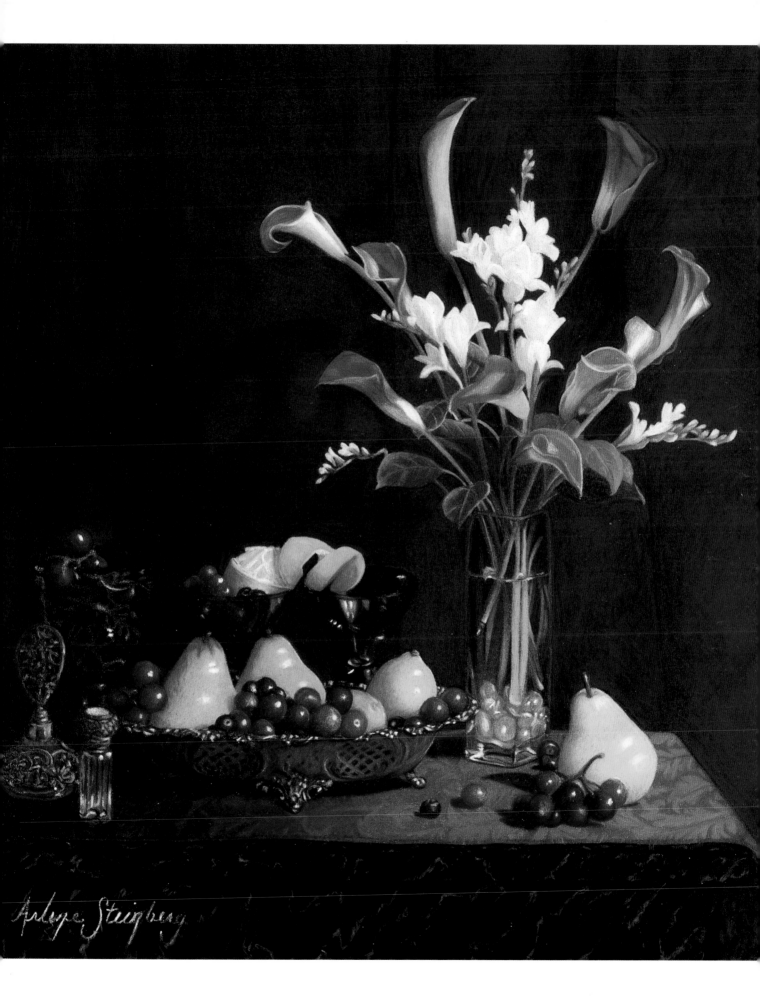

Arlene Steinberg

I'm constantly asked what it takes to become a good artist. As a native New Yorker, I'd like to answer this question by relating an old joke. A visitor to New York City asks a cab driver, "How do I get to Carnegie Hall?" The cabbie responds, "Practice! Practice! Practice!" To become a good artist, learn techniques and then practice! It is the only way to become better.

Another question involves how to stay motivated when your drawing isn't what you envisioned. You may feel like giving up in the middle or you may finish and be dissatisfied. The solution for me was learning to enjoy the process of drawing, rather than focusing on the outcome. Usually if I've been dissatisfied with a drawing, it was because what was on the paper wasn't what I had envisioned. In the past, I'd start over and never complete anything. I expected perfection and perfection is impossible. Finally, I stopped focusing on the outcome and instead gave myself permission to enjoy the process of drawing.

Nowadays, I pat myself on the back for creating a unique piece of art and accept the fact that I did the best job I was capable of doing. I'll then analyze what worked and what didn't, and I'll incorporate the lessons learned into my next drawing. Sometimes, I'll look at my drawing in the early stages, and think it's horrible and will never be a work of art. Artist friends ask me what I do when my drawing hits this "ugly stage." I remind myself that it's similar to the gangly teenager stage. If I continue to nurture my drawing by adding color, I'll wind up with a beautiful work of art.

There are other ways I stay motivated. I'll give myself a final deadline, and work to meet it or I'll try something new and out of my comfort zone to challenge myself. Another trick I use is to isolate the drawing into small sections. I'll concentrate on a leaf, a grape, or a shadow and challenge myself to add the next layers. I'll put the green in the shadows on the leaves. When I accomplish that goal, I set myself another one, get up from the drawing, take a break and reward myself. When I come back, I'll work on my next "goal."

As stated in the beginning of this book, my intent was to teach techniques of colored pencil drawing that will allow you to produce beautiful works of art in a manner similar to those produced by the great Masters. If I did my job properly, you'll get more from this book than just recipes. My hope is this book has motivated you and given you the confidence to branch out from the step-by-step instructions provided in these pages to compose your own works of art in your own style. This book provides the steppingstones; it is now up to you to use these techniques in your own way and develop your own personal style. So get comfortable, sharpen those pencils, plan your background and enjoy the process of drawing!

BIOGRAPHIES

CARYN COVILLE

is a graduate of Rochester Institute of Technology, where she received a bachelor of fine arts degree in printmaking. She has exhibited work locally and has been a student of Arlene's since 2002. Caryn resides on Long Island, New York, with her husband and two sons.

EMILY LAGORE

Having created all her life, this Edmonton, Alberta, artist now works exclusively in dramatic watercolors. Preferring to take her own reference photos, Emily's predominantly macro images often reflect her childlike sense of fun and always demonstrate her appetite for light and shadows.

MELISSA MILLER NECE

has taught drawing, colored pencil, oil and acrylic painting since 1990. A featured artist in the book *Creative Colored Pencil Portraits* by Vera Curnow, she has been active in many regional arts groups and is currently ways and means director for the Colored Pencil Society of America. Her work is in numerous corporate and private collections.

GIL WEINER

has been taking pictures since he was six years old, first using his father's old box camera, and even making his own camera out of a shoebox. He recently retired as an executive of a Long Island company and now maintains a part-time practice in alternative dispute resolution practice, which leaves him lots of time to devote to his photography.

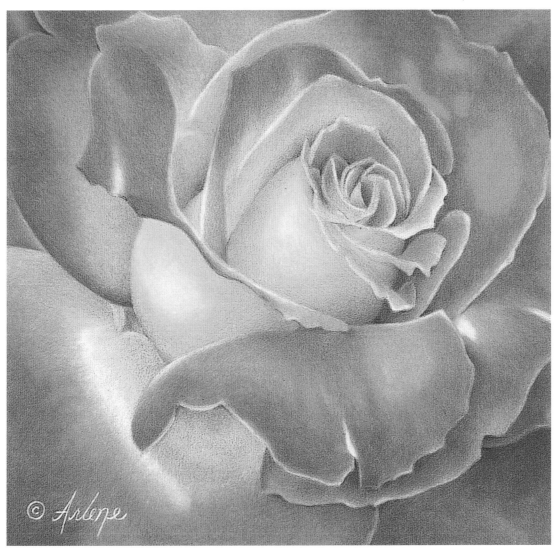

ROSE
Colored pencil on Stonehenge paper · 7" × 7¼" (18cm × 19cm)
Collection of Andrew Terhune and Janice McMillen

color chart

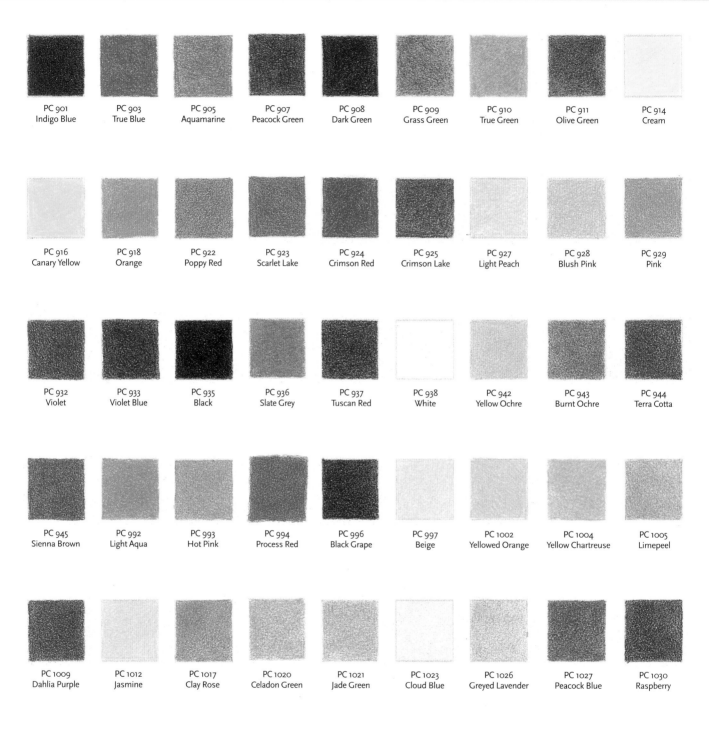

PC 901 Indigo Blue
PC 903 True Blue
PC 905 Aquamarine
PC 907 Peacock Green
PC 908 Dark Green
PC 909 Grass Green
PC 910 True Green
PC 911 Olive Green
PC 914 Cream

PC 916 Canary Yellow
PC 918 Orange
PC 922 Poppy Red
PC 923 Scarlet Lake
PC 924 Crimson Red
PC 925 Crimson Lake
PC 927 Light Peach
PC 928 Blush Pink
PC 929 Pink

PC 932 Violet
PC 933 Violet Blue
PC 935 Black
PC 936 Slate Grey
PC 937 Tuscan Red
PC 938 White
PC 942 Yellow Ochre
PC 943 Burnt Ochre
PC 944 Terra Cotta

PC 945 Sienna Brown
PC 992 Light Aqua
PC 993 Hot Pink
PC 994 Process Red
PC 996 Black Grape
PC 997 Beige
PC 1002 Yellowed Orange
PC 1004 Yellow Chartreuse
PC 1005 Limepeel

PC 1009 Dahlia Purple
PC 1012 Jasmine
PC 1017 Clay Rose
PC 1020 Celadon Green
PC 1021 Jade Green
PC 1023 Cloud Blue
PC 1026 Greyed Lavender
PC 1027 Peacock Blue
PC 1030 Raspberry

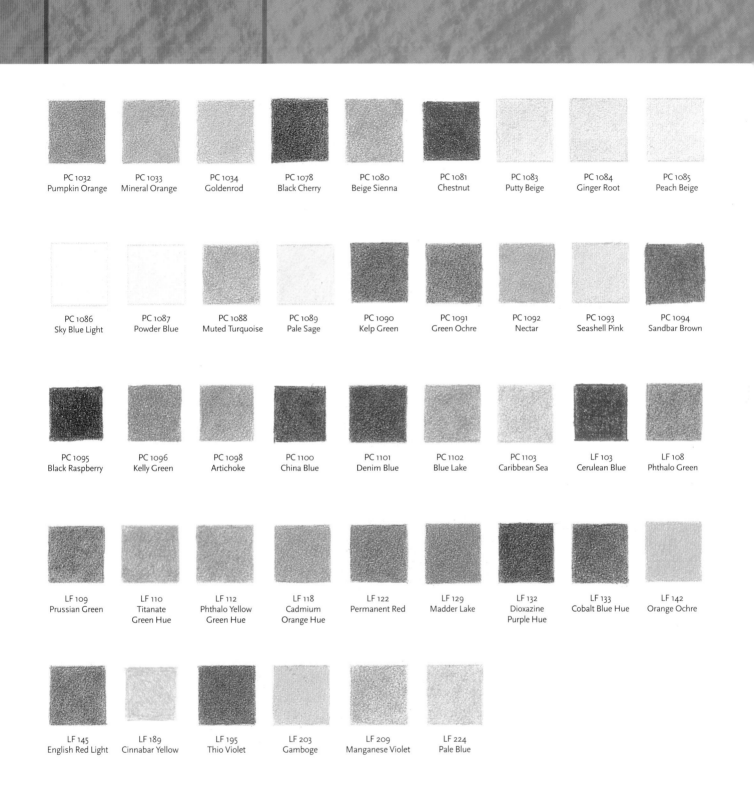

PC 1032
Pumpkin Orange

PC 1033
Mineral Orange

PC 1034
Goldenrod

PC 1078
Black Cherry

PC 1080
Beige Sienna

PC 1081
Chestnut

PC 1083
Putty Beige

PC 1084
Ginger Root

PC 1085
Peach Beige

PC 1086
Sky Blue Light

PC 1087
Powder Blue

PC 1088
Muted Turquoise

PC 1089
Pale Sage

PC 1090
Kelp Green

PC 1091
Green Ochre

PC 1092
Nectar

PC 1093
Seashell Pink

PC 1094
Sandbar Brown

PC 1095
Black Raspberry

PC 1096
Kelly Green

PC 1098
Artichoke

PC 1100
China Blue

PC 1101
Denim Blue

PC 1102
Blue Lake

PC 1103
Caribbean Sea

LF 103
Cerulean Blue

LF 108
Phthalo Green

LF 109
Prussian Green

LF 110
Titanate
Green Hue

LF 112
Phthalo Yellow
Green Hue

LF 118
Cadmium
Orange Hue

LF 122
Permanent Red

LF 129
Madder Lake

LF 132
Dioxazine
Purple Hue

LF 133
Cobalt Blue Hue

LF 142
Orange Ochre

LF 145
English Red Light

LF 189
Cinnabar Yellow

LF 195
Thio Violet

LF 203
Gamboge

LF 209
Manganese Violet

LF 224
Pale Blue

line drawings

The line drawings on the following pages are for you. You have permission to copy them to learn the color techniques demonstrated in this book. All except the final drawing are life size, but feel free to work larger if you so desire. I'm hoping you'll start to enjoy the process of painting with colored pencils.

Tomato
Page 50

Grapes, Blueberries and a Pear
Page 54

Iris
Page 58

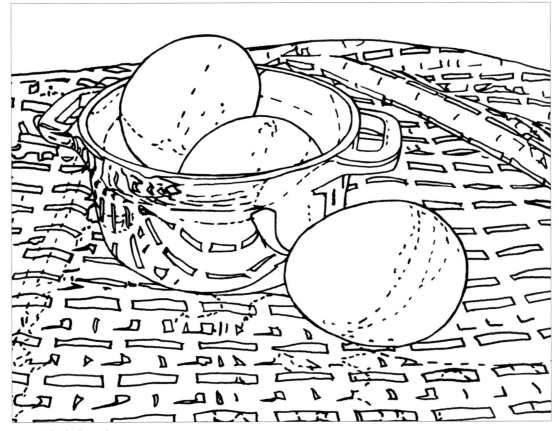

Eggs With Black Bowl
Page 66

Gray Feather
Page 71

Porcelain
Page 74

Peaches and Walnuts
Page 87

Matryoshka Dolls, Books and a Candle
Page 82

Bread and Cheese
Page 91

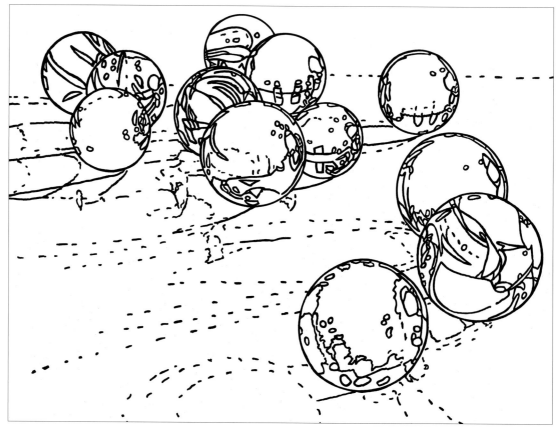

Marbles With Reflections
Page 100

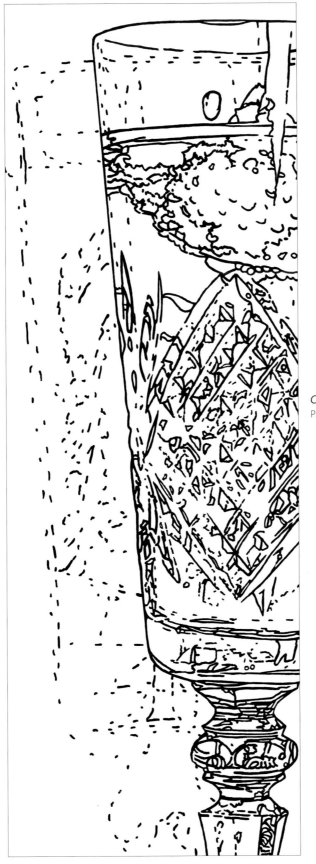

Champagne With a Strawberry
Page 104

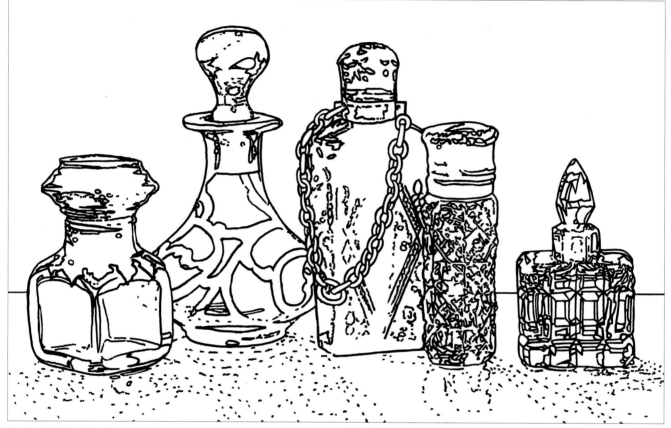

Antique Perfume Bottles
Page 108

Calla Lilies and Fruit
Page 122

index